Abstraction and Artifice in Twentieth-Century Art

Abstraction and Artifice in Twentieth-Century Art

Harold Osborne

CLARENDON PRESS · OXFORD
1979

Oxford University Press, Walton Street, Oxford OX2 6DP

OXFORD LONDON GLASGOW

NEW YORK TORONTO MELBOURNE WELLINGTON

NAIROBI DAR ES SALAAM CAPE TOWN

KUALA LUMPUR SINGAPORE JAKARTA HONG KONG TOKYO

DELHI BOMBAY CALCUTTA MADRAS KARACHI

British Library Cataloguing in Publication Data
Osborne, Harold
 Abstraction and artifice in twentieth-century art.
 1. Art, Abstract – History 2. Arts – History –
 20th century
 I. Title
 704.94´5´0904 NX456.5.A2 78–40234

 ISBN 0–19–817359–8

Printed in Great Britain by
Butler & Tanner Ltd, Frome and London

CONTENTS

ILLUSTRATIONS

(*at end*)

Sculptures

Paintings

PART ONE

Modes of Abstraction

1
General Introduction

Historians of culture like to interpret changing styles in art as the symbols of a vaguely conceived spirit of the age, endowing them with a recondite significance. There are others who give precedence to economic factors. In their writings works of art become heralds or signposts of cultural and economic trends, the inconstant iconography of social trends which transcend any conscious purpose or understanding on the part of the artists who produce them.

This method of mythologizing art and society persists among some historians and critics of the twentieth-century scene. Expressionism and Expressive Abstraction have been interpreted as an aggressive asseveration of impulsive individuality making its last stand against the levelling processes of technology and collectivization. Surrealism is seen as the symbolic welling-up of the irrational aspects of the self which are suppressed by the imposed conformity of bureaucratic society. At the opposite pole Constructivism and Geometrical Abstraction become attempts to create equivalent symbols for the cult of mechanical science and to integrate human personality into a world dominated by machine technology. Advocates of the New Humanism have believed that artists could be divided into those on the one hand who were eager to celebrate and explore the new technological environment and those on the other hand who set themselves to oppose its domination of the human spirit – what Herbert Marcuse called the 'Great Refusal'. Other artists there have been who declined to conform, preferring to retire into an imaginary wonderland of their own.

This manner of interpretation is the province of the historians and sociologists. Artists themselves are seldom deeply aware of the symbolic significance of what they are doing, or they may well be mistaken about it. Their problems are generally more practical and concrete. Therefore the present study avoids such ways of talking about art and concentrates rather on the problems with which artists themselves have wrestled and which they have discussed. Only so is it possible to know what twentieth-century art is about, what it is doing and trying to do. And this knowledge must precede and control symbolic or sociological interpretation.

The most important feature of art movements in the last hundred years has been abstraction and the many modes of abstraction, their motivations and their purposes, are traced from Impressionism to the ultimate abolition of the art object brought about by the Conceptualists. The other major trend in the art of this century is described

as the repudiation of artifice. By this is meant the determination to eliminate all those characteristics which distinguish art works from other artefacts and from natural objects. After many anticipations from the second decade of the century onwards this tendency burst into explosive prominence as the dominant aesthetic of the 1960s. It is my purpose in this book to explicate the motives and morphology of these two major tendencies in their many manifestations and the multifarious guises which they have assumed. But by concentrating upon them I do not mean to imply that these are the *only* distinguishing characteristics of outstanding importance in the art of this century. A more self-conscious concern with the structure and contents of the unconscious must be regarded as a leading feature setting off the age in which we live from the mental outlook of previous times; and in the art of this age interest in the unconscious has exercised an influence far beyond the confines of Surrealism proper. Fairly closely allied to this has been a new interest in the operations of chance, leading to theories of stochasticism and exploitation of artistic techniques of the fortuitous. While revolt from tradition has been always a pretty constant feature of artistic creation in the West, in our time special characteristics of this revolt have found expression in art as in other spheres of life. Interest in spectator response has become progressively more complex and more sophisticated, advancing from a simple desire for acceptance to complicated theories of 'co-creation' on the part of the recipient. And in general the desire to close the gap between 'art' and 'life', becoming articulate, has come to mean much more than the demand for functionality or relevance of subject-matter and has sometimes led to explicit repudiation of the traditional art object. All these changes are important for a full awareness of contemporary art. The present book is devoted to an examination of the two title-themes, but without implying any belittlement of the importance of other features.

While the making of art works has had many motives and served many ends, its most universal and persistent function has been to operate as a mode of communication among men. For this reason it seemed appropriate to adopt certain aspects of Information Theory as a framework for exposition in the chapters which follow.

The writings of artists themselves are extensively quoted or referred to in order to elucidate their motives and their aims. But even this is not a straightforward matter, necessary as it is. Artists are not usually

trained or coherent thinkers, not given to analysis. What they say is often contradictory or obscure. They often adopt current catchwords to justify what they are doing to themselves and to others. Most innovative art has been consciously pursued in reaction against a previous movement or style and the language used by artists in support of it is deliberately polemical. It is common form that neither the artists nor the critics have fully understood the aims of innovative movements until after these aims had been realized. Therefore the written statements of artists have to be understood in the light of their works. Yet in any serious attempt to understand what creative artists have been doing or trying to do, the voices of the artists themselves are paramount. They cannot not be heard.

This, then, is the plan of the book. It does not cover the whole of twentiety-century art. But it expounds certain major trends of this art in a way which has not been done before.

2

Art and Information Theory

In terms of modern Information Theory the kinds of information transmitted by works of art may be classified into three categories. When a work of art such as a picture or a poem depicts or otherwise specifies some segment of the world apart from itself, whether real or imaginary, or some characteristics of the world in general, including social conditions, the values pertaining in a particular culture, and so on, this is called *semantic* information. Works of art also, of course, transmit information about themselves, their own properties and structure, the relations among their parts, the materials from which they are made and so on. This is called *syntactical information*. The third category, *expressive* information, comprises information about emotional characteristics or concomitants of the work or what it depicts.

The language of information theory is not the only or necessarily the most rewarding way of talking about works of art, but it does, initially at any rate, offer a useful framework within which to adumbrate the characteristic features of twentieth-century art, to describe the ways in which it diverges most typically from the art of other periods and to elucidate the motives which have been predominant in shaping the various movements which have succeeded each other so rapidly and bewilderingly throughout the present century. In order to avoid the danger of over-simplification, however, and the misrepresentations to which that invariably leads, it is necessary to realize that the neat categorizations proposed by Information Theory – as indeed all classification within a living and developing phenomenon – are to some extent arbitrary. The categories are by no means so clear-cut and distinct as at first sight they seem. The kinds of information which they put into separate compartments overlap and interact, and it is necessary to understand something of the ways in which this occurs if the language of Information Theory is to be of genuine use in explaining the nature and differences among various types of art and their appreciation.

When a work of art transmits both semantic and syntactical information a tension is set up between them. Semantic information invites attention away from the properties of the work itself towards that which it depicts, specifies, or symbolizes. Syntactical information invites attention to the properties of the work itself and tends to deflect it from the subject depicted. In any one work of art either of these tendencies may predominate, and artists have a multitude of devices for influencing or controlling the flow of attention.

When semantic information is at a premium, and attention is wholly or almost wholly diverted from the properties of the work itself, we do not ordinarily call the artefact a work of art. This may occur either with very realistic or with highly schematized constructs. An example of the former would be the waxwork policeman which deceives visitors into asking for directions at Madame Tussauds, and of the latter the stereotyped figure which is painted outside a door also marked *Herren*, or the schematized bicycle which indicates a cycle path. In such cases the artefact functions as a pure 'sign' and not as a work of art.

It has sometimes been suggested that a minutely realistic depiction, for example a photograph, of a subject which itself has aesthetically interesting structural properties could be a successful work of art even though attention was diverted wholly upon the properties of the subject represented. But in traditional art this is no more than an academic supposition. Artists do indeed often select subjects and scenes of intrinsic aesthetic interest, or construct still-life subjects with the rudiments of aesthetic form, but modification and selection are necessary when these are depicted in pigment. At the very least, when a three-dimensional subject is represented on a two-dimensional canvas, two-dimensional correspondences must be sacrificed to make room for three-dimensional cues. And realism of colour representation is even more precarious. Since the pictorial artist has at his disposal only a tiny fraction of the total range of brightness variation in the external world, he must make extensive modifications of saturation and hue in order to compensate for this. These limitations of realism inherent in the medium inevitably introduce formal or structural properties of the art work itself so that it cannot be simply a mirror-like reflection of the subject it depicts. For similar though more complex reasons a mechanically accurate three-dimensional replica of a beautiful face or body is not acceptable as a work of art. Nevertheless the suggestion has relevance for certain kinds of recent art, as for instance the art of the tableau and the art of the 'happening', and it has some bearing upon a pervasive tendency of innovative artists throughout the twentieth century to eschew artifice in all its forms. It is not wholly unrelated to the practice of some Pop artists incorporating in their works magazine illustrations or other real objects instead of themselves making pictorial representations of them.

When equilibrium is achieved between the demands of semantic and syntactical information we speak of fine naturalistic art. It is for

such balance rather than simply for his power to 'catch a likeness' that the fifteenth-century Flemish painter Jan van Eyck is so greatly admired. But as conventions of pictorial representation change, what seemed naturalistic to one generation no longer seems so to another. Giotto and Masaccio had a great name for realism in their day, but nowadays they do not spontaneously give this impression, and it is necessary to study their works in their historical perspective in order to understand why once they seemed so. When this sort of change happens, and what once seemed realistic no longer seems so, attention is diverted from the subject towards the style and manner of depiction, from the semantic towards the syntactical information. Such changes do not disturb appreciation today as much as they did in the past since they are in line with a general tendency of this century to put more emphasis on the syntactical or formal properties of art than on semantic information. But our admiration still goes out to the great naturalistic painters of the past for their ability to manipulate pigment so as to produce impressively realistic semblances of our visual experience of the external world. Writing of van Eyck, Michael Levey speaks of his 'extraordinary ability to capture a likeness – whether it be the faces of his sitters or the texture of fur, satin, glass and precious stones'. And describing van Eyck's famous Arnolfini portrait, he says:

Van Eyck's rooms are not just boxes to attract and trap capricious light. At his most virtuoso he conveys a shaft of sunlight falling through stained glass to form a glowing pool on the floor or wall; and light glancing off metal or absorbed in a carpet's pile. More subtle still is the sense in the Arnolfini portrait of bright daylight just outside the open window, illuminating its brick framework and casting the faintest blur of shadow on the wooden shutters' surround; and brightness is skilfully accentuated by the silhouette of one dark shutter, not fully folded back.

This was not written in an academic study of art history but occurs in a popular article contributed to the Sunday Supplement of the *Observer* for 22 September 1974.

Although we accord it our admiration, it is nevertheless a commonplace that this sort of naturalism is no longer a prominent feature of art and has rarely been a central aspiration of progressive artists since the beginning of the present century. The 'magic realism' of the Surrealists was a more deliberate importation designed to endow an imaginary or dream reality with the convincingness and the immediacy of that which is directly perceived. The realism of the painters of the

pulls it together as it is said, and radically affects the formal relations throughout. It was certainly a recognition of the important syntactical functions which representation can be made to fulfil that influenced the early Cubists to maintain subject-matter instead of going fully abstract. The emphasis in their works was heavily on the side of syntactical rather than semantic information. Their guitars and bottles and fruit bowls held little interest in themselves, were deliberately voided of the sensory appeal of the old Flemish still lifes. Even their figures and landscapes were devoid of emotional and expressive interest for the most part. But without them the structure and syntactical meaning of their works would have fallen apart. Thus Juan Gris remarked in an article 'On the Possibilities of Painting' published in *Transatlantic Review* in 1924: 'A picture with no representational purpose is to my mind always an incomplete technical exercise, for the only purpose of any picture is to achieve representation.'

If it is the case that the semantic content of a work of art may intimately affect its formal structure, it is also true that the formal properties may influence its semantic significance. And this influence may run in two main directions, which to some extent merge and overlap. In the first place the formal properties with which an artist intends to endow his work may have an influence on his choice of what to depict and on the degree of naturalism with which he depicts whatever it may be. Whether an artist picks upon a landscape or sets up a still life or even embarks upon a commissioned portrait, he must select among the natural features of his subject which to depict and which to omit, which to emphasize and which suppress. In this he may be motivated by expressive considerations or he may concentrate on certain formal aspects or relations in his subject which seem to him interesting in relation to the coming pictorial structure, the one bearing upon the other. In some cases the choice of a subject may be still more deliberate and the artist may consciously look round for subjects which easily fit into the kind of formal structure which he wants to paint. This, or something very like it, was the way in which the American Precisionists worked in the early 1930s – Cubo-Realists as they are sometimes called. The country barns of Georgia O'Keeffe and Charles Sheeler, the factory and machine subjects of Charles Demuth, Sheeler, Morton Schamberg, Niles Spencer, were chosen for their ready exemplification of the rectilinear and geometrical forms which these artists had taken over from European Cubism.

Furthermore, formal considerations of pictorial structure may lead to modifications or even distortions of natural forms and these may be deliberately used by the artist for expressive purposes or to give prominence to this or that aspect of his subject or for the creation of visual metaphors, analogies, and so on. Such deliberate manipulation of formal properties for the sake of their bearing on semantic import is especially prominent in twentieth-century art, when particular modes of distortion or schematization are more often deliberately adopted by individual artists or groups rather than belonging to the unconscious style of a period as was the case with International Gothic and Art Nouveau. An unusually good example of this comes from the Futurists, one of whose main aims was to direct attention on speed and movement by 'synthetizing' in one picture a sequence of views of a moving object (or of a stationary object seen by a moving observer) and to indicate 'force lines' between them. Henry Moore's 'distortions' often had the purpose of creating a visual analogy between the human figure and natural land formations. And as has frequently been noticed, visual metaphor played an unusually important part in the paintings of Paul Nash. In the Introduction to the catalogue of a retrospective exhibition of his works arranged by the Scottish National Gallery of Modern Art in 1974 David Brown wrote: 'In Nash's paintings megaliths began to assume the role of personages, as could pieces of wood, pebbles and other objects, which might play some part in the drama of some strange meetings and undergo a metamorphosis of identity. Tree stumps sometimes became monsters and fungi might fly.'

When the formal arrangements of a picture impinge strongly on its semantic aspects this is commonly bound up closely with expressive considerations and to this we now turn. First, however, it will be of help to give a few examples of the way in which the interplay of semantic and syntactical features bears upon the expressive character of the picture.

Matisse's *Joie de vivre* of 1905–6 represents a pastoral scene with groups of naked figures disporting themselves in a sunlit glade. On the left a girl garlands herself with laurel while another crouches at her feet picking flowers. In the right foreground a pair of lovers are embracing and behind them is a piping shepherd tending sheep. In the middle distance a group of naked figures perform a round dance with attitudes and rhythms which were used again by Matisse in his

Dance of 1909–10. The theme evokes echoes of a long line of pastoral painting, Puvis de Chavannes, Denis, perhaps Manet's *Déjeuner sur l'herbe*. But Matisse's painting demands acclaim as a masterpiece in the *genre* of decorative abstraction. The swirling rhythms of linear arabesque which dominate the whole composition determine the positions and attitudes of the figures, binding together the groups into an over-all pattern. In the distorted shapes of the figures, the unrealistic perspectives, and unreal relations of sizes, naturalistic representation gives way to the overriding requirements of decorative rhythm. Light does not emanate naturalistically from one source but radiates from the colour surface and diffuses the whole picture space. And this idyllic, unreal picture space emerges as an edifice composed from the flat planes of colour fanning out according to the decorative scheme and bearing little relation to local tones. In this picture semantic theme and syntactical composition unite inextricably to convey an expressive character of Arcadian joy and light-heartedness which neither the theme alone nor the composition alone could achieve. The prestige which has attached to this picture depends upon its successful use of decorative or aesthetic abstraction to unite semantic and syntactical information into an expressive continuum. In it the artist has achieved a very closely knit amalgam of semantic, syntactical, and expressive features.

Perhaps an even more striking example of the joint contribution made by semantic and syntactical features to expressive character is afforded by the early Metaphysical paintings of Chirico. His paintings of empty Squares, and those in which he made use of the tailor's dummy, convey an atmosphere of mysterious ominousness which does not derive only from the semantic content, or only from the syntactical content, but from a strange union of both. Similar subject-matter could be used without conveying this strange expressive content: indeed the expressive character was largely lost or changed in the Metaphysical paintings done by Chirico and Carrà about 1920. Nor would the formal structure alone impart this particular expressive tone. The expressiveness of the syntactical structure is necessarily linked to representational content in a manner quite different from the expressive excitement which attends the non-representational forms of Wols or Hartnung, for example. Similarly in paintings such as Dali's *Perspectives* (1932), Tanguy's *Meeting of the Parallels* (1935), Max Ernst's *Garden Aeroplane-trap* (1934) the strangely disturbing dream-like

expressiveness depends upon the fact that they retain sufficient semantic information to suggest unreal space and perspectives as well as upon their unusual formal structures.

In Fernand Léger's *Le Grand Déjeuner* (1921) the three women's faces, blankly inexpressive in themselves, give three points of focus which would be absent if the picture were a structure of non-semantic forms, and thus modify in a radical way the impact made by the formal structure, the way in which it is seen. The smooth, rounded, cylindrical shapes which are imposed upon the representation of the female figures are themselves suggestive of machinery and so acquire an expressive character which as purely non-semantic forms they would lack. Such examples could be multiplied indefinitely.

The expressive character of art is often regarded as its most important aspect. It is also quite the most difficult to understand. Much has been spoken and written about it, but little progress has been made towards agreement. Psychologists often define the expressive information transmitted by works of art as information about the emotional states of the artists who created them. So in his *Aesthetics and Psychobiology* (1971), the most rewarding book that has been written on art and aesthetics from this point of view, D.E.Berlyne says: 'Information about processes within the creative artist that are peculiar to him constitutes *expressive information.*' But this won't do. If for nothing else, the information which we gain from a work of art about the mental states of the artist, his impulses, emotions, motivations, etc., are inferential, not given directly in the apprehension of the work as are semantic and syntactical information. And there is no clear or verifiable inference from the work to the emotional experiences of the artist. When we hear sad music we cannot infer that the composer was feeling sad when he composed it. Of course, everything which men deliberately do and make throws some light on their character and mental make-up; and it is arguable that works of art are more intimately bound up with the emotional make-up of the artists than are most other things that men do or make. But the connection is immensely complicated. As has been shown at some length by Charles Lalo in his books *L'Expression de la vie dans l'art* and *L'art loin de la vie*, it may be reflection or compensation or almost anything in between. A host of half irrelevant motives may intervene. Learned habits derived from the artistic conventions of the social group to which the artist belongs are inextricably mingled with his personal contributions. And

as for the Tolstoian view that it is the function of art to give the appreciator emotional experiences closely resembling those which the artist had when composing the work, Berlyne himself admits that 'the appreciator cannot hope to gain from a work of art more than a dim and reverential glimpse of the experiences of the artist ...'

More importantly, the emotional histories of artists, their feelings, impulses, motivations, are interesting only in a secondary way, as a matter of general curiosity, not integral to our appreciation and evaluation of the works of art they create. Works of art are indeed made by human beings for their own satisfaction and for the admiration of others. Undoubtedly they do at least provide an indication of the things artists have thought worth attending to, the qualities they have valued, in the perceptual sphere. And our background awareness of this affects our attitude towards works of art. But our attention is given to them primarily for the expressive qualities they themselves possess, or for the effect they have upon ourselves, not because of any emotional states which, we may infer, have been experienced by the artist in the course of their creation and which we presume to be in some way embodied or reflected in them. Self-expression has become one of the most ubiquitous catchwords of the century among artists themselves and their critics. The term has been so loosely applied that there is often difficulty in attaching any clear meaning to it, and in the mouths of artists it generally implies little more than a claim to work as they feel impelled to do for their own satisfaction rather than accept outside rules or standards which they find distasteful or cramping. Even in the appreciation of styles of art such as Expressionism, in which expressive information bulks most largely, it is not necessary, arguably it is not even useful, to obtain inferential knowledge about the affective personality and emotional experiences of a Kirchner or a Heckel in order to apprehend their works. I must, therefore, give a brief alternative account of the expressive features in works of art. The correct understanding of this is indispensable for any real insight into what has been going on in the art movements of this century, both those which have put a premium on expressiveness and those which have sought to eschew it.[1]

[1] Discussions of what follows may be found in: Sylvia Honkavaara, 'The Psychology of Expression' (*The British Journal of Psychology*, Monograph Supplement XXXII, 1961); Rudolf Arnheim, *Art and Visual Perception*, 1956, and *Visual Thinking*, 1970; Susanne Langer, *Mind: An Essay on Human Feeling*, 1967; Alan Tormey, *The Concept of Expression*, 1971.

Since Charles Darwin's pioneering *The Expression of the Emotions in Man and the Animals* (1872) it has become established by psychologists that things are perceived with 'emotional' or 'expressive' characteristics. Postures of the body, arrangements of the features, 'express' moods of joy, sadness, depression, etc. Non-human things such as trees, stones, landscapes, buildings, works of art, are also perceived with such qualities, although we do not suppose that they experience emotional states. A stock example is the weeping willow, whose drooping shape expresses sadness. The perception of such qualities is direct (we do *not* infer that the willow is feeling sad) and the qualities are perceived as objective properties of the thing we perceive not as subjective responses in ourselves, as when we see an unknown looming figure as ominous, threatening, sinister. When the weeping willow 'looks sad' we do not feel sad and do not infer that the willow is feeling sad; we see its shape as expressing sadness. These qualities of perceived things are called 'physiognomic' and when we see things in this way psychologists speak of 'physiognomic perception'. In her study *The Psychology of Expression*, for example, Sylvia Honkavaara says: 'When ... we speak about physiognomic perception, we refer to the seeing of expressions of joy, sorrow, friendliness, hostility, etc.' Susanne Langer in *Mind: An Essay on Human Feeling* writes of it as a stage in perception 'in which over-all qualities of fearfulness, friendliness, serenity, etc., seem to characterize objects more naturally than their physical constitution'. Often ranked with these qualities are 'aesthetic' properties such as majesty, dignity, flamboyance, grace, sublimity, tawdriness, etc. These too are directly perceived and not inferred. The Gestalt psychologists in particular have emphasized that these qualities are 'regional' or 'over-all' properties which are perceived as characterizing certain shapes or patterns as a whole but are no longer recognizable when the configuration is analysed into its component parts. We all recognize a wider range of physiognomic properties than we can find words to describe. For in truth the world is peopled by an abundance and infinitely variable subtlety of physiognomic and aesthetic properties that far transcends the most exquisite powers of artistic language to discriminate.

It has been suggested that among primitive peoples physiognomic perception was far more pervasive than it is nowadays and that development towards the matter-of-fact, practical perceptual habits of the educated adult civilized man today has tended to suppress physiog-

nomic perception except in unusual and rare circumstances. Wolfgang Metzger says: 'Expressive qualities are in inanimate nature more predominant and lively at an early stage than later' (*Psychologie*, 1941). And Heinz Werner similarly maintained: 'There is a good deal of evidence that physiognomic perception plays a greater role in the primitive world than in our own, in which the "geometrical-technical" type of perception is the rule' (*Comparative Psychology of Mental Development*, 1948). Some psychologists have thought that young children are more given to physiognomic perception than adults, though this has been disputed. What is beyond dispute is that most artists at most times have cultivated physiognomic perception, giving an exceptional degree of prominence to expressive qualities. To go back as far as we know, it seems reasonable to suppose that the expressiveness and vitality which appeal to us so strongly today in the Palaeolithic cave-paintings must be attributed to the fact that their artists were accustomed to seeing in a physiognomic way. The connection with what is sometimes rather loosely called 'beauty' is very close. Writing of the Palaeolithic artist who painted the Reindeer in the Font-de-Gaume cave in Dordogne, Helen Gardner says in *Art through the Ages* (1926): 'In the instantaneous pose that he has caught as the reindeer is about to bend his head, he has seen the beauty of the curve of the back; and in the wide sweeping line with which he has painted the antlers he has given expression to his innate feeling for the beauty of line itself.' There is an even closer approximation to what in the third chapter of his *Last Lectures* (1939) Roger Fry spoke of as the vitality of the artistic image. 'Some images', he says, 'give us a strong illusion that they possess a life of their own, others may appear to us exact likenesses of living things and are yet themselves devoid of life.' He adds that 'the vitality of an image – its power of communicating to us the feeling that it has an inner life of its own – is not at all dependent upon its being a likeness of a living thing. We may even suspect that complete likeness to a living thing will deprive us of that feeling – we shall think of the original as alive but not the image itself.' Twentieth-century artists have exploited and pursued this quality of the vitality of the image not only in the depiction of living and inanimate things but also in abstract, non-representational work. So pervasive and dominant is it and so closely linked with expressive seeing that those schools of art which have repudiated it – mainly Constructivism and Cubism – stand segregated from other twentieth-century trends mainly for this reason.

Expressive qualities belong to works of art both in their representational and in their formal or structural capacity. The physiognomic and aesthetic qualities which pervade the world we perceive attach also to the reproductions of the perceived world which artists produce. And not only today but throughout the centuries artists have tended to emphasize these qualities and give them prominence so that by constant exposure to works of art of this kind a person may become more sensitive and alert to them in the actual world. He may transfer the habit of physiognomic seeing to ordinary life. Or conversely a person who is more alert to physiognomic properties in ordinary life will come better equipped to perceive works of art of this kind. The point is well made by L.R.Rogers in his book *Sculpture* (1969), when he writes:

There are some qualities of sculpture which may be appreciated without much effort. They are almost universally recognizable and immediate in their appeal. Consider, for example, the overwhelming pathos of the Perpignan Crucifix, the dignity and power of Michelangelo's *Moses*, the tenderness of the gesture of the man's hand in Rodin's *The Kiss*, the warm radiance of Maillol's and Renoir's sculptures of women, the erotic appeal of an Indian apsaras, and the youthful charm of the choirboys from Luca della Robbia's *Cantoria*. All these are qualities to which most people can readily respond because, although they are raised above their normal intensity, they are all qualities to which we habitually respond in everyday life. The deeper our ordinary feelings are, and the sharper our emotional responses in life, the more keenly do we appreciate such qualities of sculpture. Certainly we need no special skills, attitudes, and sensibilities in order to apprehend and enjoy them. There is only one way to develop our responses to this aspect of the art of sculpture and that is by becoming more generally sensitive human beings.

The expressive character of a work of art may reside predominantly in the subject depicted or in the abstract, formal structure of the work. For colours, shapes and patterns, abstract artistic 'images', may have expressive impact even though they represent nothing in the actual world. This point too has been made by Rogers:

In our perception of three-dimensional form we do not simply apprehend its geometric properties, its shape as such; we become aware also of its expressive character. These two aspects are in fact inseparable; we perceive not just forms but *expressive* forms.... In the perceptual experience of three-dimensional forms these expressive qualities are regarded as properties of the forms themselves, as objective as any of their neutral, measurable, geometric properties. The forms of sculpture are expressive in this sense and if we are to appreciate

a sculpture as a work of art we must be able to perceive the expressive character of its component forms both in themselves and in the context of the expressiveness of the sculpture as a whole. For this it is necessary to develop a wider and more refined sensitivity to the expressive qualities of three-dimensional form than is required for ordinary practical purposes. This is also part of what is included in a highly developed sense of form.

Similar things might be said about painting and its appreciation.

Some twentieth-century art deliberately emphasizes the expressive character of the objective situation depicted or represented to the virtual exclusion of expressiveness in the art form. The *objets trouvés* of Paul Nash and others are chosen in order to display the expressive qualities almost exclusively of casual objects such as pebbles and branches without additional appeal from artistry. Tableaux by some modern artists such as Edward Kienholz, particularly the exponents of so-called 'funk' art such as Paul Thek, Bruce Conner, and the Englishman, Colin Self, consist of situations assembled from real things virtually without artifice. Their appeal depends upon their expressive impact, and sometimes images are created of haunting, almost terrifying vivacity. To the same category belong the occasional real-life constructs of Antonio Tápies and other artists, such as an open wardrobe with a welter of old clothes spilling out on to the floor. In his tableaux composed from rough plaster casts of real figures associated with real furniture, doors, windows, etc., the American sculptor George Segal mirrors the human isolation and spiritual disengagement of modern man with an almost unendurable pathos and virtually without artifice. At the opposite extreme abstract art such as Abstract Expressionism, Tachism, the paintings of Asger Jorn and other members of the COBRA group, relied to a varying but usually a considerable extent on exploiting the expressive qualities of formal, non-representational images and their combinations. Between these extremes the Metaphysical painting initiated by Chirico and much of Surrealist painting aimed at achieving an intimate two-way interaction between the physiognomic properties of specially devised semantic content with expressive formal constructions in order to convey the peculiar feeling of unreality which attaches to dream imagery.

In contrast with these, most schools of geometrical abstraction – Constructivism, Suprematism, Neo-Plasticism, Concrete art, etc. – made it their aim to minimize expressive qualities in favour of a

generalized feeling arising from the subtle organization of formal relations into a unified composition or organic unity. Without abandoning representation, expressive qualities were also played down by Cubism and Purism. This was a main point of difference in the impact made by still lifes of Ozenfant and Jeanneret, and to some extent also those of Lhote, and the still lifes of say Morandi or William Scott.

The deployment of expressive qualities both of the semantic content, when this exists, and of the syntactical structure has been one of the most potent weapons in the hands of artists for controlling attention, distributing emphasis and organizing their works as well as the appeal which it has for its own sake. This is not a new thing in twentieth-century art, but in twentieth-century art it has become more studied and deliberate, as well as more experimental, than at any time in the past. Exploration of the uses made of this weapon is of primary importance for understanding the diversities, and sometimes the apparently wanton unconventionalities, so characteristic of the art produced in this century.

To sum up. The things which we see in the world around us are perceived with a powerful penumbra of expressive characteristics and these may be either intrinsic to them or conferred upon them by association. In the latter case the associations may be individual – scenes of childhood, the place where a man first met his future wife, the portrait of a friend, etc. have associations for him which he does not expect other people to share – or they may be more general. The associations which attach to ancient ruins, industrial complexes, slum properties, racing-cars, red roses, and which endow them with their expressive tone, may be fairly general within a cultural group. Expressive characteristics are intrinsic when they depend upon the perceptual qualities of things and not upon associations. Such expressive characteristics are usually fairly general, although people differ much in their sensibility towards them. A landscape may look friendly or dreary, the grotesque branches of a dead tree seen against the night sky may look menacing, a building may look hostile even before we know it is a prison. And so on. Expressive character may also attach to artistic representations of things, and intrinsic expressive characteristics may attach to abstract works of art. This is the basis of expressive abstraction in art.

When we become aware of the expressive character of a thing or of its artistic representation or of a non-representational work of art

we do *not* first experience the corresponding mood in ourselves (e.g. sadness, solemnity, gaiety when listening to music) and then project our emotional reaction upon the thing, or the abstract configuration, which we perceive. We *perceive* the expressive quality as an objective property of whatever it is we are attending to.

Nevertheless it is commonly, and plausibly, believed that the way in which an artist perceives and depicts the expressive aspects of the world is to some extent peculiar to himself and an expression of his own personality. In particular, it was believed by Abstract Expressionists and by exponents of *Art Informel* and Tachism that the expressive qualities of their spontaneously executed abstract paintings directly 'expressed' and communicated the emotional mood of the artist who executed them.

These are basic facts, which have not yet been assimilated into the structure of aesthetic theory. But their recognition as facts is fundamental for the understanding of twentieth-century art.

PART TWO

Abstraction from Nature

3

Introduction: Semantic and Non-Iconic Abstraction

In a lecture entitled 'Abstraction in Contemporary Art', delivered at the Philosophical Institute of the University of Brussels in 1963, the late Professor Panayotis A.Michelis said:

Contemporary art is a revolutionary art; therefore, as in every revolution, there is first of all a denial of the established principles and forms of the past, since only in such denial can the revolution be relieved of the existing forms and conventions and move freely to its new positive contributions. If we are to analyse contemporary art aesthetically, it would be useful to examine its negative aspects to see which forms it destroyed and which forms it established. In other words, we should examine first the destructive aspects of the movement of contemporary art to understand more fully its constructive aspect. Painting and sculpture, of all the fine arts, were the first to deny the principle of the imitation of the apparent objects of the external world, and thus from being descriptive they finally became non-descriptive. This is in fact their new characteristic feature – that they are non-descriptive, or non-figurative – and we erroneously interpret them as abstract.[1]

Both in philosophical and in everyday language 'to abstract' means to withdraw or separate, particularly to withdraw attention from something or from some aspect of a thing. So it is that an absent-minded man is called 'abstracted' when he is not paying attention to what is going on around him and 'abstract thinking' is thinking in terms of general ideas or concepts, which bring together a number of particular things or qualities in virtue of the features they have in common by disregarding, or abstracting attention from, the features in which they differ. But in the language of twentieth-century art two different meanings of 'abstract' have become firmly established. One of these – when we say, for example, that a picture of a certain object or scene is abstract rather than naturalistic – is on all fours with the uses of 'abstract' in other contexts. The other – as when we describe a picture as 'abstract' because it is not a picture *of* anything at all – has little or nothing in common with the former usage and is, linguistically, far more arbitrary. Constant misunderstandings and confusion occur, even among artists themselves, owing to failure to grasp the difference between these two uses of 'abstract'.

According to the former sense of the word a work of figurative or representational art, i.e. one which – in the language of Information

[1] Published in Italian, 'L'astrattismo nell' arte contemporanea' in *Rivista di Estetica* (3, 1965), and in Greek in *Aesthetika Theoremata* (1965); English translation in Panayotis A.Michelis, *Aisthetikós. Essays in Art, Architecture and Aesthetics* (Detroit, Mich., 1977).

Theory – transmits information about some segment of the visible world outside itself, is said to be more or less abstract according as the information it transmits is less or more complete. In this sense abstraction is equivalent to incomplete specification. Some of the details in which things differ are omitted or played down so that in the representation things appear more alike than in the reality they are perceived to be. But it presupposes specification. Abstraction in this sense is a matter of degree and the term has no relevance or application outside the sphere of representational art. It is a factor of the relation between a work of art and that which the work represents.

But 'abstract' is also commonly employed as a general descriptive term denoting all the many kinds of art production which do not transmit, or purport to transmit, information about anything in the world apart from themselves. Other terms that have been used are: 'non-representational', 'non-figurative', 'non-objective', 'non-iconic'. 'Abstract' is the term which has obtained the widest currency although it is perhaps the least appropriate of all both linguistically and because of its established use in a different sense within the sphere of representational art. There are many types of pictures and sculptures within the wide spectrum of twentieth-century art which are not pictures or sculptures *of* anything at all; they are artefacts made up from non-iconic elements fashioned into non-iconic structures. These works are not more 'abstract' or less 'abstract'. There *is* no relation between the work and something represented because the work represents nothing apart from what it is. The very idea of abstraction in the sense of partial or incomplete specification is foreign to their conception and has no more relevance than to the building of a house or the making of a child's perambulator. It was partly because the word 'abstraction' in its ordinary sense is inappropriate to describe non-representational works of art that Theo van Doesburg proposed 'concrete' in its place.

In practice the differentiation between the two types of abstract art is by no means so clear-cut. Progressive abstraction from natural appearances may proceed indefinitely until at the extreme limit the subject of the picture is no longer recognizable and even the fact that the picture *has* semantic reference may not be detectable by visual inspection alone. Sometimes when abstraction from nature has reached a point where natural objects can no longer be detected, the emotional or expressive properties of the theme may survive in the painting and in such cases some abstract artists – such as Ivon

Hitchens, Roger Bissière, Jean-René Bazaine, Maurice Estève – occasionally give to their paintings titles which indicate the source in nature of the expressive properties which persist after recognition clues have been eliminated. But abstract works in the second sense, i.e. those which do not embody progressive abstraction from specific natural appearances, often have expressive qualities too and the line between expressive abstraction and Abstract Expressionism is a thin one. Even an artist such as Helen Frankenthaler, who presumably did not work by abstraction from natural appearances, gave titles such as *Sky Gardens* and *Brooding Light* to pictures painted in 1974. Nevertheless, although particular works may often be difficult to classify, although artists may waver and there will be borderline cases, the two sorts of abstraction are fundamentally different in principle and involve vastly different attitudes towards artistic creation.

Since different principles are involved I shall discuss the two types of abstraction separately, using the name 'semantic abstraction' where what is involved is an incomplete or restricted presentation of natural appearances and 'non-iconic abstraction' for those kinds of art which are unconcerned with the presentation of natural appearances.

4
Semantic Abstraction

Every representational picture, that is every picture which transmits semantic information, is abstract in the sense that the specification of the subject is to some degree incomplete. Indeed a picture has been defined in Information Theory as an image which represents something else at a lower degree of abstraction than itself. This definition holds good whenever we speak about a picture *of* something – not, of course, of a non-representational abstract. An exact replica of something is not called a picture. Even a replica of, say, another picture is not called a picture of a picture but a copy or a reproduction of it.

Certain parameters of semantic abstraction derive as a necessary consequence of the art-form or medium and are therefore imposed upon all works in that art-form and medium. Other modes of abstraction are voluntary and are cultivated for a variety of purposes: to underline significance of one sort or another; to deflect attention from the representational to the formal or expressive aspects of the work; to emphasize certain aspects of things above others in order to present the visible world in a particular light; to conform to a particular artistic style; and so on. In practice the language of criticism and art history employs the term 'abstract' and its cognates irregularly and on no settled principle. We tend to call a work abstract only if there are circumstances which particularly invite attention to the incompleteness of the information it transmits: if this information is notably less complete than the medium would allow or than recognized and accepted artistic conventions would lead us to expect, more incomplete than is usual in the style to which the work belongs, more incomplete than the observer expected or welcomes, and so on. We do not, for example, say that a monochrome engraving or a painting in grisaille is abstract because it imposes an unnecessary limitation in the dimension of colour information; we regard this added limitation as a restriction inherent to a different medium or as a convention with which we are familiar. Art historians may well point out that one *style* is more abstract than another or that within any one style some artists are habitually more abstract than others. But always in practice the word depends upon context and is slanted towards some particular emphasis.

The major semantic limitations inherent to the pictorial art-form as such have to do with the representation of a moving and changing world in a static medium, the representation of a three-dimensional world in a two-dimensional medium and the representation of the light

and colour of the visible world by means of the much narrower colour range, particularly in the dimension of brightness, which can be achieved by pigment colours, dyes or stains. A high proportion of artistic endeavour in past centuries has been devoted to finding artifices by which to overcome these limitations; to suggest movement, to create a three-dimensional picture image with pigmented canvas and to depict such qualities of colour as lustre, glow, translucency by the use of pigments which do not possess these qualities. One of the recurrent trends of twentieth-century art, most dominant from the 1960s, has been the repudiation of such artifices and the desire, even in non-representational art, to present the artistic materials as they are in themselves with no artistic 'image'.

In addition to the above the factor of size has a bearing. Ordinarily a picture image in virtual picture space, say a landscape or a street scene, is more extensive than could be taken in at a glance by a person situated at a distance from it corresponding to the optimum viewing distance from the canvas. This in itself demands modification of detail. When more than the appropriate detail is introduced – as for instance in the 'magical realism' of Andrew Wyeth and some of the Surrealists – an almost hallucinatory effect is produced. When looking at a picture image we *also* have background awareness of the pigmented canvas and therefore the restriction of size enhances the effects of what has been called 'simultaneous contrast' of colour. The importance of size may be observed in small colour reproductions of large pictures, where however exactly individual areas of colour are reproduced the exaggerated interaction makes the total result garish and harsh. A statue – whether full figure, head or bust – may be life size but when it is placed in a gallery it seems to exist in a space of its own and is not readily comparable for size in a straightforward way with other objects in its vicinity. It has been one of the aims of Minimal art to eliminate this effect and bring non-representational sculpture into the real space of its setting.

Voluntary abstraction covers all modes of abstraction which are not dictated by the art-form and the medium, that is all abstraction which the artist *could* have avoided even though he may not have been consciously and deliberately planning to abstract but was perhaps unpremeditatedly following some current fashion of representation or depicting things as he had been conditioned to see them in his capacity of artist. Voluntary abstraction in this sense has been prevalent from the earliest times and among virtually all peoples in every part of the

world. *Deliberate* abstraction, when an artist or group of artists consciously and knowingly chooses to abstract, has been a dominant feature of twentieth-century art and more prevalent than in any previous age. The motives for it are multifarious and in any single work several modes of abstraction may overlap. Often an artist may himself be unable to formulate in words his reasons for abstracting although he knows perfectly well in his professional capacity what he is doing and why. It is possible to classify the motives for abstraction into three large categories: to point up some idea which the work of art is intended to illustrate; to emphasize some aspect of the things represented in the work or to present them in a particular light; or to emphasize or enhance some formal (non-representational) properties of the work itself. Yet even these broad divisions are not mutually exclusive. In order to emphasize the emotional and physiognomic aspects of their subject, Gauguin and the Synthetists, for example, and to some extent the Fauves, painted flat areas of uniform colour, abstracting from the differences of surface texture and the gradations and shadings which indicate modelling. But at the same time these areas of uniform colour and the strong flowing lines by which they were encased had the purpose of emphasizing and enhancing the emotional and aesthetic character of the formal composition to which they contributed. Nevertheless some discussion of these modes of abstraction is essential as a preliminary to understanding what twentieth-century art is about.

(1) Irrelevant detail is eliminated with the object of throwing into prominence a message which it is the purpose of the work to communicate. This is a mode of abstraction which is familiar in engineers' drawings, architects' plans, diagrams, textbook figures, etc. In a less extreme form it is prevalent in advertisement art and often in anecdotal or illustrative art (Max Beerbohm, Damon Runyon). It has been a permanent feature of caricature and is often used in minor religious art – where the figures and their attributes become 'formulae' to carry a story with which it is assumed the viewers are familiar. In the twentieth century this mode of abstraction has been favoured by politically oriented art, and was an important though not always blatant element in the technique of, for example, Mexican mural painting, the official Socialist Realist art of the Soviet Union and social satire such as the Neue Sachlichkeit of Grosz, Dix, and Beckmann, and the work of such artists as Ben Shahn and Jack Levine in America.

(2) Detail may be curtailed in order to throw into greater prominence chosen aspects of the subject depicted. And this mode of abstraction may be deliberate as in the case of the Purists, who used abstraction in order to emphasize shapes indicative of the functional aspects of their *objets types*, or it may result from a predominant interest of the artist. A classical example of the latter may be found in the line drawings of sculptors. Sculptors are, typically, interested in the solid structure of figures rather than the play of light on the surface, and their lines, therefore, as distinct from those of painters, tend to indicate the lie of planes running at a slant from the eye of the viewer. This may be seen in the drawings of Despiau, Maillol, Gaudier-Brzeska, Dobson, and others.

(*a*) To this mode of abstraction belongs the suppression of individuating detail in order to display the generic type to which a thing belongs. A picture of a horse may be a portrait of this or that individual horse or else, by eliminating the features in respect of which individual horses differ from each other, it may approximate to the generic form of a horse as such. Generic abstraction does not necessarily serve an artistic purpose. It may be used, for example, in figures illustrating a textbook of biology or botany; and a composite photograph has no aesthetic merit except accidentally. But generic abstraction or something like it – a preoccupation with the type rather than the individual – has been very prevalent in twentieth-century art. It has sometimes been assumed that progressive abstraction in the direction of the type would issue in geometrical forms of the sort favoured by the Cubists or Constructivists, but this does not seem to be the case. Indeed the greatest modern master of generic abstraction is Brancusi in such works as the several versions of *Maiastra* (*Magic Bird*), *Bird in Space*, *The Seal*, *Fish*, etc.

The reason for the enormous popularity of generic abstraction in twentieth-century art – some smatch of it is almost ubiquitous in representational art up to Pop and the New Realism – is not at all clear. It seems to derive partly from a belief in the aesthetic value of simple, clearly articulated forms both in themselves and as elements in an over-all composition; partly perhaps from a rather confused feeling that the typical in the sense of the generic is somehow revealing of a profounder aspect of reality than the individual and particular. (Modern generic abstraction has nothing in common with the

preference for the generic over the particular which formed one of the principles of the Grand Manner as formulated by Sir Joshua Reynolds. Generic abstraction today has no literary connotations and is not connected with an old-fashioned preference for 'nobility' of subject-matter.)

(b) Similar in principle to generic abstraction, though very different in its application and results, is the elimination of detail for the purpose of throwing into prominence some characteristic physiognomic trait of the subject depicted. We might say of a drawing of a horse: 'It has caught the very essence of the animal, proud yet docile, tamed yet still its own master.' It is for their power to communicate vividly in abstraction some typical physiognomic trait that the Palaeolithic cave-drawings are greatly admired. A similar quality infuses the animal art of the Kuban and the Altai mountains and indeed the art of many primitive peoples. I have found the same quality in small terra cottas made among isolated Indian groups in the Andean mountains today. It is an outcome of keen observation rather than slovenly perception and there is reason to believe that this type of artistic production results from a habit of physiognomic perception which was more strongly developed among primitive peoples, at any rate in their relations with the animal and vegetable kingdoms, than it is among modern urbanized men. It is, as has been said, a noteworthy feature of physiognomic abstraction that it tends to confer what Roger Fry called 'the quality of vitality' in artistic images. This 'vitality' of the image – or call it what you will – seems to derive from abstraction which places emphasis on physiognomic qualities. It can belong even to non-iconic images.

Physiognomic abstraction has not flourished importantly in the representational art of this century. It has been an isolated talent of individual artists rather than a general characteristic. Something of it may be found in early animal drawings and sculptures of John Skeapping, in some drawings by Toulouse-Lautrec and Forain. Despite his phantasy it is an important element for the understanding of Paul Klee, and it is a feature of much of the work of Dubuffet. Some artists, such as Lyonel Feininger and L.S.Lowry, have in their different ways captured something of the physiognomic quality of industrial scenes. But this mode of abstraction has its most important significance in twentieth-century art as a bridge between semantic and non-iconic

abstraction. Particularly during the 1920s and 1930s many artists created images with physiognomic vitality, and voiding them of semantic content sought to retain the feeling of life and urgency while setting them in a non-iconic abstract composition or in the context of Surrealist fantasy.

(c) Finally, it is by selective abstraction that an artist of genius can present a new way of seeing the world. We can cope with only a small proportion of the information which continuously flows in upon us through the organs of sense. Selection is essential: indeed this is what perception means. It is a selective focusing of attention upon some items among the mass of sensory information with which we are bombarded and the imposition of order upon them by applying associations of relevance. Perception is, moreover, a feedback system. Our perceptions supply the basic material by which our behaviour, both automatic and deliberate, overt and internal, is guided; but the responses we make and the interests which are stimulated in turn act upon the principles of selectivity which determine how and what we perceive. In daily life we are conditioned by habit and need to attend mainly, almost indeed exclusively, to the aspects of information which have practical significance for object recognition, determination of attitude, behaviour. But when we are confronted with an artistic representation instead of the reality, practical considerations fall into abeyance and we are able to give our attention more alertly than usual to the visual qualities of the pictorial image. Moreover because artists often present us with complex visual organizations of great perceptual interest, which stimulate and expand awareness, this operates to heighten attention for the intrinsic qualities of the colours and shapes, balance, rhythms, etc., which are the elements from which these organizations are built up. Most importantly, too, in a picture the total volume of information confronting the viewer on the practical plane is reduced by the limitations inherent in the pictorial medium, owing to the sheer restriction of size and through the selectivity already exercised by the artist. Selection has been done for us and we can attend impartially to all the information presented. It is sometimes claimed that a great work of art is inexhaustible: we may go on looking at it indefinitely and always find something new in it. This may be true of the syntactical information, the higher-level structural and aesthetic properties of the work and the semantic content in relation

to them. It is not true of the semantic information as such which is always less than would be available from the actual things depicted.

When we look at a picture, while the total volume of semantic information confronting us is reduced and ordered, nevertheless the same principles of perception as in ordinary life are involved in discriminating and recognizing the objects depicted. At the same time we are made more vividly aware of the intrinsic qualities of colour and shape and line to which in practical life we are normally insensible or obtuse and our interest is also stimulated by higher-level organizations and Gestalten, which may cut across or be irrelevant to object recognition. By this alerting of attention and control of perception we are predisposed to find interesting the artist's own manner of perceiving and presenting the things he depicts. It is through his individual manner of perceptual selection that an original artist arrives at his personal vision of the world and by this selective abstraction, integral to his very manner of perceiving, he communicates and recommends his vision to others by the pictures he paints. Two of the outstanding artists who have done this, and by doing it have changed men's way of seeing the world, are Constable and Cézanne. It is not a thing which is peculiar to our own century except in so far as this century has set more store by originality than any other time. Schools of art have proliferated and artists have been encouraged to cultivate and trumpet forth their idiosyncratic ways of looking at the world. This is one of the things which has been meant by the much talk about self-expression.

(3) A third category of abstraction, which is exploited by all artists who are deeply concerned with composition or formal pictorial structure, is motivated by the need to adapt the semantic content of a picture to its formal or syntactical properties. The interest in it may be deliberate or instinctive. It was instinctive on the part of Gauguin and Van Gogh; Seurat, with Signac and Pissarro, thought it could be reduced to rule. This category of abstraction is rarely if ever independent and self-subsistent, but rather combines inextricably with those already discussed. Its influence is, however, important and may in some cases be predominant. It takes two major forms. *(a)* The forms of things may be depicted more uniform than they are in order that the depictions may fit more aptly into a unified pictorial structure. This type of abstraction is one of the roots of a representational style

such as International Gothic or Pre-Raphaelitism in the past, *Jugendstil* or Cubism today. *(b)* Detail and hence individuality may be suppressed for preponderantly psychological reasons in order to deflect attention from what is represented towards the formal or syntactical properties of the work.

(a) Decorative stylization, which is the reduction of naturalistic forms to abstract or semi-abstract motifs for the embellishment of architecture or other objects of craftsmanship, has been a universal feature wherever decoration has flourished. Since the time of the Symbolists, however, 'decorative' art has meant not merely a subordinate technique of embellishment but an independent *genre* of fine art in which the importance of pattern is paramount but which at its best achieves supremely satisfying structural form combined with strong expressive impact. Matisse stands out as the supreme master of decorative art in this sense, and his pictures *Luxe, calme et volupté* (1904) and *Bonheur de vivre* (1905), in which he achieved a personal synthesis of the decorative features of Seurat, Gauguin and Art Nouveau, are no less important landmarks in the development of this trend in twentieth-century abstraction than Picasso's *Les Demoiselles d'Avignon* is for the trend that led through Cubism. Decorative abstraction may also be used to impart a superficial air of fashionableness and a spurious uniformity to works of little intrinsic merit, and this, together with the use of the word for ornamental stylization, has contributed to give to the phrase 'decorative art' an unfortunate pejorative connotation. Examples of artists who have used decorative abstraction in a meretricious way are Elie Nadelman, Cornelius Van Dongen, and the later Bernard Buffet. Others, such as Raoul Dufy and Marie Laurencin, have made it the basis of original and charming, if not profound, personal styles.

The root principle of decorative abstraction was formulated by Matisse in 1909 when, in an interview with Charles Estienne, he said: 'Details lessen the purity of the lines and harm the emotional intensity; we reject them.'

(b) The semantic content of a painting is not a matter of indifference to its formal properties as Clive Bell has sometimes been incorrectly interpreted to have taught. The fact that any form in a picture is seen as representational alters its prominence, insistence, impact in the structure of the picture, and the nature of the semantic reference also

has a bearing. This is a psychological fact of which artists must perforce take account. They therefore modify and abstract from the semantic content in order to bring it into line with the compositional structure which is the central idea of the work. The deliberate suppression of natural features in the interests of aesthetic structure has been a particular feature of twentieth-century art and has been carried further in the twentieth century than at any previous time, even to the point where the underlying source in nature is no longer detectable. Some of Roger Bissière's later abstracts have the appearance of gorgeous magic tapestries; yet he himself declared that he always worked from nature. Francisco Borès has been too little appreciated as an artist who united decorative abstraction of the kind of which Matisse was the supreme master with aesthetic abstraction in the mode here described.

(4) Absorbing into itself but rising above the cult of the irrational which had supplied its main motive force to Dada, Surrealism put forward the professed aim of encompassing a superior reality which should transcend both the normal reality of waking life and the irrational world of fantasy, dream, etc. Central to the pursuit of this aim was the unpremeditated juxtaposition of incongruities in order to evoke a sense of magical insight and of a revelation which could not, however, be articulated in logical terms. For this the Comte de Lautréamont was regarded as a main inspiration with his famous formula *beau comme* – 'beautiful like the unexpected encounter of a cataract and a bottle' or 'the chance meeting on a dissecting table of a sewing machine and an umbrella'. Artists such as Magritte and Salvador Dali achieved the disturbing impact of this magical fusion of the real and the irrational by an accentuated verism, depicting with hallucinatory realism things and scenes which disrupted the commonplace order of things and affronted the logic of common sense. Others within the movement pursued their aims by means of abstraction. And basically their aims were similar. Although superficially the modes of abstraction employed by such artists as Ives Tanguy, Masson, Miró, Mattà were very diverse, nevertheless in so far as they were actuated by the spirit of Surrealism the abstract artists also sought to communicate the impression of a superior reality beyond those of the everyday world and ordinary controlled imagination, or at least to evoke the emotional impact of confrontation with such a reality. The sense of

strangeness, of anxiety in face of the illogical posturing as real, lends a certain nightmare quality to their works too. It is this which justifies grouping them together as a separate category of abstraction distinct from the modes that have already been described.

Typically, the abstractions of the Surrealists were conjured up with the help of a variety of automatic techniques whose object was to give access to the unconscious mind and by lulling into abeyance both the dominating control of reason and the inhibiting sense of reality to give release to the imagery which is usually locked within it. For it often used to be wrongly assumed that once conscious control is voided the creative impetuosity of the unconscious will well up involuntarily to the surface in imagery of artistic merit. The truth of the matter appears to be that in addition to the painstakingly detailed images characteristic of psychotic art, the unconscious may also be a receptacle (if we may be allowed this metaphor) of abstract or near-abstract images which have an energy of their own not wholly deriving from their likeness to familiar things. Sometimes they seem not to be in fact abstractions from perceived things but to represent rather an earlier and more primitive stage of perceptual experience. In particular we should notice a special form of space which fuses suggestions of infinite extension with arbitrary delimitations of unreal perspective and is precisely articulated by impossible shadows and light. This is not the same as the space of dreams although it has been plausibly likened to dream space. In pictorial art the depiction of such unreal space with the emotionally disturbing impact of reality was heralded by the early Metaphysical works of Chirico. Among later artists his most interesting successor in this respect has been Ives Tanguy in those paintings whose abstractions may, but need not, be interpreted as monolithic rock structures occupying a dream-like space on an empty but infinitely extending beach. And the same suggestion of unreal dream space, taking hold upon and merging into the picture space, is sometimes apparent also in the hallucinatory works of Dali and in the overall abstract compositions of Kandinsky and Miró.

Despite the sense of the comic which has sometimes been ascribed to them, the biomorphic shapes of Miró belong to a different department of fantasy from the inexhaustible but more self-conscious playfulness of Klee, seeming to spring spontaneously from the unconscious, rather than to be based deliberately upon microscopic cell forms or primitive organisms. Others, such as Matta, have indulged

in cosmic and apocalyptic imagery, abstractions suggestive of a mythological attitude to the universe, or abstractions reminiscent of features in primitive art. Echoes of these modes of Surrealist abstraction reappear in the biomorphic forms of Baziotes, Theodoros Stamos, and Arshile Gorky, in the primitive mythic symbols and the later explosive apocalyptic clashes of Adolph Gottlieb.

It is characteristic of the abstractions of Surrealism that they carry a special, disturbing emotional flavour which derives primarily from their source in the unconscious rather than by transference from our emotional attitudes to any real things from whose forms they are abstracted.

(5) Before leaving the topic of semantic abstraction something should be said about the relation of abstraction to distortion, which is also a factor of the relation between a representational work and its subject. In brief it may be said that while abstraction is incomplete specification, distortion involves the provision of *incorrect* information. There can be distortion without abstraction – or without a higher degree of abstraction than is inherent in the medium and art-form employed. There may also exist a high level of abstraction without distortion – as in Brancusi's *The Seal* and Georgia O'Keefe's *Patio with Cloud* (Milwaukee Art Center). Distortion and abstraction are combined in Brancusi's *Pasarea Maiastra* (the first of the *Maiastra* series), where the disproportion in size between the large ovoid body and the other parts lends to the work a dramatic effect, and in most of the figures done by Barbara Hepworth during the early 1930s. Many of the paintings in which Matisse employs decorative and aesthetic abstraction also embody some measure of distortion.

Although in principle abstraction and distortion are distinct, in practice it is often difficult to draw a hard-and-fast line between the two or to know when the information transmitted by a depiction is to be regarded as 'incorrect' or when it represents a new and personal way of seeing reality, an artist's original vision. In fact distortion has served many of the same functions as abstraction. It has been used to point up an extra-artistic message, as with the 'psychological perspective' employed in some Egyptian, Late Classical, and medieval art, where psychological importance is indicated by disproportionate size; with the prominence given to sexual characteristics in some primitive and much pornographic art; with the exaggerations of cari-

cature; and so on. Distortion has been used for primarily decorative purposes, as notably in the work of Beardsley, Klimt, Obrist, and others of the Art Nouveau movement. It has been used for its expressive power both to give prominence to certain expressive features in the object depicted and also to emphasize by their very semantic incorrectness certain formal elements – shapes and colours – in a picture which has expressive power. A rather more sophisticated use of distortion, combined usually with a measure of abstraction, has been to point up a visual metaphor as in some of the work of Henry Moore, when for instance a human form may take on something of the appearance of a range of hills, and even more prominently in that of Paul Nash.

It is worth mentioning here, as more than a curiosity, experiments made by some artists in colour distortion for the purpose of finding a way round the enormous limitations imposed by the medium upon the representation of natural colour. The limitations are especially serious in the dimension of brightness. For example, as one looks out upon a landscape the most striking object in view, that which makes the strongest impact (*Auffälligkeit* in German), will probably be the sun. But yellow has not strong prominence among pigment colours and is not capable of a high degree of saturation. Therefore, in order to retain prominence, Paul Klee sometimes painted his sun black and modified other local colours accordingly. Martin Bloch used a systematic distortion of hue on a similar principle in order to bring the whole picture into keeping with some central idea of representing prominence or illumination. In general twentieth-century art has paid less attention to verisimilitude in the reproduction of local colour than did the past, but has freely distorted hue in the interests of other aspects of colour.

(6) Semantic style is itself a mode of abstraction. For by style in representational art we mean that certain ideal forms and preferred schemata are imposed upon natural appearances, so that among the infinite ways in which things might be seen and shown to differ, certain options are eliminated or suppressed, and representations are brought within certain favoured channels. With the reduction in the possibilities of difference, things are depicted more alike than they might otherwise be seen to be and more alike than the necessities of abstraction inherent in the artistic medium would otherwise allow. Examples

of such semantic styles in the past are International Gothic, Neo-Classicism, Pre-Raphaelitism. In our own century Art Nouveau with its preference for rhythmical, curvilinear forms, German Expressionism with its harsh, angular schemata, Cubism with its bias towards analysing appearances into geometrical shapes, Futurism, Purism, Vorticism, Rayonism, and so on, come within this category. Semantic styles may be peculiar to an individual artist and his followers, or common to a whole period or movement. Examples of individual styles are those of Giacometti, who carried elongated abstraction very far in order to emphasize the spacial connections and gestural attitudes of groups of figures, and the heavy cylindrical forms imposed by Léger upon his representations.

In assessing the total style of an artist one must have regard to the sorts of physiognomic, expressive, and aesthetic qualities to which he inclines, both in the segments of nature which he selects for representation and in the formal aspects of the works he creates. We must also have regard to the kinds of physiognomic, emotional, and aesthetic properties which he favours, both in the world he depicts and in the artistic structures he creates, and to the modes of abstraction and distortion he manipulates. For all this gives its character and direction to his work. From an objective point of view all this – his style in its totality – is the artist's self-expression, though when an artist himself speaks of self-expression he usually means something more limited and less precisely articulated than this.

Realizing that the ways in which they themselves perceive and represent the world differ from what is commonly regarded as 'natural' by their contemporaries (even perhaps by themselves when they are not functioning as artists), many twentieth-century artists have claimed that they saw more truly or more profoundly than the average man into a world of reality behind the superficiality of appearances. Cézanne made this sort of claim about his exacting efforts to see the structure of natural things geometrically and similar claims have been made by the supporters of Cubism and other movements. They have even been made with prophetic fervour by non-iconic abstract artists such as Kandinsky, Malevich, and Mondrian. While there is no reason to doubt that the artists who make these claims are trying to enunciate something of vital importance to themselves, it is certain that there is no substance in what they do in fact say. If there is a more ultimate, arcane reality behind the world of appearances, as no doubt philo-

sophy is right in supposing, it is certainly not simply another set of appearances. Nor is there good sense in believing that one way of perceiving the visible world – though it may be richer and more satisfying – is or could be more 'true' or more 'real' than another way.

5

From Impressionism to Expressionism

Soon after the middle of the nineteenth century, in his 'Manifeste' of 1861, Gustave Courbet set forth the principles of what we may call neutral or matter-of-fact Realism. The same principles which Courbet advocated for painting lay at the heart of the form of Social Realism that was already pretty firmly established in the field of literature. In his dissertation, *The Aesthetic Relations of Art to Reality*, first published in 1855, for example, the Russian literary theorist N.G.Chernyshevsky maintained that literary art is essentially factual reportage ('The first purpose of art is to reproduce reality') with a secondary function of 'explaining life'. Courbet's stature as an artist is too great indeed to be circumscribed by the theories which he took over from his literary friends, and in general the tenets of neutral Realism exerted a much smaller inspirational influence in the visual arts than they did on the novel. Its usefulness as a starting-point for the present study lies in the fact that, just as neutral Realism itself was put forward in opposition to the then prevailing Academic practice, so Realism in one form or another served as a sounding board against which innovative aesthetic doctrines were voiced at least until the 1930s. In this chapter, then, I propose to indicate very summarily a few main paths of abstraction which led through the tangled jungle of theory and profession from Courbet to French and German Expressionism. Confused as much of the writing is, whether it was intended as a guide to artistic practice or as a vindication of it, the work that was being done in the latter half of the nineteenth century, and the aesthetic aims and aspirations implicit in it, constitute the soil in which were nurtured the aesthetic motives of early twentieth-century art. Some rudimentary knowledge of this background is not otiose but is wholly germane to an understanding of the art of this century.

In the 'Manifeste' published in the *Courrier du Dimanche* for 25 December 1861 Courbet declared: 'The art of painting should consist solely of the representation of objects visible and tangible to the artist.... I also hold that painting is essentially a *concrete* art and does not consist of anything but the representation of *real* and *existing* things.' Like so many pronouncements by artists, the 'Manifeste' was polemical rather than philosophical in character. Courbet made clear that he intended it as a declaration of revolt in the name of Social Realism against the religious, historical, and mythological painting which flourished in the Academies of the Second Empire, and a repudiation of imaginative painting in general. 'Imagination in art',

he said, 'consists in knowing how to find the most complete expression of an existing thing, but never to suppose or create that thing.' He went on:

Beauty is in nature and is found in reality under the most diverse forms. After it is found there it belongs to art, or above all to the artist who knows how to see it. Rather, beauty is real and visible; it has in itself its own artistic expression. But the artist has not the right to amplify that expression. He cannot touch it without risk of changing its nature and consequently weakening it. The beauty given by nature is superior to all the conventions of the artist.... The expression of beauty is in direct ratio to the power of perception acquired by the artist.

This too was directed against the Academic belief in a hierarchy of subject-matter and the aftermath of the Neo-Classical doctrine that the task of the artist is to 'embellish' nature by bringing his representations into line with an 'ideal' beauty which is reflected only imperfectly in the phenomenal world but was realized once for all in the art of classical antiquity. Against this assumption, which lay at the very base of Academic painting, Courbet asserts that beauty is present in the everyday world for those who are able to see it, that when seen it can be depicted only by straightforward reproduction and that any endeavour to make the appearances of things conform to artistic conventions can only dim the beauty that is in them.

But even as its tenets were being formulated, neutral Realism was giving place to the less radical concept of interpretative or 'Aspect' Realism. Instead of 'holding up a mirror to nature' in the sense of reflecting natural appearances impartially and without bias – an ideal nowadays long recognized to be impossible if not meaningless – artists were expected to depict an aspect of nature depending on their own interests, their personal manner of perceiving, and their temperament. This aspect – the things an artist chose to paint and the way in which he painted them – was what nature meant to him, his own interpretation of the visible world. Thus Émile Zola defined art as 'a segment (*coin*) of nature seen through a temperament'. And Balzac may have meant much the same sort of thing when he said that 'the mission of art is not to copy nature but to express it'. The nineteenth-century Romantics were also in opposition to Neo-Classical idealization, and in contrast to the hierarchical principles of the Grand Manner loved to emphasize the variety of artistic subject-matter, claiming beauty in the mundane, the banal, the grotesque, the commonplace, and even

in the conventionally ugly. Delacroix went so far as to declare: 'One must see beauty where the artist has wished to put it.' Although he did not intend it in this way, there is a hint that pictorial beauty depends to some extent on the intervention of the artist when Courbet says: 'Beauty, like truth, is a thing relative to the time in which it is seen and to the individual fit to conceive it. The expression of beauty is in direct ratio to the power of perception acquired by the artist.'

Aspect Realism is a mode of abstraction which developed both in an objective and in a subjective direction. When emphasis was placed primarily on the depiction of nature it could be adapted to the systematic interest of the Neo-Impressionists in aesthetic composition. Or, as in the rather muddled thinking of the Symbolists, it might be believed that the aspect of nature into which an artist had insight contained a revelation of arcane truths behind the world of appearance. Alternatively, since the aspect of the world depicted by an artist is personal to him, Aspect Realism is also susceptible of a subjective emphasis if prominence is given to the expression of the artist's temperament rather than objective, if partial, depiction of natural appearances. Such subjective emphasis is apparent in the not entirely typical saying of Gauguin: 'The work of art for him who can see is a mirror wherein is reflected the soul of the artist.' So long as the Romantic notion of the artist-genius remained unquestioned, the thought was unlikely to occur to any vocational artist that a docile public might be little interested to use his picture as a mirror in which to see a reflection of the artist's soul. Therefore this subjectivist tendency continued and in 1909 Maurice Denis went so far as to say that for the artist nature is 'a state of his own subjectivity' – a statement which might well be regarded as the formula of French Expressionism. For an artist who thinks in this kind of way will inevitably think of himself as *using* the depiction of nature as a means of expressing his own personality.

The painting of the Impressionists was a classic example of Aspect Realism. They were not a school with a uniform style or common aesthetic doctrines but a group of highly individualistic artists with, for a time, certain coincidences of taste and interest. By and large they were unresponsive to the teachings about the social functions of art propounded by the Saint-Simonists, the aesthetician P.G.Proudhon and critics such as Étienne Arago, Henri Robert, and Charles Blanc. The most important thing they had in common was a lively interest

in phenomenological or, as it has been called, 'optical' Realism. When we open our eyes and look out upon the world in an endeavour to see it more strenuously and more completely instead of terminating our perceptions at the point where practical clues for object recognition are obtained, what we see, they thought, are the coloured surfaces of things conditioned by the light which reaches them through the envelope of the atmosphere and renders them visible. The Impressionists made it their aim to depict in pigment the coloured surfaces of the visible world and to suggest the light in virtue of which things become visible. In order to bring this aspect of the world into prominence they diverted or abstracted attention from other aspects to such an extent that in some of their works, notably some of the later paintings by Monet, and in some parts of many of their works, objects are broken up and dissolve, rendered almost undetectable by the emphasis given to the interplay of light and colour. It was this concern with the 'superficiality' of things that was repudiated by most later artists from Seurat to Matisse, and by the Cubists. The originality of Cézanne, as will later be shown, lay in his substituting for this aspect of reality an interest in the perceived structure of things and his inauguration of a new mode of abstraction, a new paradigm of perception, which formed one of the roots of Cubism and which continued to refresh artists with renewed inspiration in the field of semantic abstraction through until the 1960s.

In consequence of the aspect of reality which engrossed them the Impressionists were inclined to represent the world as fragmentary, disjointed, as it were an assemblage of snapshots from a candid camera. Even when their pictures were composed in the studio – a usual practice with Degas in particular – they tended to retain or even to exaggerate this fragmentary and superficially uncomposed or accidental character of their representations. The type of Realism they introduced provoked almost immediately a twofold reaction. In the syntactical sphere more importance began to be set upon pictorial structure and concern with the mechanics of aesthetic composition came to predominate over realistic representation. In the semantic sphere artists set themselves to find means to represent the more permanent, less fleeting aspects of things or even to represent supposedly more ultimate realities behind the changing appearances of the world. Although these reactions were closely interlocked, the former was inclined to carry greater weight with the Neo-Impressionists and the latter with the Symbolists.

It was assumed by most of the Neo-Impressionists that good com-
position, a well-balanced pictorial structure, lay at the heart of artistic
excellence and although the Impressionists achieved this by instinct
and intuition, the Neo-Impressionists made it a matter of overt doc-
trine and sought to find scientific principles of aesthetically har-
monious composition. In the definitive statement of his aesthetic
views contained in a letter written to Maurice Beaubourg on 28 August
1890, Seurat said: 'Art is harmony. Harmony is the analogy of oppo-
sites, the analogy of similar elements, of *value*, *hue* and *line*, considered
according to their dominants and under the influence of lighting, in
gay, calm or sad combinations.' Seurat believed that this harmonious
structure could be achieved by the application of scientifically valid
rules, or at least that it could be formulated in terms of such rules.
Gauguin and Van Gogh preferred to work by feeling and instinct.
But the overriding importance attached to composition persisted and
increased. As late as 1904, as reported in an article by Robert de Ville-
herve published in the *Havre-Éclaire* for 25 September, Pissarro said:
'The big problem to resolve is how to pull back everything, even the
smallest details of a picture, into the harmony of the ensemble, into
full agreement.' And there is a famous passage in Matisse's *Notes d'un
peintre* of 1908 in which he says:

There is an impelling proportion of tones that may lead me to change the
shape of a figure or to transform my composition. Until I have achieved this
proportion in all the parts of the composition I strive towards it and keep on
working. Then a moment comes when all the parts have found their definite
relationships, and from then on it would be impossible for me to add a stroke
to my picture without having to repaint it entirely.

This attitude spells the rejection of Realism for it puts the aesthetic
demands of composition above the semantic demands of representa-
tion.

In the words of André Malraux: 'What the new art sought was a
reversal of the relation between the object and the picture, the subordi-
nation of the object to the picture.' The attitude was foreshadowed
in a well-known sentence with which Maurice Denis began his essay
'Definition de *néo-traditionalisme*', first published in *Art et Critique*
in August 1890, and reprinted in his *Théories, 1890–1910*: 'It must
be recalled that a picture – before it is a picture of a battle-horse, nude
woman, or some anecdote – is essentially a plane surface covered by
colours arranged in a certain order.' This elevation of the syntactical

function of art, and the subordination of semantic functions to it, led to the most deeply ingrained assumption, which predominated in the aesthetic outlook of the first fifty years of the twentieth century, the assumption, namely, that the production of a work of art brings into being a new and independent reality which is to be appreciated and assessed by autonomous aesthetic standards and not by any resemblances it may have to something else or by any semantic information it may impart about the rest of the world. It is this assumption which made possible the massive advances in semantic abstraction and the emergence of non-iconic abstraction which has been the most distinctive feature of the age.

The attitude which I have called Aspect Realism signifies that instead of aspiring to give a mater-of-fact reproduction of the visible world with impartial neutrality as the early Realists supposed, an artist was understood to offer an *interpretation* of reality, making prominent some significant aspect of things, perhaps one which he alone had perceived, and moulding his whole representation into conformity with this aspect. In order the more effectively to present his personal vision of reality, he might systematically subordinate or modify other aspects of reality in accordance with the controlling idea. Already in 1895, in lectures delivered at the École des Beaux-Arts and later published as *La Philosophie de l'art*, Hippolyte Taine declared: 'The end of a work of art is to manifest some essential, salient character, consequently some important idea, more clearly and completely than is obtainable from real objects.' This is part of what was meant when in his classical article on Modernism in Art, published in the *Mercure de France* for March 1891, the critic Albert Aurier invented the term *Idéisme* for the new Symbolist painting, notably that of Gauguin, because he believed it to be expressive of 'ideas' implicit in appearances. Behind this lay the literary Symbolism launched by the poet Jean Moréas in 1886, and behind this again the Idealist philosophy of Schelling, which taught that the perceptible world is a concrete symbol of an invisible Absolute. Aurier took as the motto for his article, 'Le Symbolisme en peinture', a sentence from the Neo-Platonic philosopher Plotinus: 'We attach ourselves to the exterior of things, not knowing that it is within them that what moves us is hidden.'

In the rather muddled thinking of the Symbolists painting was to be liberated from rigid reproduction of natural appearances – what

Gauguin called 'the shackles of probability' – and give direct expression to the recondite truths of which the appearances were a symbol. For this reason the artists of the Pont-Aven school rejected the optical Realism of the Impressionists in favour of what they called a 'synthesis' in memory and imagination – one of the titles given to the new style was 'Synthetism' – which by abstracting from local colour, generalizing shape and neglecting the effects of changing light, would, they believed, express the more permanent and fundamental characteristics of reality. Seurat also used the word 'synthesis'. Matisse, preferring the term 'condensation', accepted by and large the Synthetist doctrines though without the metaphysical implications attached to them by the Symbolists.

Impressed by the memorial exhibitions of Seurat (1900), Van Gogh (1901), and Gauguin (1903), and stirred by the new recognition being accorded to Cézanne, Matisse and the Fauves regarded these artists as the precursors of a new philosophy and a new sensibility of which they saw themselves as heirs and successors. They accepted with alacrity the inadequacy of Impressionist Realism. 'We must at all costs break out of the fold in which the realists have imprisoned us', said Derain in 1906. Instead of reproducing realistically the immediate impression, they declared it their aim to record the 'essential character' of a scene. Although they had little use for the philosophical background of Symbolism with its theories of naturalistic allegory, it was of the first importance to them – and to Matisse in particular – that instead of giving direct expression to an artist's first fleeting emotional reactions, the picture should embody his more mature and permanent feelings. For this purpose objective representation must give way to an expressive pattern of linear arabesque and a harmonious interplay of colour, for it was assumed that the 'abstract' qualities of line and colour in formal composition can 'express' fundamental emotional attitudes. Even in 1921 Paul Sérusier, in the tradition of the Symbolists, could say in his *ABC de la peinture*: 'Thoughts and moral qualities can only be represented by formal equivalents.' Thus the representation of the 'essential' character of a scene and giving expression to the artist's inner emotional relation to visible reality were spoken of at this time as one and the same thing and the word 'expression' came to be used in a sense virtually equivalent to 'construction' or what we now call 'composition'.

All this comes out with particular clarity in the writings of Matisse

during the first decade of the century. In his *Notes d'un peintre* (1908) he repeatedly emphasized that he was dissatisfied with recording 'fugitive sensations' – by which he meant momentary perceptions of the optical and expressive features of visible reality and the artist's immediate affective responses to them – and sought instead to achieve a composition which would mirror the 'essential' or more permanent character of his subject. In a typical passage he wrote:

The Impressionist painters, especially Monet and Sisley, had delicate sensations, quite close to each other: as a result their canvases all look alike. The word 'impressionist' perfectly characterises their style, for they register fleeting impressions. It is not an appropriate designation for certain more recent painters who avoid the first impression and consider it almost dishonest. A rapid rendering of a landscape represents only one moment of its history [*durée*]. I prefer, by insisting upon its essential character, to risk losing charm in order to obtain greater stability.

He leaves no doubt that his dominant aim is expression, beginning his essay with the sentence: 'What I am after, above all, is expression.' But he goes on to explain that by 'expression' he means neither isolated expressive qualities in the visible scene nor the immediate emotional reactions of the artist but a quality which resides in the total composition. He says: 'Expression for me does not reside in passions glowing in a human face or manifested by violent movement. The entire arrangement of my picture is expressive: the place occupied by the figures, the empty space around them, the proportions, everything has its share. Composition is the art of arranging in a decorative manner the diverse elements at a painter's command to express his feelings.' Of what is the over-all composition expressive? At one moment Matisse says it is to be expressive of the artist's (deeper) feelings, at another he says it is expressive of the 'essential' character of reality. The two are not differentiated. But the whole essay makes it evident that in his view aesthetic composition with abstraction from visible nature has priority over naturalistic representation. He says that when he is painting an artist 'should feel that he has copied nature'. This is a psychological pronouncement. But he also says: 'I cannot copy nature in a servile way; I am forced to interpret nature and submit it to the spirit of the picture. From the relationship I have found in all the tones there must result a living harmony of colours, a harmony analogous to that of a musical composition.'

It is significant that although Matisse was certainly not an Expressionist artist as that term has come to be understood, but the greatest of all the exponents of decorative or aesthetic abstraction in this century, he yet at this time expressed himself in Expressionist terms. And it is indicative of the power exercised by the idea of 'expression' at this time that it was the expressive character of such paintings as *Joie de vivre* (1905) and *Luxe* (1907) rather than the more intellectual character of his work and its striving for decorative form which for a long while had the greater influence.

Artists still explain themselves in terms of 'expression' and mean by it at one moment the expression of their own feelings and at the next moment the representation of 'expressive' characteristics in the outside world. One of the most prominent aspects of the world to interest them has traditionally been the physiognomic and emotional, that is the 'expressive', characteristics of things in so far as these are manifested in their formal properties of colour and shape. Artists have always been more than usually sensitive to expressive qualities, but in the period which followed Impressionism this interest became more conscious and overt and there arose what might well be called 'Expressionist Realism'. By this is meant a kind of Aspect Realism in which the formal and optical properties of things are attended to primarily for the sake of the expressive qualities inherent in them, and the artist makes it his aim to depict realistically the expressive and emotional qualities of the world he sees. Clearly this interest is closely allied with the preference for the more permanent and significant properties of things rather than the fleeting optical properties which are dependent on changing conditions of atmosphere, light, and perspective.

Expressionist Realism also developed in an objective and a subjective direction.

From the time when it was inaugurated by Gustav Fechner's *Vorschule der Ästhetik* in 1876 Experimental Aesthetics has tried inconclusively to demonstrate that uniform expressive qualities attach to elementary shapes and simple colours in isolation or in combination. Seurat's aesthetic doctrine was grounded in a belief that this is so. In his recollections of Seurat, published in *L'Art dans les deux mondes* for 18 April 1891, shortly after the artist's death, Teodor de Wyzewa wrote:

He wanted to make a more logical art out of painting, more systematic, where less room would be left for chance effect. Just as there are rules of technique, he also wanted there to be rules for the conception, composition and expression

of subjects, understanding well that personal inspiration would suffer no more from these rules than from others.

He added:

First of all he analysed colour: he searched for diverse means of rendering it, tried to discover the way which rendered it with the most accuracy and variety. Then it was the expression of colours which attracted him. He wanted to know why certain combinations of tones produced an impression of sadness, certain others an impression of gaiety; and from this point of view he made a sort of catalogue for himself, where each nuance of colour was associated with the emotion it suggested. Next in turn expression through lines seemed to him a problem capable of a definite solution, for lines also have an innate, secret power of joy or melancholy ...

Later on Kandinsky, having in mind an art of non-iconic – or, as he called it, 'non-objective' – abstraction, undertook a similar sort of investigation in his book *Über das Geistige in der Kunst* (1912). More recently an attempt was made by Deryck Cooke in *The Language of Music* (1959) to explain the expressive character of music in terms of expressive properties attaching to the musical elements. None of these attempts has come within measurable distance of success if only because the expressive properties of artificially simple perceptual elements, if they do possess uniform expressive qualities at all, are submerged and transformed in the expressive qualities of higher-level configurations to which they contribute.

The purposes of such investigations into expressive properties by artists have been fourfold: to be able to perceive sensitively and to record the expressive properties of the world we see; to be able to penetrate behind the momentary and superficial character of appearances to the more permanent and significant expressive character of things; to be able to pierce behind individual things to the over-all expressive character of a scene such as a landscape or a tableau; and to be able to deploy this knowledge in order to merge and harmonize the constituent parts of a pictorial structure into a configuration which combines over-all expressive mood with sufficient variety to ensure vivacity. Many artists have pursued basically similar aims without wanting to systematize expressive qualities or reduce them to elements. Working intuitively their purpose has been to combine a measure of Expressionist Realism in the depiction of external reality with the creation of an aesthetic configuration which has over-all expressive character of its own as well as structural unity.

But artists are not as a rule objective and passionless recording machines. They are apt to become emotionally involved in their subject-matter and apprehend the expressive nature of the world they see by a kind of empathy and emotional identification. Therefore in depicting the expressive aspect of the world as they see it, their own vision of the world, they may be doing something of an intensely emotional nature. When this happens an artist may well say that he is 'expressing his own feelings' even though his work belongs rather to the category of Expressionist Realism than to subjective Expressionism. As Matisse once said, 'a painter's best spokesman is his work'. There is a well-known saying of Van Gogh which has been quoted with a variety of implications. In a letter to his brother Theo about the painting *Night Café* (1888) he wrote that he 'had tried to express the terrible passions of humanity'. He went on to explain that the picture was painted in harmonies of red, green, and yellow, 'colour not locally true from the point of view of the stereoscopic realist, but colour to suggest any emotion of an ardent temperament'. And the sentence from which the quotation is taken concludes: 'and the idea that the café is a place where one can ruin oneself, run mad, or commit a crime'. Van Gogh, who, more than most artists, was liable to become dominated by his emotional engagement with his subject, has tried by abstractions and distortion in form and colour to make salient the expressive qualities which were most significant in his own vision of the café' He was still trying to depict the emotional aspects of the scene though he perceived them with strong emotionality. In a similar vein he wrote of his portrait *Dr. Paul Gachet* (1890): 'I should like to paint portraits which would appear after a century to the people living then as apparitions. By which I mean that I do not endeavour to achieve this by a photographic resemblance, but by means of our impassioned expressions – that is to say, using our knowledge of and our modern taste for colour as a means of arriving at the expression and the intensification of character.'

For an artist in whom the capacity for emotional perception is strongly developed there is a very small shift in emphasis between representing a strongly felt expressive quality and expressing his own emotional reactions. And from expressing his own feelings to the assumption that the purpose and function of art is to serve as an instrument of subjective expression involves no more than a change of attitude. Fundamental as it is, the passage from Expressionist Realism

to Expressionism is an easy one. Thus Van Gogh could say: 'Instead of trying to record what I see, I use colour arbitrarily to express my feelings forcibly.' He meant that instead of reproducing perceived reality with matter-of-fact Realism, he used abstraction and distortion for the purpose of giving prominence to the expressive qualities he saw and felt to be in it. But if the words are taken literally and out of context they could well serve as a motto for German Expressionism.

The outlook of Expressionism received its classical formulation in the *Aesthetics* of Eugène Véron, which was published in 1878 and translated into English the following year. In a key passage he put it as follows:

Imitation is not the aim of art. . . . Just because he is endowed with sensibility and imaginative power, the artist, in presence of the facts of nature or the events of history, finds himself, whether he will or not, in a peculiar situation. However thorough a realist he may think himself, he does not leave himself to chance. Now choice of a subject alone is enough to prove that some preference has existed, the result of a more or less predeterminate impression and of a more or less unconscious agreement between the character of the object and that of the artist. The impression and agreement he sets to work to embody in outward form; it is the real aim of his work and its possession gives him his claim to the name of artist. Without wishing or even knowing it he moulds the features of nature to his dominant impression and to the idea which caused him to take brush in hand . . .

We see, then, that the beautiful in art springs mainly from the intervention of the genius of man when excited by special emotion. A work is beautiful when it bears strong marks of the individuality of its author, of the permanent personality of the artist, and of the more or less accidental impression produced upon him by the sight of the object or event rendered.

By way of a general definition Véron therefore said that visual art is 'the manifestation of emotion obtaining external interpretation . . . by expressive arrangements of line, form and colour'.

To this extent Aspect Realism and Expressionism are two sides of the same coin. Both are concerned with the relations between semantic and expressive information in a work of art. Whenever an artist depicts something, gives semantic information about the world, he necessarily depicts an aspect of it as seen through the spectacles of his own personality. Aspect Realism holds that this is the purpose of art, and, as formulated for example by Taine, maintains that a work is successful in so far as the aspect of reality which it depicts is presented consistently and coherently in accordance with a dominant 'idea'. But

whenever an artist depicts an aspect of the world as it appears to him personally he is also, necessarily, expressing his own personality, conveying 'expressive' information about himself. This, Véron maintains, is the purpose of art. And a work of art is successful in so far as the expressive information about the artist which it conveys is consistently and coherently presented in accordance with a dominant impression or idea.

6

Expressionism in Germany

The word 'Expressionism' does not indicate a school or movement like Fauvism, Cubism, Vorticism, etc. and the meanings attached to it in the literature of twentieth-century art have been fluid and diverse. Its use to describe art whose prominent feature is the expression of emotions was the earliest. In his book *Expressionism* (1970) John Willett traced this use to an article in *Tait's Edinburgh Magazine* for June 1850, which spoke of 'the expressionist school of modern painters' and also mentioned a lecture given by Charles Rowley in February 1880, in which he used the phrase 'the expressionists, those who undertake to express special emotions or passions'. But as the antonym of 'Impressionism' the word came inevitably to be applied to those schools of art which had moved away from the optical Realism of the Impressionists towards a type of Aspect Realism that gave prominence to representing the expressive characteristics of nature – what I have called Expressive Realism. The first example of this use was by the critic Louis Vauxcelles (who also coined the name *Fauves*) when he described pictures exhibited by Matisse at the Salon des Indépendants as 'expressionist'. The word gained currency in this sense. Indeed Roger Fry was at one time in two minds whether to adopt it instead of coining the new term 'Post-Impressionists' for the title of his London exhibition of 1910–11, which centred around the works of Cézanne, Gauguin, Van Gogh, and the Fauves. In Germany *Expressionismus* came into vogue after 1911, at first in a very general sense covering all European and particularly French *avant-garde* art. As late as 1934, despite the counter-expressive movements such as Cubism and Constructivism, Sheldon Chaney in his book *Expressionism in Art*, for some time a standard work, argued the implausible thesis that 'Expressionism' properly covered all that is innovative and creative in contemporary art.

Nowadays the term 'Expressionist' is current in both these general senses and is applied to artists in whose work the 'expressive' properties of things are given prominence and to artists in whose work is manifested a particular concern to 'express' their emotional attitudes to reality. But the word is also used to refer to a family resemblance among much Germanic art – almost a national characteristic. Although at first the term *Expressionismus* was applied in Germany to the work of the Post-Impressionists and the Fauves, which began to be exhibited there in 1911, its meaning underwent a change, and from about 1915 it was represented as a typically Germanic

movement. Prominent among those who engineered this change was Wilhelm Worringer, a friend of Kandinsky at Munich and the leading supporter of the 'non-objective' Expressionist art inaugurated by the Blaue Reiter group. Emphasizing the connection between contemporary German Expressionist art and medieval Gothic, with patriotic partiality Worringer wrongly represented the Gothic as a Germanic instead of a European phenomenon. In a still more restricted sense 'Expressionism' is also used in reference to a group of movements in German art usually considered to begin with the formation of Die Brücke in 1905 and lasting until the early 1920s. It was in this narrowest sense of the word that Worringer, at a lecture given in Munich in 1920, declared that the spirit of German Expressionism was dead. Similarly the Austrian art historian Hans Tietze, who had been an early patron and supporter of Kokoschka, announced the death of Expressionism in 1924, as in the following year did Carl Georg Heise, who had founded the Expressionist periodical *Genius* in 1919.

At the beginning of the century German art lacked a coherent and continuous tradition, and perhaps in consequence of this was extremely susceptible to outside influences. The most important among these were the medieval woodcut, Grünewald and Dürer, Art Nouveau in its guise of Jugendstil, and French Symbolism, Fauvism, and Cubism. Some artists were also alive to the exotic appeal of African and Indonesian art works. Among individual artists Van Gogh, Munch, and Hodler made the strongest impact on innovative movements in Germany. Moreover, owing to the protracted political fragmentation, Berlin was not so important a cultural centre in Germany as Paris was in France, and German cultural development proceeded much longer on a regional basis. Among the Expressionists or proto-Expressionists Nolde, Rohlfs, and Paula Modersohn were working in northern Germany, and Rohlfs was converted from German *Naturlyrismus* late in life by contact with the work of Monet and Van Gogh, Modersohn taking an isolated path within the Worpswede school; the Brücke was formed by a group of Dresden artists who did not move to Berlin until 1911; the Blaue Reiter separated off from the *Neue Künstlervereinigung* of Munich; in Vienna the move from Jugendstil to Expressionism was led by Kokoschka.

The public statements of the German Expressionists contain surprisingly little that is revolutionary or new, but repeat sentiments which had become familiar from the discussions of the Symbolists

and the Fauves, or which might well have come from the pen of Matisse. Yet there is no reasonable doubt that modern criticism is right in finding stylistic features which distinguish Germanic Expressionism from expressive art in general. Difficult as it is to generalize in stylistic matters, I shall try, therefore, to indicate what those special features of Germanic Expressionism were, so that when the pronouncements of these artists are looked at in the light of what they were doing, their true import may be better understood.

Expressive Realism, it has been said, is a species of Aspect Realism which concerns itself with depiction of the expressive qualities of things. To represent a scene with strong emphasis on its expressive character may be regarded as sufficient as an end in itself, as with Van Gogh's *Night Café*. Or the depiction of expressive qualities may be subordinated to the creation of an aesthetic configuration having both structural coherence and a unified expressive mood. This was the aim of the Neo-Impressionists and the Fauves and is amply set forth in the writings of Seurat and Matisse. Yet again, as with the Symbolists, the representation of expressive qualities may, by an act of metaphysical faith, be thought of as a way to depict recondite truths behind the appearances of things. This was the argument of Émile Bernard, who originated the mode of abstraction practised by Gauguin and the Pont-Aven school, reducing natural appearances to strong linear patterns and the 'seven fundamental colours of the prism'. He claimed that 'anything which overloads a spectacle ... occupies our eyes to the detriment of our minds' and that we must '*simplify* natural appearances' in order to disclose their meaning and to 'catch the symbolism inherent in nature'. These are all forms of Realism – the representation of the phenomenal world with a particular interest in its expressive features. But an artist who is powerfully engaged with the emotional aspects of his subject-matter, as very many artists are, may easily come to think of his work as expressing his own emotional reactions to that subject-matter rather than depicting its expressive characteristics. Or, of course, he may fail to distinguish between the two. From this it is but a short step to supposing the aim and function of art to be the expression of personal emotions. Indeed, unless expressive representation is subordinated to the creation of an aesthetic configuration, that is unless the semantic function is made secondary to the syntactical, this step is very likely to be taken. And that means that the expressive function of art in the sense of self-expression by the artist rather

than semantic representation of expressive characteristics is given precedence over the syntactical function. It was this last step which at the most general level distinguished German from French Expressionism. Rather than subordinating the expressive features of depicted things to the overriding purpose of creating a unified aesthetic configuration and to the over-all emotional mood of the total configuration, by a determined use of abstraction and distortion in the representation of particular things the German Expressionists emphasized the expressive features of things with the object of expressing the artist's emotional reaction towards them. As in a very different context the Synthetists had believed that by simplification and abstraction they could depict symbolically the realities behind appearances, so many of the German Expressionists believed that by giving emphatic expression to their idiosyncratic emotional reactions they could pierce the veil of appearances and penetrate to some ultimate reality behind them. It is difficult not to suggest a temperamental analogy to the central assumption of German Idealist philosophy, that by penetrating to the innermost depths of his own being a man may find himself in contact with the ultimate reality of the Absolute. Be that as it may, the achievement of German Expressionist art must be seen as a predominance of the expressive over the semantic and the syntactical functions of art. It is with this in mind that their statements should be read.

The Preface to the catalogue of the 1911 exhibition of the *Neue Sezession* at Berlin, which was dominated by the members of the Brücke, contained the following comprehensive statement of their aims:

The Impressionists sought to present the harmony of the momentary sensation. They left to the succeeding generation, with the same means but with greater liberation from the object, the task of creating great decoration, building the house with the stones that had been discovered. A decorative art derived from the colour sensations of Impressionism, that is the programme of the young artists of all countries. They no longer take their rules from the object, of which the Impressionists wanted to present the sensation by the means of pure painting, but instead they think of the wall for the wall, that is in terms of colour. They no longer are willing to represent nature in its fugitive external forms but want to concentrate their personal sensations of the object. They want to condense them until they find their characteristic expression. They want the expression of their personal emotion to be strong

enough for a mural painting. . . . The areas of colour do not destroy the funda-
mental lines of the coloured objects but on the contrary create a new function,
which is neither to represent nor to create form but to circumscribe emotional
expression so as to indicate it and fix figurative life on the surface. . . . Each
and every object is nothing more than the carrier of a composition of colour
and the total work no longer aspires to an impression of nature but the expres-
sion of feelings.

This betrays the same mistake as was made by Roger Fry and most
critics at that time of regarding the work of the Post-Impressionists as
a further advance in abstraction from that of the Impressionists, a
'greater liberation from the object'. As we have shown, it should be
seen rather as a different *kind* of Aspect Realism, with a weighting
of interest towards the expressive rather than the optical character-
istics of things. The members of the Brücke correctly formulated what
had become a commonplace, that the newer art sought to depict the
more permanent and typical aspects of things rather than their percep-
tual surfaces as seen instantaneously in the manner of the Impression-
ists. The 'concentration' of sensations was the language of the Symbol-
ists and 'condense' was the word preferred by Matisse. As has been
seen, Matisse also could speak of the 'expression of feelings'. But he
meant by this, primarily, the feelings experienced by the artist for the
unified aesthetic structure which was his picture and to which were
subordinated particular feelings for particular depicted things. With
the German Expressionists the 'expression of personal emotion' meant
rather the artist's individual emotional response to the things in the
outside world which he portrayed in his picture. And this makes all
the difference between an art which combines semantic with syntacti-
cal aims and one whose primary aims are self-expression.

The following three quotations combine the doctrine of self-expres-
sion with the belief that by its means the artist can express ultimate
spiritual truths and penetrate the veil of appearances to the reality
behind.

A circular issued in 1909 to mark the foundation of the *Neue Künst-
lervereinigung* at Munich and reprinted as a preface to the catalogue
of their first exhibition was couched in the language of the Synthetists,
but by the turn of phrase – 'the search for artistic forms by which
to give expression' – betrays the characteristic switch of emphasis from
interest in depicting expressive aspects of phenomena to interest in
the personal emotions they evoke.

Our starting point is the conviction that the artist is constantly engaged in assembling experiences in an inner world in addition to the impressions he receives from the external world, from nature. The search for artistic forms by which to give expression to the mutual interpenetration of these two kinds of experience, forms which must be liberated from every kind of irrelevancy in order to express nothing but essentials – in short the search for artistic synthesis – this seems to us to be a criterion which is uniting more and more artists at the present time.

After Kandinsky and his friends had broken with the *Neue Künstler-vereinigung* and formed their splinter group, the Blaue Reiter, an article by Franz Marc on 'Die neue Malerei' was published in the journal *Pan* in 1912 and was used as a prospectus attached to the catalogue of the first Blaue Reiter exhibition. Although the Blaue Reiter group is now famous for having made non-iconic expressive abstraction respectable, Marc, in this article still speaks of the attempt to penetrate 'the veil of external appearances' as if it were the same as finding 'the spiritual side of *ourselves* in nature'.

Today we search behind the veil of external appearances for the hidden things of nature which seem to us more important than the discoveries of the Impressionists. ... We seek and we paint this spiritual side of ourselves in nature, and this is not from caprice or the desire to be different but because we see this other side just as before they suddenly saw violet shadows and the atmosphere before everything else. ... Art in its purest essence is and has always been the most audacious departure from nature and the natural. It is the bridge to the world of the Spirit.

In 1938, in a lecture delivered at the New Burlington Galleries, London, Max Beckmann, who at first vigorously opposed the ideas of Marc, echoed his words as follows: 'What I want to show in my work is the idea which hides itself behind so-called reality. I am seeking for the bridge which leads from the visible to the invisible. ... My aim is always to get hold of the magic of reality and to transfer this reality into painting – to make the invisible visible through reality.'

Apart from this slant, it was less by any new artistic doctrine or insight than by the portentous tone of their pronouncements, their evangelical sense of mission, and the solemn arrogance with which they put themselves forward as the torch-bearers of a new cultural Renaissance, that these artists are distinguished. In the 'Manifesto of the Brücke', which in 1906 Kirchner cut on wood and printed by hand,

he declared: 'With faith in development and in a new generation of creators and appreciators we summon together all youth. As youth, carrying the future with us, we intend to create for ourselves freedom of life and movement over against the established older forces. Everyone belongs to us who with directness and genuineness reproduces that which impels him to create.' In an article on the 'young savages' (a coinage on the analogy of 'Fauves'), contributed by Marc to the *Blaue Reiter Almanac* he said: 'Their thinking has a different aim [from that of the Impressionists]: To create out of their work *symbols* for their own time, symbols that belong on the altars of a future spiritual religion, symbols behind which the technical heritage cannot be seen.' A draft Preface written by Marc and Kandinsky announced: 'We are standing at the threshold of one of the greatest epochs that mankind has ever experienced, the epoch of great spirituality ... Our most important aim is to reflect phenomena in the field of art that are directly connected with this change and the essential facts that shed light on these phenomena in other fields of spiritual life.' There was little or nothing positive or new behind this bombastic beating of the big drum. It was in the performance that the difference lay. Whereas the French on the whole favoured classical restraint, the German Expressionists were disposed generally to overstatement, blatancy, and the blare of the trumpet. Except perhaps for Macke when most under the influence of the Fauves and the Orphists, they were inclined to exaggerate the expressive features of the object to the point of transfiguration by mannered distortions and harsh angularities. They were self-conscious about the artistic duty, as they thought it, to give public vent to their private emotional predicaments, hoping to dignify with cosmic significance their frustrations, exasperations, and violent restlessness; but they lacked the patience to school their perceptions to a new vision of reality. An artist's manner and technique of painting can, of course, be seen as a symbol of his personality just as a man's handwriting or even the way he walks can be read as a sign or expression of his character. Van Gogh's violent and restless brush-strokes were an evident sign of his emotional constitution and his illness. But the Germans self-consciously courted restlessness and violence as a symbol of the spiritual sublimity they longed for. A revealing insight into this difference is contained in an incidental remark made in 1922 by the philosopher Karl Jaspers in an essay comparing Van Gogh and Strindberg (*Strindberg und Van Gogh. Versuch einer*

Pathographischen Analyse): 'In this exhibition at Cologne in 1912 Expressionist art, which was strangely monotonous and came from all over Europe, could be seen against the magnificent Van Goghs. One frequently felt that Van Gogh was sublimely the only artist mad against his will among so many who wished to be mad but were only all too healthy.'

Nothing of this is said in derogation of the fine artistic achievements of the German Expressionists, which stand unassailed for what they are. It is intended as an indication that in the development of twentieth-century art German Expressionism represents an efflorescence of certain national attitudes and characteristics which to some extent survived even the National Socialist intervention. It does not represent any positive innovation either in artistic vision or in aesthetic insight.

7
Cubism, Cézanne, and Perceptual Realism

The Impressionists concentrated on depicting the lighted surfaces of things and mistook this for a true reproduction of 'real' perception. The Neo-Impressionists, the Symbolists, the Post-Impressionists, the Fauves, and the Expressionists gave more deliberate attention to the expressive qualities of things and to their permanent and typical, rather than their transitory, optical properties. The Futurists, as will be seen, were chiefly engrossed with the realistic rendering of movement. All these were forms of Aspect Realism, although the aspects of the world in which they were interested were not the same. The Cubists, too, were at first Realists, and they were distinguished by their interest in depicting the perceived structure of things. Although many other motives and purposes coincided to produce the Cubist revolution, it is this which was central to the innovatory work of Picasso and Braque in the early years of Analytical Cubism.

But the Cubists worked with a better idea of what perception is. They understood that when, for example, we perceive a square box we do not in fact, as the Impressionists wrongly thought, perceive a pattern of coloured surfaces and casts shadows, then *infer* that we are in the presence of a three-dimensional hollow cube. We *perceive* the three-dimensional object directly. There is, if you like, a gap between what we *see* and what we *perceive*, for we perceive more than we see. The Analytical Cubists set themselves the problem of depicting what we *perceive*, not by the use of recognized pictorial conventions such as linear and aerial perspective, but directly combining what we see with what we perceive. Since a painter can reproduce on a two-dimensional canvas only what we *see* – corresponding to a retinal image – this constituted a problem which had no straightforward solution – like the Futurists' problem of depicting movement in a static medium. Both were aspirations to take realistic representation beyond the bounds of ordinary possibility. It was in pursuit of this, which they conceived to be a technical problem, that the Analytical Cubists invented the fragmentation of objects, the disruption of planes, faceting, and similar devices.

As the Cubists themselves recognized, Cézanne was their most important forerunner in this central aim of their work. Like the Impressionists, Cézanne was an Aspect Realist. But he was interested in a different aspect of the world from theirs and different from that of the Expressive Realists. He was interested in the perceived structure of things, and he may be called the first Perceptual Realist.

In *Panorama des arts plastiques contemporains* (1960) M. Jean Cassou wrote: 'L'intellect de Cézanne l'a suivie avec une farouche et anxieuse obstination, y soumettant toute sa sensibilité externe, et d'abord ce mode de notre sensibilité qu'est l'espace.' To describe Cézanne as an intellectual is an all too common misapprehension, which has distracted attention from the real nature of his contributions to Cubism. Cézanne was a Perceptual Realist who engaged in a solitary lifelong struggle to work out an intuitive insight with painstaking consistency, and hoped eventually to understand what he was doing and be able to explain it to others. In 1889 he wrote to Octave Maus, the leader of the Belgian group Les Vingt: 'I have resolved to work in silence until the day when I shall feel myself capable of defending theoretically the result of my attempts.' The often quoted 'theoretical' pronouncements are contained in letters written to Émile Bernard during the last two years of his life and to Bernard's questions he would reply: 'I am not in the habit of reasoning so much.'

The Perceptual Realism of Cézanne was a reaction against the optical Realism of Impressionism. He repudiated in its entirety the central innovation of the Impressionists, their assumption that what we see are the coloured surfaces of things animated by constantly changing light. His new insight consisted precisely in understanding that we perceive nature as a physical reality composed of solid, tangible objects existing in three-dimensional space. In this insight he foreshadowed the modern Phenomenological philosophers such as Merleau-Ponty, who understood that there is a built-in 'noetic' element in the very nature of perception. We perceive, in a sense, more than we see. But it is what we *see* that the painter can directly depict, as the Impressionists very well knew, and Cézanne's intractable problem, inherited by the Analytical Cubists, was to find the artistic means of depicting nature as he perceived it. This he called 'means of expression'. Despite the seeming impossibility of what he wanted to do Cézanne remained obstinately faithful to his Perceptual Realism, again and again recurring in his letters to the necessity for an artist to train himself to perceive nature 'as it is'. At one point he even suggested that a knowledge of geology might have helped him the better to perceive the true structural reality of a landscape.

The solution which he eventually and laboriously found was to train the eye to perceive and the hand to depict nature as a system of volumes articulated by juxtaposed and overlapping planes, receding from the

eye in a three-dimensional space defined by linear and aerial perspective – the latter represented by his use of blue. This is the purport of his letter to Bernard of 15 April 1904:

> Treat nature by the cylinder, the sphere, and the cone; the whole placed in perspective, let each side of an object or a plane be directed towards a central point. Lines parallel to the horizontal give extent, whether it be a section of nature or, if you prefer, some spectacle which the Omnipotent Father, Holy God, spreads before your eyes. Lines perpendicular to this horizon give depth. Indeed, nature for men is more a thing of depth than of surface, whence comes the necessity of introducing in our vibrations of light, represented by the reds and the yellows, a sufficient sum of blues for the air to be felt.

The injunction to 'treat nature by the cylinder, the sphere, and the cone', the most frequently quoted of all his words, was for Cézanne a heuristic principle, a way of learning to perceive nature as a system of solid, tangible, voluminous objects. It was not a precept for representation; he did not paint things as cylinders, spheres, and cones. It was only after Cubism became a 'school' and a style that the imposition of geometrical forms (not, curiously enough, those mentioned by Cézanne) upon the appearances of things became a stylistic mode of abstraction.

Cézanne amplified this central advice as follows in subsequent letters:

> In an orange, an apple, a bowl, a head there is a culminating point, and this point is always – in spite of the terrible effect: light and shade, coloured sensations – drawn closest to the eye; the borders of objects flee towards a centre placed at our horizon. (Letter of 25 July 1904)

> Now the coloured sensations which give light are the cause of abstractions which prevent me, an old man, about seventy, from covering my canvas and from pursuing the delimitations of objects when the points of contact are tenuous and delicate, from which it is implied that my image or picture is incomplete. In another way the planes fall one upon the other, from which Neo-Impressionism arises, which circumscribes the contours with a black stroke, a fault which it is necessary to combat with all force. Now nature, when we consult it, gives us the ways of attaining this purpose. (Letter of 23 October 1904)

> An optic sensation is produced in our visual organ, which makes us class by light, half-tone or quarter-tone the planes represented by coloured sensations (light does not exist, therefore, for the painter). (Letter of 23 December 1904)

Cézanne agreed with the Impressionists that there are no lines in nature, and held that pure drawing is 'an abstraction'. Colour and drawing are one and the same thing: 'while one paints one draws'. But unlike Gauguin, Van Gogh, and Matisse he was less interested in the expressive qualities of colour than in using colour as an instrument for representing the voluminous structure of the perceptible world. He stood apart from the other Post-Impressionists in that his concern was rather with depiction of structural reality than with exploiting the expressive properties of colours and shapes or with abstracting for the purpose of giving prominence to the physiognomic and emotional properties of things. 'The form and contour of objects', he said, 'are conveyed to us through the opposition and contrast resulting from their individual colours.' Although it is not one of his most typical works, the contrast may be admirably illustrated by comparing the structural qualities of Cézanne's *Bathers* (Philadelphia Museum of Art, 1899–1906) with the decorative character of Matisse's *Bonheur de vivre* (The Barnes Foundation, Merion, 1905).

Two other intuitive motivations influenced Cézanne's development, both of them in conflict with his Perceptual Realism and both important for understanding the full extent of his bearing upon contemporary abstraction. While Cézanne wrestled with the problem of creating a pictorial image which would represent the perceived solidarity and voluminousness of nature, he was also conscious of a tension between the 'virtual' solidarity of the pictorial image and the flat plane of the pigmented picture surface which we also simultaneously see. And although he did not to any great extent anticipate the shallow picture space of the Cubists, he was unwilling to subordinate entirely the reality of the pigmented canvas to the simulated reality of the pictorial image. This interest in 'preserving the picture plane', as it came to be called, acquired increasing importance for the Cubists and other schools of contemporary art. It was an aspect of the ascetic dislike of artifice and illusion which became a dominant feature of Concrete art and later of Minimal art. Cézanne's method of using a shifting perspective was also adopted in some pictures by Picasso and Braque during the formative years of Cubism. A similar use of multiple perspective, though in a very different artistic context, may be seen in Stanley Spencer's *Resurrection of Soldiers* at Burghclere.

Cézanne's other concern, modifying his Realism, was to create a unified composition which would have monumentality and authority

as opposed to the fugacity inherent to the typical Impressionist images. In this he was at one with Seurat and the Neo-Impressionists and with most of the Post-Impressionists. This is the implication of his famous saying that he aspired to 'faire du Poussin d'après nature' and his statement to Joachim Gasquet: 'Alors je veux être un vrai classique, redevenir classique par la nature, par la sensation.' There is here, of course, a tension between two diverse aims, or at any rate between aims tending in opposite directions. On the one hand his Perceptual Realism demanded fidelity to the perceptual properties of natural appearances. On the other hand his aspiration to achieve the 'classical' aesthetic balance of a composition by Poussin demanded abstraction and subordination of the perceptual properties of reality to the overriding requirements of aesthetic structure.

It is a mark of his genius that Cézanne succeeded in reconciling these conflicting and imperfectly understood motivations in works whose impact has been an inspiration to more, and more diverse, styles of modern art than those of any other single artist.

With the advantages of hindsight we are now able to bring into perspective the insouciant poetic exaggerations of Guillaume Apollinaire when he wrote in *Les Peintres cubistes. Méditations esthétiques* (1913): 'We are moving towards an art which is entirely new, whose relation to painting as it has been envisaged up to now will be like the relation of music to literature.' Cubism *was* revolutionary in its day, but it was a revolution within painting itself and it had its roots in a Realist tradition running from Courbet through to Cézanne. In their book *Du cubisme*, written in 1912 by the two Cubist painters Albert Gleizes and Jean Metzinger in collaboration, they do justice to this background, beginning with the statement: 'To evaluate the importance of Cubism we must go back to Gustave Courbet', and going on: 'He who understands Cézanne is close to Cubism.' Cubism in its early years represented a drastic and complete break with all current forms of Expressionism. So far as was possible it eliminated the expressive properties of things from their representation and neither colours nor forms were used to display physiognomic or emotional properties in the picture image. It also excluded the anecdotal and symbolic elements with greater rigidity than had been done before. It was these deliberate restrictions which earned the movement its name for austerity and which in part accounted for the limited scope of its subject-matter and its preference for emotionally neutral subjects. Since they

rejected most of what people had learned to find appealing in art, it is no wonder that the work of the early Cubists proved difficult. They did not indulge in shock tactics for their own sake like the later Dada; but despite their fundamental seriousness, there was a certain ironic pleasure in being disconcerting and they were rarely willing to make concessions in order to avoid misunderstanding.

Because Cubism was interested in the measurable rather than the emotional properties of things, in their structural configuration rather than their ephemeral surface appearances, it has been described as an intellectual rather than a visual art – though seldom with any clear idea what sort of thing an intellectual art would be. This, perhaps the most persistent of many misunderstandings, was also given its vogue by Apollinaire. He says that 'the young painters offer us works which are more cerebral than sensual' and that 'scientific Cubism ... is the art of painting new ensembles with elements borrowed not from the reality of vision but from the reality of knowledge'. Gleizes and Metzinger knew that this was wrong. They wrote: 'It therefore amazes us that well-meaning critics explain the remarkable difference between the forms attributed to nature and those of modern painting by a desire to represent things not as they appear but as they are.' But the idea has persisted and in *Panorama des arts plastiques contemporains* Jean Cassou was still describing Cubism as an 'œuvre de la faculté intellective, non de l'appareil sensoriel'. Douglas Cooper began his book *The Cubist Epoch* (1971) – certainly the most perceptive account of Cubism that has been written – with a claim that Cubism was a 'conceptual' art which rejected the 'eye-fooling' illusion introduced at the Renaissance and 'involved a return to the earlier conceptual principle, in so far as the artist assumed the right to fill gaps in our seeing, and to make pictures whose reality would be independent of, but no less valid than, our visual impressions of reality, and was thus stylistically the antithesis of Renaissance art'.

In so far as and in the sense that there is a 'noetic' factor in all perception, the method of the Analytical Cubists was strongly noetic. They did not, like the Impressionists, try to go behind perception to pure optical sensation. And they were not content, like the artists of the Renaissance, to create on canvas a visual pattern which in perception could serve as an optical analogue for the reality which it represented. They tried, vainly but interestingly, to make visible the unseen factors of the perceived. It may well be that Juan Gris

and Metzinger, for example, were more knowingly conceptual in their approach. But none of the Cubist art was noetic in the rather elementary sense in which some primitive, Egyptian, or medieval art is described as noetic.[1]

No Cubist artist draws in the backbone and alimentary canal of a fish because he knows they are there although he cannot see them. Nor does he open out the cube and show the six faces simultaneously as Gleizes and Metzinger facetiously suggest a noetic artist would. It is the engineer's drawing and the textbook diagram which speak to the mind rather than the eye. The later Synthetic Cubism had noetic elements of a still different kind. But Synthetic Cubism had to a large extent forsaken the original Perceptual Realism of Analytical Cubism in favour of a mode of construction which had something in common with the motivation of aesthetic or decorative abstraction.

The correct antithesis is that between the Perceptual Realism inaugurated by Cézanne and the optical Realism of the Impressionists, not that between an art of the intellect and an art of the senses. It is a commonplace in modern psychology that perception even at its most elementary involves a large and significant measure of conceptual interpretation and that no sharp lines can be drawn between sensation, perception, and conceptualization. In his book *Visual Thinking* (1970) Rudolf Arnheim has argued at length for the importance to artistic activity of the thought factor inherent in all perception. Sensation divorced from perception may well be a fiction which we can always approach but never quite achieve. Certainly it is perception not sensation that is primary. We perceive the world directly as three-dimensional space inhabited by solid, voluminous, extended objects able to be palpated and manipulated, classifiable into known types. The problem which exercised Cézanne, and which the Cubists pursued more

[1] Juan Gris, for example, said in reply to a questionnaire sent out by the *Bulletin de la Vie Artistique* (1 Jan. 1925) 'Today I am clearly aware that at the start Cubism was simply a new way of representing the world. By way of natural reaction against the fugitive elements employed by the Impressionists, painters felt the need to discover less unstable elements in the objects to be represented. And they chose that category of elements which remains in the mind through apprehension and is not continually changing. For the momentary effects of light, for example, they substituted what they believed to be the local colours of objects. For the visual appearance of a form they substituted what they believed to be the actual quality of this form. But that led to a kind of representation which was purely analytical, for the relationship that existed was that between the intellect of the painter and the objects, and practically never was there any relationship between the objects themselves.'

rigorously still, was to depict the world as so perceived, to depict, in the words of Douglas Cooper, 'the solid tangible reality of things'. It was a problem because the painter can depict what he sees but not what he knows, in so far as what he knows in perception transcends what he sees. The old-fashioned Realism offered, within accepted artistic conventions, the cues for perception. The Impressionists wished to reproduce the lighted areas of colour which are the sensory element in our perceptions of the world, neglecting the palpable structure of things which we know. In principle their aim could be realized though in practice the physical resources of coloration were (and are) inadequate. The Post-Impressionists turned largely to the expressive features of perceived reality, abstracting from other properties in order to give prominence to these. It was with Cézanne that the problems of Perceptual Realism began. With Cézanne, and still more with the Cubists, it was essentially a problem of devising a pictorial technique for representing reality as perceived rather than a new way of perceiving reality. It was because they were engrossed with this technical problem of representation that the early Cubists preferred neutral subjects and eschewed subjects with strong emotional appeal. There was therefore some justification for the accusation made by Wyndham Lewis that Cubism was an 'acrobatics' of visual intelligence and that it failed to 'synthesize the quality of life with the significance or spiritual weight that is the mark of all the greatest art'. But is was also because Cubism was a technique for depicting perceived reality that it could never eliminate representation and pass over into non-iconic abstraction – as did Wyndham Lewis. Gleizes and Metzinger wrote: 'Nevertheless, let us admit that the reminiscence of natural forms cannot be absolutely banished; as yet, at all events. An art cannot be raised all at once to the level of a pure effusion.' But it was not a matter of time and maturity. Without representation Cubism as a technique of representation could not have existed.

Like other modern movements Cubism was a complex phenomenon resulting from a blending of several only partially integrated motivations. Among these what was called the desire to 'preserve the picture plane' strongly influenced the modes of abstraction by which the early Cubists coped with the problems of representation inherent to Perceptual Realism. In 'illusionist' painting as introduced at the Renaissance we look 'through' the canvas, as it were through a window, at the three-dimensional picture image and the attention is entirely distracted from

the physical canvas, which 'disappears'. But from the time of the Impressionists, and particularly as 'direct' or *alla prima* painting increased its vogue, a number of artists, including Cézanne, began to be interested in the fact that as well as seing the picture image we may simultaneously see the pigmented canvas, which is a flat plane at right angles to the line of vision and at a specific distance from the eye, with its own textural surface properties. There was a tendency to flatten the pictorial image in order to weaken its illusory effect and so restore visibility to the physical canvas and invite attention to the surface qualities of the pigment and texture. Indeed there have been aestheticians who have taken the view that the tension resulting from simultaneous perception of a three-dimensional picture image and the flat, two-dimensional pigmented canvas forms an integral part of the aesthetic response to painting.[1] In twentieth-century art this wish to 'preserve the picture plane', to retain the visibility of the pigmented canvas, was one aspect of a general impulse to reduce artifice and illusionism which culminated in the extreme positions of Concrete art and Minimal art. The Cubists showed relatively small interest in textural qualities until the second phase of 'Synthetic Cubism', when the problems of perceptual representation had receded. But from the beginning their austere, anti-artifice motivation took the form of reducing recession in a manner analogous to relief sculpture, and allowing only an artificially shallow picture image. Within this shallow picture space they set about coping with their special problems of representation.

The best known of the Cubist devices was, of course, the analysis of volumes into planes suggestive of geometrical solids. It was a method whose beginnings can already be seen in Picasso's *Les Demoiselles d'Avignon*, and one which can be studied in some of his drawings of heads and in pictures such as Juan Gris's *Portrait of Picasso* (1912). This was only one of many modes of abstraction by which the solidity and internal three-dimensional structure of a depicted object can be suggested. But this was the mode of abstraction which turned into a Cubist style when Cubism was taken up more widely and became a school. By Braque and Picasso in the early years of Cubism the technique of faceted planes was used in a far more subtle way to articulate their artificially shallow picture space and to integrate objects into it. Sometimes the articulation of the picture space may take precedence

[1] For example, George Kubler in *The Shape of Time* (1962).

over representation of objects and the objects may virtually disappear or be indicated only by occasional clues. But the object always remains necessary, however marginal, in order that the system of overlapping and juxtaposed planes with their complicated changes of inclination and direction shall be seen as an articulation of picture space and not *merely* as a non-representational abstract pattern.

Geometrical abstraction by faceted planes is not the only possible mode of abstraction for representing perceived things in their structural solidity, though in the hands of the Cubists it turned into one of the most subtle instruments for the articulation of picture space that had been known up to then. Nor is geometrical abstraction necessarily rectilinear. Even among the Cubists Léger preferred cylindrical forms – as in his *Houses Among Trees* (1914) at the Kunstmuseum, Basel – and both Picasso and Braque combined curvilinear forms with rectilinear planes in their still lifes. The Cubist mode of abstraction has sometimes mistakenly been confused with generic abstraction, The two are quite different, however. In generic abstraction the features in respect of which individuals of a species differ from each other are successively eliminated until a generalized form common to the whole species is reached. This form is not necessarily, or even probably, geometrical – as witness the abstractions of Brancusi. The Cubists worked in the opposite way and analysed perceived things into pre-selected types of abstract forms.

Two subsidiary devices contributed to the representational techniques of Perceptual Realism. That of unstable or shifting perspectives was used also by Cézanne. Its employment by the early Cubists was mainly to help and enrich the sensitive organization of their shallow picture space. The other manœuvre – and this is more especially associated with the Cubists – consisted in the combination of different views of the same thing in one picture. Sometimes a head is depicted simultaneously both full-face and in profile. Gris in particular liked to build up a pictorial image by assembling partial views of one object seen in section, plan, elevation, profile, and frontally. Sometimes, in answer to the accusation of the Futurists that Cubism presented a static picture of the world from which movement had been eliminated, it has been claimed that this device did in fact introduce the suggestion of movement, not on the part of the object, but movement by the spectator, intellectually if not visually, around the object, which was depicted from different angles and points of view. No such arcane and

unlikely explanation is necessary or even plausible. In the still lifes, where we see fragmented parts of a guitar or a violin, frontally, in profile, and at some intermediate angle, it is impossible to decide intellectually, and a matter of indifference visually, whether they are parts of the same instrument or parts of different instruments juxtaposed in the sort of way that incongruous objects often are juxtaposed in these still lifes. The practice constitutes a trend *away* from Perceptual Realism which was implicit from the first although it became of major importance only in the later, Synthetic Cubism. The various fragmented aspects combined in one picture are bound together and made coherent not by their contribution to Perceptual Realism but by the structural demands of formal composition. The coherence is syntactical, not representational.

Synthetic Cubism grew out of the technique of *papiers collés* initiated by Braque and taken up almost immediately by Picasso in the autumn of 1912. From this time Perceptual Realism was in abeyance and Cubism was no longer primarily a technique of representation. Two linked motivations were dominant in the creation of this new Cubism, which owed much to the robust genius of Juan Gris. Perhaps the stronger of the two was an obsessive conviction that a work of art is a self-sufficient entity, standing on its own feet, not justified by its success in representing a perceived reality other than itself but an independent addition to the existing world of reality. They called their pictures *tableaux-objets* – the picture *was* the 'object' before it was a representation of a segment of the perceived world. This was, of course, the principle underlying non-objective abstraction, though none of the major Cubist painters abandoned figuration. In an article published in *Transatlantic Review* for July 1924 (reprinted in Daniel-Henry Kahnweiler's *Juan Gris*) Gris wrote: 'A picture with no representational purpose is to my mind always an incomplete technical exercise, for the only purpose of any picture is to achieve representation . . . the essence of painting is the expression of certain relationships between the painter and the outside world, and . . . a picture is the intimate association of these relationships with the limited surface which contains them.' But he gives no reasons why this *must* be so.

In the second place the 'anti-artifice' motive, which had been partly responsible for causing the early Cubists to contract the depth of the picture space in order to bring into greater prominence the reality of the picture surface, now advanced from the periphery to the centre

of attention. Real materials such as pieces of newspaper, wallpaper, matchboxes, oilcloth, etc. were combined with drawing (Braque) or with oil painting (Picasso and Gris) to make the picture. Partly with Picasso there was a romantic, iconoclastic desire to debunk the idea that fine art could only be produced from 'noble' materials and to show that the artist could produce pictures even from the humblest scraps. But more fundamental was the concentration of attention upon the physical reality of the materials which this novel technique encouraged and the consequent heightening of the tension between the reality of the picture surface and the illusion of the picture image. By a deliberate ambiguity the pasted materials often performed a double role, being seen both as the real things they were and also as illusionistic elements in a representational picture image. As Douglas Cooper points out, in Braque's *Still Life on a Table* (1913) strips of wallpaper printed to represent oak panelling 'came to represent a background plane of panelling and in the foreground a drawer in a wooden table'. A second-order ambiguity was soon introduced when the whole picture came to be painted in oils but the picture image depicted collages of newspapers, etc. combined with painted still lifes. In other ways, too, attention began to be drawn to the surface texture. Instead of *camaïeu* painting typical of early Cubism, colours became stronger and more contrasting, flat areas of local colour used descriptively being combined with monochromatic shading to suggest form. Picasso and Gris now found oil pigments unsuited to their purpose and thickened them with sand and other substances in order to create real textural variations. But all these things were directed to primarily structural or syntactical purposes rather than to expressive ends as, for example, with the collages of Schwitters.

Synthetic Cubism involved a significant change of attitude, which has been imperfectly understood. In his book on Gris, written in 1947, Kahnweiler, who knew the artists intimately, named it 'conceptual painting' and tried to explain what he meant by this as follows:

What these painters [Gris and his friends] did was to recall all their visual perceptions of a given object and then attempt to re-create it by means of a new emblem. Henceforth, the emblems which Juan Gris invented 'signified' the whole of the object which he meant to represent. All the details are not present. The emblems are not comprehensible without previous visual experiences. But the justification for calling this conceptual painting is the fact that the picture contains not the forms which have been collected in the visual

memory of the painter, but *new forms*, forms which differ from those of the 'real' objects we meet with in the visible world, forms which are truly emblems and which only become objects in the apperception of the spectator. ... And so Gris was able to invent new emblems to signify 'table,' 'guitar,' or 'violin;' but he was determined that these emblems should incorporate the whole of his knowledge about the plastic qualities of the solid bodies which they represented.

This is both incorrect and confused, but it is a confusion which has had a strange power of persistence in face of patent facts. It is possible, by abstracting from the differences among individuals of one species, to arrive at a 'generic' image representing the species. It is possible to combine different views of a single thing in one picture, as was sometimes done in Analytical Cubism. But there is no possibility that an abstract visual form could represent a concept comprising all our visual knowledge (e.g. both frontal and profile views) of a single individual thing. The idea makes no sense. Moreover, as Gris himself knew well, representational Realism was no longer primarily the motive of Synthetic Cubism.

Gris came to see that the purpose of Analytical Cubism had been to work out a technique of representation for Perceptual Realism. In reply to a questionnaire issued by the *Bulletin de la Vie Artistique* and published on 1 January 1925, he said: 'Today I am clearly aware that at the start Cubism was simply a new way of representing the world.' He was well aware that the purpose had changed, although his account of the aims of Synthetic Cubism was less satisfactory. The best known statement was contained in a contribution to Amédée Ozenfant's review *L'Esprit Nouveau* for 1921. 'I try to make concrete that which is abstract. I proceed from the general to the particular, by which I mean that I start with an abstraction in order to arrive at a true fact. Mine is an art of synthesis, of deduction, as Raynal has said.... Cézanne turns a bottle into a cylinder, but I begin with a cylinder and create an individual of a special type: I make a bottle – a particular bottle – out of a cylinder.' Like so many statements from the pens of artists, this is a rather unclear account of his own psychological procedure in composing a picture. His painted bottle is of course a particular in the sense that every painted image is a particular thing; but it is not a recognizable representation of a particular bottle in the world of perceptual reality. This, however, has no great relevance. What I think is clear from his account is that the pictorial structure

is primary, and representation has become a secondary consideration though he does not abandon it.

That this is so can be confirmed from the works of the major Cubists from say 1914 to 1921. Considerations of pictorial structure are predominant. Although figuration is retained, abstractions tend to become stereotyped rather than heuristic and are subordinated to the requirements of composition and over-all pictorial structure. Tension between picture surface and the composed picture image is increased though with little or no increase of interest in expressive properties either of the picture image or of the depicted objects. It is a decorative art in the better sense of the term, and the semantic interest has ceased to predominate.

8
Futurism and the Representation of Movement

The problem of representing movement in a static medium has offered a perennial challenge to painters and sculptors. While the qualities of solid grandeur and monumental gravity have always been sought after, it has also been felt that an art lacking any suggestion of the dynamic movement and fluctuation which are so ubiquitous a feature of the world around us would be lifeless and inert. Artists have therefore tried almost universally to overcome this limitation inherent in their medium and to overcome it in such a way as to turn it to aesthetic advantage. The methods they have devised include techniques of depiction and techniques of composition.

Much primitive art, Far Eastern art, and most art in the Western naturalistic tradition has attempted to convey the idea of movement by depicting figures and objects caught and as it were 'frozen' in a posture characteristic of a familiar movement sequence. Even the art of naïve painters spontaneously adopts this device. Indeed the method of depicting arrested movement has been so ingrained in the naturalistic traditions, both Eastern and Western, that at any rate until recently it came to be accepted as a convention which an experienced observer would automatically discount and of which he might well remain unconscious. Among literally thousands of examples it may be seen in the *Diskobolos* of Myron, the *Alexander Mosaic* and the *Laokoon* from antiquity; in *The Rape of the Sabines* by Giovanni di Bologna, Agostino di Duccio's relief carving *Gideon* and Bernini's *Neptune with a Trident*; in Bruegel's *Der Bauertanz*, Titian's *Bacchus and Ariadne*, and in the gestures and attitudes of Raphael's *School of Athens* and the *Las Meninas* of Velazquez. It is the method used also in innumerable Indian dancing figures, sometimes along with the multiplication of limbs – though the latter was an iconographical device with other connotations as well as the suggestion of movement.

In addition to portraying a figure or other object in arrested movement (semantic suggestion) artists have also sought means to confer apparent or 'virtual' movement on their compositions (syntactical suggestion) by the orchestration of planes and masses, of colours and shapes, in such a way as to cause the spectator's eye to travel along a predetermined path over and into the picture. This virtual movement within the composition – 'dynamic rhythm' as it has sometimes been called – is not the same thing as the depiction of objects frozen in the course of movement and the two devices have often been used

in conjunction to reinforce each other. Notable examples of this are Michelangelo's *The Creation of the Sun and Moon* and *The Origin of the Milky Way* by Tintoretto.

Many of the Impressionists were particularly interested in the depiction of moving things – horses at the gallop, dancers in action, the mechanical movements of boats and trains, the bustling activities of crowds. In this as in other things they made it their aim to transfer the retinal impression directly to canvas and *faute de mieux* they adopted the 'snapshot' technique. But in this field their optical Realism was most patently inadequate to their purpose. It was obvious at the time, and the progress of photography has made it more obvious since, that the reproduction of frozen attitudes of arrested motion, however realistic, cannot convey a convincing impression of actual movement. In a snapshot we know, but we do not see or feel, that the curious pose or gesture represents a momentary stance in a continuous movement sequence. Artists therefore wanted to find better ways of making the spectator *sense* motion instead of merely understanding intellectually that the objects depicted were supposed to be caught in the midst of movement. Instead of the equanimity of classical balance with its 'dynamic rhythms' which carried the eye through and across and within the pictorial structure, later artists sought to impart an inner tension and ambiguity among the structural elements. This inner tension was also called 'dynamism' and was felt to be the same thing as, or at least very close to, the suggestion of movement. Attempts to combine structural dynamism with more realistic ways of depicting moving objects – a combination of semantic and syntactical techniques – culminated in Futurism and the related schools of Rayonism and Vorticism. It was not until about the middle of the century that a widely dispersed and very diverse group of artists, to whose works the term 'kinetic art' has been chiefly applied, abandoned the attempt to represent objects in movement or to impart 'virtual' movement to their works, incorporating instead actual movement in their usually non-representational constructs. Kinetic art belongs to the general category of *concrete* art, which abandons illusion and artifice for the real thing.

Sculptors have also been exercised over the problem of movement and for sculpture the problem is even more intractable than for painting. This is because a piece of sculpture is, traditionally, massive, weighty, voluminous, bound by forces of gravity to the pedestal on

which it stands; and these properties are *sensed* in the process of appreciation. Although a piece of sculpture does create its own virtual space around itself, it does so in a different fashion from a painting; it has actual volume, occupies actual space in three dimensions. And it does not move. It is there, static in real space.

Some sculptors have set great store by the manipulation of planes and masses and contours in such a way as to create an impression of *energy*, a syntactical property which has been described as apparent pressure from within, outwards against the surface skin of the work. Maillol, Bourdelle, Dobson were sculptors who sought this effect. But it is different from the representation of movement – indeed representations of non-moving figures may be given this effect – and it is not the same thing as virtual or syntactical movement. Rodin, a contemporary of the Impressionists, was much concerned with the problem of movement both in his theoretical writings and in his sculptural practice. He thought that the impression of natural movement is achieved in sculpture by catching and 'freezing' the moment when one gesture or attitude is at the point of transition into another. 'Movement', he said, 'is the transition from one attitude to another.' What he had in mind may be seen from the *Walking Man* of 1905 (Musée Rodin, Paris). Different as they are in purpose and conception, the elongated walking figures of Giacometti tend similarly to suggest uncompleted movement or transitional posture.

These are semantic techniques, techniques of representation, and are often combined with a measure of structural dynamism. While the representational techniques are not unimportant, the most effective means of achieving an impression of movement in sculpture has been by the creation of an inner tension, as it were a conflict or suspended balance among the planes and masses into which a structure is analysed. It is this quality rather than being poised on one hoof which imparts the vivid sense of life and movement to the famous Chinese *Flying Horse* from the Han dynasty, of which Mr. Edmund Capon has well said that 'it gives a vivid and tremendous impression of speed and enduring strength'. It may be seen in Degas's *Grande arabesque* (National Gallery of Scotland, Edinburgh). It is this quality which imparts such vital inner energy to Raymond Duchamp-Villon's semi-Cubistic *Horse* and Boccioni's *Unique Forms of Continuity in Space* while it was lacking to such works as Barlach's *The Avenger* and Gilbert Bayes's *Sigurd* at the Tate Gallery.

The representation of movement has sometimes been likened to the creation of 'virtual' picture space, which is incommensurable in shape and size with the pigmented canvas and cannot be co-ordinated with the actual space in which the observer's body and the picture exist. The comparison is mistaken. When we look at a picture we enter imaginatively into the picture space and see perhaps miles upon miles of open country although at the same time with a part of our minds we know that we are looking at a flat canvas, say 60 cm by 80 cm hanging in a closed room. By means of flat marks on a flat ground the artist can fashion his picture space at will: he can give it greater or less depth; make it resemble the actual space we see in everyday life or distort it by variations of perspective; he can give it the curious qualities of dream space as Chirico did, or he can make it appear unreal in other ways, for example by introducing a degree of detail in distant objects inconsistent with ordinary vision – a method adopted by many naïve painters and by some of the New Realists. This virtual space of pictures is, of course, 'unreal' in the sense that it is real only for the eyes. You cannot walk in the streets of a Utrillo or feel with your fingers the coldness of the snow; you cannot submit to measuring devices the objects in a Van Eyck or Vermeer interior or weigh the fish in a Snyders still life. But it is not an illusion. It is a visual reality, seen with perceptual immediacy and not constructed by means of some elaborate and unconscious mental gymnastics. This is of course now a commonplace. The point I want to make here is that there is no direct analogy between this three-dimensional picture space and the representation of movement. Virtual movement would be in a different logical category from virtual picture space. The latter is based on normal principles of perception. As soon as you put a coloured mark on an empty canvas or a black mark on white paper you create visually a representation of a third dimension: the mark seems either to lie above the ground or to extend behind it, being seen through a hole in the ground. The same sort of thing occurs in ordinary life – when we see cracks in a ceiling, marks on a wall, trees in the distance and so on. In ordinary life we are continually having to correct our immediate perceptions by our experiental knowledge of how things are. But with movement the case is different.

Movement involves change *in time*. That is essential to the concept of movement. If there is no change in the course of time there is no movement. And if we do not perceive change within the time that

our perception of an object endures, then there is no perceived movement. When a thing is seen to be different in one perception from a previous one, but we see no process of change in the course of one perception, then we speak of change but not of movement. By movement we usually mean change in respect of spatial location taking place more or less continuously (but not necessarily regularly) over a period of time. But we are also able to speak of movement when the change is other than spatial, for example a sequence of musical sounds or the colour and light changes in neon advertisements. The musician is able to create an artificial or virtual time with its own movements and characteristics quite separate from the 'objective' time within which the performance takes place. The listener enters imaginatively into the virtual time of the music, lives in it as one says, and is 'lost' to real or objective time until the music ends. This possibility is analogous to what happens in ordinary life: the well-known difference between 'inner' and 'outer' time or, as is sometimes said, 'subjective' and 'objective' time. When we are waiting for a friend to arrive the hands of the clock move tantalizingly slowly; when the party is in progress they move unbelievably fast, and when we look at the clock we are unable to credit that so much time has passed. The musician invites us to enter into a new dimension of time which he has divided and organized to his own will by manipulating changes in the sounds presented to our auditory sense. But he can do this only because the sounds do in fact persist through time, there is real change in time; and on the basis of this he can create a new 'virtual' time dimension. But the visual artist has no such recourse. The stimuli he furnishes for perception do indeed persist through time but do not change in time. A picture and a piece of sculpture do not change in the course of being perceived. Therefore there is no way in which virtual movement in virtual time can be created in them. This is a logical impossibility, not merely in empirical difficulty. For this reason the painter and the sculptor who wish to represent movement must search for various analogues or indirect ways of doing so.

One of the things which artists throughout history have tried to do, and which the Futurists believed they had succeeded in doing, was to circumvent the limitations of the medium and find a way of representing movement. They wanted to do this by creating virtual movement visible to the eyes without appealing to literary or intellectual conventions. I may say: 'Let us agree that when I paint a horse

with all four feet off the ground you will understand that I am telling you it is galloping.' Or I may say: 'When I paint a winged figure in the sky with feet higher than its head you will know that I intend it to be an angel (or a witch) in flight.' Or: 'When I paint a ship and high waves and clouds you will understand that I am telling you there is a storm and that the waves and clouds and ship are in violent movement.' If I appeal to any such conventions, I am behaving as a writer rather than a painter. The painter wishes to make the movement visible to the eyes. Therefore painters have sought a mode of abstraction which would enable them by a kind of conjuror's magic to direct the observer's attention upon a movement which is not there.

If one is content with the dynamics of inner tension, the possibilities have been extensively explored. If virtual movement is still the aim, artists have not achieved the impossible and Gabo's criticism of Futurism holds good. In 1920 he said: 'It is obvious now to every one of us that by the simple graphic registration of a row of arrested movements, one cannot recreate movement itself. It makes one think of the pulse of a dead body.'

Futurism

The Futurists with their aggressively vociferous addiction to speed, mechanization, and urban industrialism threw themselves into the problem of depicting motion as if they had invented it and made it a major plank in their artistic programme. Thus, in his First Futurist Manifesto of 20 February 1909, Marinetti called on the young to immerse themselves in the dynamism of the modern age, which for him was symbolized by speed and by the technology of the machine. 'We declare that the world's splendour has been enriched by a new beauty: the beauty of speed. A racing motor car, its frame adorned with great pipes, like snakes with explosive breath ... a roaring motor car, which seems to run on shrapnel, is more beautiful than the *Victory of Samothrace.*' These remained the dominant ideas of the movement so that in 1913 Severini could write: 'We choose to concentrate our attention on things in motion, because our modern sensibility is particularly qualified to grasp the idea of speed.' Much as they learned from the Cubists, the Futurists criticized them for the static quality of their work. The catalogue for the Bernheim-Jeune exhibition of 1912 complained that the Cubists 'persist in painting the immobile,

the frozen, and all the static states of nature; they adore the traditionalism of Poussin, Ingres, Corot, aging and petrifying their art with a passéiste obstinacy which remains absolutely incomprehensible to us'. The artistic programme was made more specific by a *Technical Manifesto of Futurist Painting* dated 11 April 1910, which appeared in French translation in the Paris *Comoedia* of 18 May. Like other Futurist pronouncements it was couched in a turgid style of Messianic enthusiasm not founded upon conceptual clarity. Interpretation is essential but necessarily precarious. Yet it is hardly open to doubt that the concern of the Futurist artist for rendering dynamic movement extended both semantically to the choice of subject-matter (speeding objects) and syntactically to the organization of their compositions – though they did not succeed in distinguishing the two. They were obsessed with a Bergsonian idea of a universal life-force permeating and animating inorganic objects as well as living things and they wished to embody this life-force, which they called 'universal dynamism', into their paintings and render it 'eternal'. 'The gesture for us will no longer be an *arrested moment* of the universal dynamism: it will be specifically the *dynamic sensation* itself made eternal.'

After their contact with the work of the Cubists in 1911 the Futurist painters took over the Cubist techniques of interpenetrating planes and the simultaneous presentation of several aspects of one object in the same picture. But both techniques were adapted to their own very different purposes. Whereas Analytical Cubism had combined different viewpoints of one object primarily for reinforcing the impression of substantial solidarity, the Futurist painters developed a method of incorporating a number of successive positions of an object in continuous movement, or otherwise bringing together positions of moving objects. They called this 'dynamic synthesis' – the technique of showing in one picture successive phases of a continuous movement. Excellent examples of this technique may be seen in Giacomo Balla's *Dinamismo di un cane a guinzaglio* (1912), in which successive positions of the legs, tail and leash of a trotting dog are simultaneously depicted, and in the same artist's *Ritmi dell' archetto* (1912), which shows in one picture successive positions of a violin bow and the violinist's fingers. A variant of this technique, later connected with *aeropittura*, attempted to create an impression of speed by showing apparent movement of the landscape when an observer is in a moving vehicle. In Luigi Russolo's *Treno in velocità* (1911) both techniques are

combined. The impression of a train speeding through the darkness is given as seen from outside by the lighted carriage windows articulated by abstract knife-like wedges, while above the lights in the more distant landscape are blurred and streaky as if seen by a moving passenger in the train.

The *Technical Manifesto* took account of the fact that perception is not instantaneous but extends over a short period of time, called the 'sensory' or 'specious' present, within which interval successive stimli may combine into a single impression. It also took account of the persistence of after-images and claimed that movingobjects are multiplied and distorted in perception and their material consistency is destroyed so that they vibrate and intepenetrate and are not seen in a stable and unified space. 'On account of the persistence of an image upon the retina, moving objects constantly multiply themselves, they are deformed and succeed each other like vibrations in the space they move through.' They may have been influenced too by the developing technique of moving pictures. But the investigations of the Futurists were not scientific. Their facts were wrong. Psychologists now take the view that we perceive movement as a unified pattern not as a construct from a number of successive perceptions of static positions. Thus R.S.Woodworth and D.G.Marquis say in their handbook *Psychology* (1949): 'We perceive the movement as a continuous pattern, and do not perceive the consecutive positions'. And: 'So in a horse's gallop; it is a unit in execution, and when you watch the horse's movement you see the movement as a whole and not as a series of different positions.' Semantically the Futurist technique of depicting objects in movement was not well conceived and not successful. In their use of abstraction to produce a sense of movement in the formal composition they were probably far more effective.

While the Cubists employed their system of faceted planes for the dual purpose of articulating their shallow picture space and 'analysing' the three-dimensional voluminous structure of depicted objects, the Futurists used their planes more loosely to create a generalized impression of restless movement. Sometimes abstraction was carried so far that the object, the semantic content, became practically undecipherable – as in Giacomo Ballà's *Velocità astratta* of 1913, Ardengo Soffici's *Linee e volumi di una strada* (1913), Boccioni's *Dinamismo di un ciclista* (1913) and *Dinamismo di un footballer* (1913), Carlo Carrà's *Ritmi di oggetti* (1912) and *Simultaneità* (1913), and Rus-

solo's *Automobile in corsa* (1913). Their use of sharp, arrow-shaped planes to indicate speed has some affinity with the 'direction signs' sometimes introduced by Paul Klee and other artists. But the most successful of these Futurist paintings do by their formal qualities and their structure create an impression of restless or directional movement more effectively than had been done hitherto.

In the course of 1911 the doctrine of 'dynamic sensation' was amplified by an equally obscure doctrine of 'lines of force' (*lignes-forces*), first expounded in the Bernheim-Jeune catalogue. There it was said that all objects aspire towards infinity by their lines of force 'whose continuity is measured by our intuition'. Allied to this was a doctrine, Bergsonian in origin, of the inner 'emotional' life of insentient objects bound up with our emotional reaction towards them. Objects, it was said,

reveal in their lines calm or frenzy, sadness or gaiety. These diverse tendencies give to their formative lines a sentiment and a character of weighty stability or of airy lightness. Each object reveals by its lines how it would be decomposed according to the tendencies of its forces. This decomposition is not guided by fixed laws, but varies according to the characteristic personality of the object and the emotion of the one who looks at it. Moreover, each object influences its neighbour, not by reflections of light (the basis of Impressionist positivism), but by a real concurrence of the emotion which governs the picture (basis of Futurist primitivism).

The idea of force-lines probably influenced Rayonism. But the rest of this is obscure.

Before leaving the Futurists a word must be said about their use of abstraction in an expressive way to depict 'states of mind'. *La Musica* and *Ricordi di una notte* by Russolo, who inaugurated this kind of painting in 1910–11 are 'autobiographical' in character, uniting memory images and personal associations. But the same artist's *Profumo* (1910), Boccioni's *Luto* (1910), and Carrà's *Nuoto* (1910–11) and *Sobbalzi di un fiacre* (Museum of Modern Art, New York) were attempts to express more generalized states of mind such as the sensation of swimming or the jolting of a cab rather than to give vent to passing emotions being experienced by the artist. This was overtly the intention of Boccioni's three paintings *Stati d'animo* of 1911. He wished them to be regarded as *descriptive* of collective sentiments by which men are united together in the modern world rather than expressive or evocative of particular emotions. Although figurative

elements are not excluded, the expressive or descriptive impact of this group of paintings derives preponderantly from the abstract formal organization. In a letter written in the autumn of 1910 Boccioni said:

> If it shall be in my power (and I hope it is), emotion will be suggested with the smallest possible recourse to the objects which have evoked it. For me the ideal would be a painter who, wishing to suggest sleep, does not lead the mind to the being (man, animals, etc.) which sleeps, but by means of lines and colours could evoke the idea of sleep, that is universal sleep beyond the accidentals of time and place.

The most illustrious picture produced within the ambit of Futurist ideas was not done by a member of the group. It was Marcel Duchamp's *Nude Descending a Staircase No. 2*, which was the runaway sensation of the American Armory Show in 1913. This picture, painted in the winter of 1911–12, reduces the female figure to 'a sequence of rectangular and circular planes whose parallel multiplication represented not a figure in motion but the movement of the figure down and across the picture plane'. It also represents an attempt to translate natural forms into machine-like shapes and anticipates the machine aesthetics which came to the fore in the 1920s. Whether or not Duchamp was influenced by the Futurist pictures (which were not exhibited in Paris until the beginning of 1912), it is the most successful achievement in combining the Futurists' ideas of representing moving things by a kind of cinematic technique with virtual movement within the pictorial structure. It was, of course, also an implicit criticism of the static quality of Analytical Cubism. Douglas Cooper has described this picture as follows:

> Duchamp rejected any suggestion of representing reality and turned the figure into a symbolic but seemingly powerful machine – a sort of descending-machine, in fact – which rattles its metallic structure and devours the staircase as it descends. This second *Nude* is intensely clever but equivocal painting, part serious, part ironical, part revolutionary, owing something both to Futurism and to the cinema, but fundamentally anti-Cubist. For there is no doubt that Duchamp intended to produce an ultra-modern subject-picture which would be understood as an assault on the seriousness and static realism of the Cubist painting of Braque and Picasso, but which would also shake up the Cubist pretensions of his friends.

Rayonism

Rayonism was the creation of two Russian painters, Mikhail Larionov and Natalia Goncharova, between the years 1911 and 1914. The first Rayonist painting, *Glass* by Larionov, was shown in 1911 and the movement was launched at the 'Target' exhibition of 1913, when Larionov issued his Rayonist Manifesto. The style was claimed to be a blending of the structural innovations of Cubism with the dynamism of Futurism, but in fact it was much further removed from Cubism in spirit and in manner than the more solid Cubo-Futurism developed by Malevich between 1911 and 1913. Its most notable feature was a tangle of criss-crossing lines and bundles of lines, which were supposed to represent rays of light reflected from invisible objects and revealing paths of energy. Some of the paintings, such as *Glass* (1911) and *Blue Rayonism* (1912) by Larionov and *Cats* (1911–12) by Goncharova, were taken to such a pitch of abstraction that the subject, if it exists, is not discernible. Others, such as *Rayonnist Landscape* (1912) and *Sea Beach* (1913–14) by Larionov and *The Green and Yellow Forest* (1912) by Goncharova, retain vestiges of representation.

Larionov's Manifesto was written in the bombastic style made popular by the Futurists and is hardly more enlightening about his basic artistic ideas. The substantive portion, as quoted by Camilla Gray in *The Russian Experiment in Art* (1962), runs as follows:

The style of Rayonnist painting promoted by us is concerned with spatial forms which are obtained through the crossing of reflected rays from various objects, and forms which are singled out by the artist. The ray is conventionally represented on the surface by a line of colour. The essence of painting is in-dicated in this – combination of colour, its saturation, the relationship of coloured masses, the intensity of surface working. The painting is revealed as a skimmed impression, it is perceived out of time and place – it gives rise to a sensation of what one may call the 'fourth dimension,' that is the length, width and thickness of colour layers. These are the sole symbols of perception which emerge from this painting, which is of another order. In this way paint-ing parallels music while remaining itself. Here begins a way of painting which may be pursued only following the specific laws of colour and its application to canvas.

Vorticism

The Vorticist movement in England grew out of the Rebel Art Centre founded in 1914 by Wyndham Lewis together with Wadsworth, Etchells, Nevinson, and Cuthbert Hamilton, joined later by Bomberg, Epstein, Gaudier-Brzeska, and William Roberts, and supported by the writers Ezra Pound and T.E.Hulme. Its organ *Blast*, written in a tone of violent propaganda, was denunciatory rather than expository. Like the Futurists, Lewis and his friends criticized the Cubists for their exclusive concern with visual research and representational techniques, the limitation of their subject-matter and their dissociation from the vital interests of contemporary life. Lewis accused Cubism of being a mere 'acrobatics' of visual intelligence and of failure to 'synthesize the quality of life with the significance or spiritual weight that is the mark of all the greatest art'. But the austere objectivity and restraint which characterized Cubist pictorial construction was congenial to the Vorticists, as they were repelled by the 'romantic and sentimental' devotion of the Futurists to mechanized speed. In the excellent summary written by Richard Cork in his introduction to the catalogue of the exhibition 'Vorticism and its Allies' organized by the Arts Council of Great Britain at the Hayward Gallery in 1974, he says:

Vorticist art intended, therefore, to arrive at an original synthesis, poised halfway between the kinetic dynamics of Futurism and the static monumentality of Cubism, and rejecting the French preference for domestic studio motifs as firmly as it replaced the Italians' rapturous worship of mechanical imagery with a more detached, classical approach. Where the Futurists identified themselves unconditionally with the machine, the Vorticists stood back and described in *Blast No.1* how 'we hunt machines, they are our favourite game. We invent them and then hunt them down.' They abhorred the Italians' insistence on multiplying objects to mirror the chaotic speed of modern life. ... Hence the consistent bias in Vorticist art towards precise linear definition, enclosing the most explosive compositions and high-pitched tonal orchestrations in static contours which reflected *Blast No.1*'s proud cry that 'the Vorticist is at his maximum point of energy when stillest.' And so a typical Vorticist design shoots outwards in iconoclastic shafts, zig-zags or diagonally oriented fragments, and at the same time asserts the need for a solidly impacted, almost sculptural order.

The Vorticists anticipated the 'machine aesthetic' which inspired much European Constructivist art. But they created analogues of the precision and autonomous power of the machine rather than attempts

to depict representations of violently speeding cars and trains. They were among the first artists to produce non-iconic abstract paintings as well as carrying abstraction from nature to the limits of recognizability. At the Second Post-Impressionist Exhibition in 1912–13 Lewis showed drawings from his *Timon of Athens* portfolio which may have been the earliest non-representational abstracts in Europe. William Roberts's *Study for Two-Step II* (c.1915) creates an analogue of the hectic energy of the war-time dance by means of abstract forms in which the figural content is no longer discernible. Etchell's gouache *Stilts* (1914–15), Lewis's *Red Duet* (1914), and David Bomberg's *The Mud Bath* all carry abstraction to a point where without the guidance of the titles semantic reference could not be detected. Unmodulated colours are used in strong and energetic contrast and contours are firmly patterned. Besides looking forward to Constructivism in one direction and to a new 'machine aesthetic' in another, Vorticism originated a novel idiom of form combining elements from both Futurism and Cubism in an authentic synthesis which might have had important possibilities of development if the war had not intervened.

Purism

At the beginning of the 1920s there emerged a new concept of aesthetics, which swept on one side both the Expressionist and the Realist traditions. It corresponded to an outlook which was fundamental to machine aesthetics and Constructivism and it links up with the spirit which inspired the new functionalism in architecture and the teachings of the Bauhaus. Its protagonists were Amédée Ozenfant and the Swiss painter and architect Charles-Édouard Jeanneret, who from 1921 took the name Le Corbusier. Their aesthetic theory was known as Purism.

In *Foundations of Modern Art* (1931) Ozenfant tells how after 1916 he 'felt that Cubism was slipping into decorative art' and promulgated his views in his review *L'Élan*, which appeared from 1915 to 1917. He met Jeanneret in 1917 and in 1918 began an association with him which lasted until 1925. The purpose of their collaboration was a 'campaign for the reconstruction of a healthy art'. In 1918 they issued a book *Après le cubisme*, in which they 'affirmed that art must tend always to precision and . . . laid down the foundations of a Purism that would . . . inoculate artists with the new spirit of the age'. They

attached 'especial importance to the lessons inherent in the precision of machinery and the imminent metamorphosis that must result therefrom'. In 1920 they founded the journal *L'Esprit Nouveau* to give wider publicity to their views and in 1924 published *La Peinture Moderne*, which Ozenfant describes as 'a résumé of the *L'Esprit Nouveau* campaigns'. In 1931 Ozenfant wrote: 'What ten years ago seemed hypothetical in our writings has now come to realisation: or more truly is not even realised, so accustomed have we grown to it. ... The necessity for order, the only efficiency, has brought about a beginning of that geometrisation of the spirit which more and more enters into all our activities.' Typical of their outlook were the assertion that 'the spirit of construction is as necessary for creating a picture or a poem as for building a bridge' and Jeanneret's often quoted aphorism that 'a house is a machine for living in'.

Ozenfant and Jeanneret were very much in the swim. They were effective because they represented an attitude which had already taken a firm hold in many of the arts and they became the mouthpiece for a powerful trend of opinion in opposition to the anti-intellectualism of Dada and Surrealism. The influence of *L'Esprit Nouveau* was important because it succeeded in bringing together personalities from several of the arts with writers, critics, and aestheticians. These included Louis Aragon, André Breton, Roger Bissière, Blaise Cendrars, Jean Cocteau, Paul Éluard, Charles Lalo, Maurice Raynal, Max Jacob, Eric Satie, Darius Milhaud, Carlo Carrà, Tristan Tzara.

The clearest and most succinct formulation of the principles of Purism is to be found in an essay 'Le Purisme' which appeared in the fourth number of *L'Esprit Nouveau*. The essay deals with both general aesthetic considerations and principles of pictorial composition. The general considerations have such a wide import that a summary of them is given here.

Purism is a rational system of aesthetics based upon universal constants of human response: 'Nothing is worth while which is not general, nothing is worth while which is not transmittable. We have attempted to establish an aesthetics that is rational, and therefore human.'

The highest form of aesthetic experience is intellectual apprehension of order:

With regard to man aesthetic sensations are not all of the same degree of intensity or quality; we might say that there is a hierarchy. The highest level

of this hierarchy seems to us to be that special state of a mathematical sort to which we are raised, for example, by the clear perception of a great general law (the state of mathematical lyricism, one might say); it is superior to the brute pleasure of the senses; the senses are involved, however, because every being in this state is as if in a state of beatitude. ... It is true that plastic art has to address itself more directly to the sense than pure mathematics which only acts by symbols, these symbols sufficing to trigger in the mind consequences of a superior order; in plastic art the senses should be strongly moved in order to predispose the mind to the release into play of subjective reactions without which there is no work of art, but there is no art without having this excitement of an intellectual order, of a mathematical order ...

In art man is able to realize his own participation in the order of nature: 'One of the highest delights of the human mind is to perceive the order of nature and to measure its own participation in the scheme of things; the work of art seems to us to be a labour of putting into order, a masterpiece of human order. ... In summary, a work of art should induce a sensation of a mathematical order and the means of inducing this mathematical order should be sought among universal means.'

Perceptions were divided into constants, which were said to be invariant from man to man, and secondary perceptions, which vary according to a man's innate and cultural endowment. The invariant perceptions are our perceptions of primary shapes, primary colours, and primary lines; the secondary and variable perceptions arise from our associations. For example, if a European and a Papuan are shown a cube marked with black geometric spots, both have the same perception of the primary form of a cube. But this may release in a civilized man the idea of a die to play with, whereas the Papuan would see only ornament. It is the primary perceptual invariants which supply a universal and transmittable plastic language: 'Primary sensations constitute the bases of the plastic language; these are the fixed words of the plastic language; it is a fixed, formal, explicit, universal language determining subjective reactions of an individual order which permit the erection on these raw foundations of a sensitive work, rich in emotion.'

Experimental aesthetics has investigated inconclusively whether there are universal, constant reactions to simple colours and shapes, as Seurat, Kandinsky, and other artists believed. But what these artists, and the psychologists, had in mind were emotional responses to

the elements from which works of art may be constructed. The concept of Purism was different. Purism envisaged a work of art as an ordered system constructed from elements the perception of which is constant and invariable, modified only by the needs of pictorial composition, considerations of optical interaction, optical illusion, etc. Our emotional response would be to the apprehension of order not an amalgam of subjective emotions aroused by the constituent elements. This or something like this has been the fundamental assumption implicit to most forms of Constructivism.

Although these theories were the implicit basis of Constructivism, Ozenfant and Jeanneret themselves believed that without semantic content they would lead only to an ornamental art, 'rich in geometrical aspects' but 'denuded of all sufficient human resonance'. It was necessary for art to have 'theme-objects . . . rich in subjective trigger action'. And those theme-objects should be chosen whose 'secondary trigger actions are the most universal'. Such objects are the basic consumer goods – containers, weapons, musical instruments, objects for transport – because by a process of 'mechanical selection' in the march of evolution their basic shapes have been adapted to function with the maximum of economy and efficiency: 'It is by the phenomenon of mechanical selection that the forms are established which can almost be called permanent, all interrelated, associated with human scale, containing curves of a mathematical order, curves of the greatest capacity, curves of the greatest strength, curves of the greatest elasticity, etc. These curves obey the laws which govern matter. They lead us quite naturally to satisfactions of a mathematical order.' The mass-produced objects of modern machine culture were said to belong to the same formal category: 'The machine has applied with a rigour greater than ever the physical laws of the world's structure . . . If blind nature, which produces eggs, were also to make bottles, they would certainly be like those made by the machine born of man's intelligence.'

In dealing with this subject-matter the artist should not aim at Perceptual Realism, which 'appeals nearly exclusively to sensations of a secondary order and is consequently deprived of what could be universal and durable'. Still less should he employ arbitrary or fanciful abstraction as did the Synthetic Cubists. He should abstract in such a way as to give prominence to the constant and unvarying functional shapes which are inherent in machine-made consumer goods. 'It is by a skilful, synthesizing figuration of these invariable elements that

the painter will, upon bases of primary sensations, make his disposition of secondary sensations that are transmittable and universal: the "Purist" quest.' And this too is as good a theoretical foundation for machine art as has usually been advanced.

Within the ambit of German Expressionism, but dominated by the Russian, Kandinsky first germinated the seeds of non-iconic Expressive Abstraction, which sought to exploit the universal expressive characteristics of forms divorced from the representation of concrete things. In a similar way the more general tenets of Purist theory anticipated what was the central doctrine of Constructivism, that aesthetic response is an emotional apprehension of order whose elements are not themselves either iconic or fraught with expressive characteristics. The more particular doctrine that artists should abstract for the purpose of giving prominence to the typical forms of traditional utility objects or modern machine-made products had little influence outside Purism itself.

Constructivist Abstraction

9

Non-Iconic Abstraction and Kandinsky

From semantic abstraction we now turn to non-iconic abstraction, which came more and more to occupy the centre of the stage from the 1920s until the end of the 1950s. There are three major modes on non-iconic abstraction, each of which was prolific of related schools and styles. These modes are: (1) Expressive Abstraction, whose most widely bruited manifestations have been the New York school of Abstract Expressionism and its European counterparts, Tachism, *art informel*, lyrical abstraction, gestural art, etc.; (2) International Constructivism together with its post-war sequels within the ambits of Minimal Art; and (3) Concrete art, which from one point of view is not abstraction at all and from another is the most radical abstraction of all.

Non-iconic abstraction, it will be recalled, covers those works of art which are without representational significance. They do not carry or contain any reference to things or events outside the work of art itself and they do not result from incomplete specification, that is the elimination of detail in the depiction of natural appearances. They do not depict.

Expressive Abstraction denotes works whose primary interest derives from their expressive characteristics, whether these are claimed to reflect emotional states of the artist or not. They do not reflect expressive characteristics of natural scenes, objects or events, i.e. they are not a branch of Aspect Realism. They are not a kind of Realism at all since they carry no objective reference. Their impact derives from the expressive characteristics inherent in the picture image and often goes with intense emotional attachment to the expressive characteristics of pigment colours from Kandinsky through Abstract Expressionists to Colour Field painters.

Constructivist art deliberately plays down expressive and emotional characteristics of the picture image and the physical materials. Hence it prefers an impersonal finish to a facture which emphasizes sensuous appeal and prefers to construct from neutral elements, i.e. parts which are free from any associative or intrinsic emotional appeal. For this reason the parts are usually geometrical or quasi-geometrical and it is therefore known as Geometrical Abstraction. It aims to construct from such elements a unified Gestalt or configuration which shall exercise and expand perceptual activity.

Historically, the idea of Expressive Abstraction was earliest in the field and evolved along two paths. On the one hand it was thought that decoration could be elevated into an autonomous art by rendering

it expressive, and on the other hand many people theorized that just as music is a non-semantic structure of expressive sounds, so there could be a non-iconic art of coloured shapes expressly organized into aesthetic compositions. These ideas were germinating before the turn of the century. In 1890 August Endell, a *Jugendstil* sculptor and designer working in Munich, spoke of an art 'which stirs the human soul through forms which resemble nothing known, an art which resembles nothing and symbolizes nothing, which works solely through freely invented forms, like music through freely invented notes'. Adolf Hoelzel (1855–1934), born in Czechoslovakia and trained at the Academy in Vienna, who settled at Dachau and later became head of the Stuttgart Academy, was evolving his own colour system by 1895 and over the years came very close to non-iconic colour abstraction. In 1917 he began a series of compositions on the theme of 'coloured sounds', which were to exemplify his concept of an 'absolute art' with music as its paradigm. The decorative painter Hans Schmithals, who also worked in Munich, was producing what could be regarded as decorative abstracts from 1900 although, as in all such work, it is difficult to decide whether his pictures are genuinely non-iconic or whether they are highly stylized formulations of ultimately naturalistic decorative motifs. The eccentric Lithuanian artist Nikolojus Konstantas Čiurlionis (1875–1911), who lost his reason about 1908 and died insane, has sometimes been regarded as the forerunner of this type of abstraction. Trained as a musician and self-taught as an artist, he took up painting about 1905 with the hope of being able to express in paint the transcendental ideas he had been unable to express in music. He conceived his paintings as abstract musical compositions whose lines represented melodies, their colour gradations pitch, their curves tempi, etc., and he named them fugues and sonatas. They were largely indebted to the decorative manner of the *Jugendstil* and they say little to us today, although the artist wanted their forms to be expressive of transcendental cosmic forces. Perhaps the earliest artist to produce genuine colour abstracts with expressive overtones was Augusto Giacometti, uncle of the more famous sculptor Alberto Giacometti.

The idea of non-iconic abstraction was much in the air during the second decade of the century and a variety of short-lived experiments was initiated. Although he never entirely banished representation, Boccioni had grasped the idea of expressive abstraction when he wrote

in a letter of 1910 that his ideal was an art which would express the idea of sleep without depicting any sleeping thing. His *Stati d'animo*, painted in 1911, came very close to this. The expressive mood is created by abstract forms which do not derive from natural appearances and the vague suggestions of semantic content are subsidiary to these. About the same time an American painter, Arthur Dove, who had known *avant-garde* French artists between 1907 and 1909, began to do non-representational compositions conveying the expressive qualities of landscape as in his *Abstract Number 2* at the Whitney Museum of American Art. This was painted about 1911, and he continued to do non-iconic abstracts although he also painted pictures with residual suggestions of representation such as his well-known *Fog Horns* (1929), whose forms were supposed both to echo the mournful sound of fog horns and to suggest their shapes. He wrote: 'I should like to take wind and water and sand as a motif and work with them, but it has to be simplified in most cases to colour and force lines and substances just as music has done with sounds.'

Picabia made the occasional abstract from 1910 and within the orbit of Cubism Léger experimented briefly with non-iconic abstraction in 1913 and 1914 in a series entitled *Contrasts of Forms*. The Puteaux circle of artists, who met informally at the studio of Jacques Villon between the years 1911 and 1914 and who gave birth to the Section d'Or movement, were interested in the mathematical basis of composition and believed that Cubism should be developed in the direction of non-representational abstraction. It was the analogy of music, experiments with the colour organ and the 'colour music' of Scriabin, which influenced the Czech member of the group, Frank Kupka, in working out a personal system of colour combination with the intention to 'liberate colour from form'. In 1912 Robert Delaunay began his systematic experiments with colour discs, applying the colour theories of Eugène Chevreul, while the expatriate American artists Patrick Bruce, Stanton Macdonald-Wright, and Morgan Russell inaugurated the parallel movement which they called Synchromism, although they did not produce non-representational abstracts until later. In England Wyndham Lewis exhibited non-representational abstracts in 1911 and the Vorticists continued to produce non-iconic abstracts alongside their characteristic modes of semantic abstraction. As yet, however, the distinction between geometrical and expressive non-iconic abstraction lay still in the future. The cylindrical shapes

of Léger were imposed upon natural appearances but were themselves derived from machine forms and in their abstract rhythmic combinations were intended to function as an expressive analogue for the dynamism of modern life, though their impact was often heavy and static. Unlike the musically expressive abstractions of Kupka, the *Fenêtres* of Delaunay must be seen as lying somewhere between Aspect Realism and the aesthetic or decorative abstraction of his *Formes circulaires*. Both the semantic abstractions of the Synchromists at this time and their later non-iconic abstractions were more in the manner of decorative than of expressive abstraction.

Meanwhile semantic abstraction was pursued to a variety of purposes. Each school had its preferred forms and schemata, which were *imposed* upon natural appearances so that its representational style was not impartial but approximated towards these 'ideal' forms. The rounded shapes of Léger were characteristically different from the faceted planes of Picasso and Braque; the forms of the Vorticists were different from those of the Analytical Cubists as were both from those of the Russian Cubo-Futurists and the Cubist-Realists of America. In all these styles the interest in producing an aesthetic composition with 'syntactical' appeal came to be as strong as, or even stronger than, the semantic interest in depiction. As may be seen particularly clearly in some of the major work of the Vorticists, the distinction between semantic abstraction and non-iconic abstraction was unimportant and the main interest lay in producing a characteristic composition of forms. It would therefore seem logical that representation should be abandoned in favour of free abstract composition. And this step was in fact taken. But it did not come easily or quickly. The final step required a change in psychological outlook which was delayed until the 1920s.

As a technique of Perceptual Realism Cubism was tied to representation. As has been said, in their book *Cubisme* Gleizes and Metzinger supported the current view that the time had not yet come for non-iconic abstraction, and none of the major Cubist painters entirely abandoned representation until much later. In England Clive Bell's doctrines of 'significant form', supported by Roger Fry and the Bloomsbury school, might well have become a theoretical justification for non-iconic abstraction; but in critical appreciation this group did not advance beyond Post-Impressionism and stood aloof from the more radical movements of the early 1930s. When Kandinsky and his

friends broke away from the *Neue Künstlervereinigung* at Munich on the issue of Expressive Abstraction and formed the Blaue Reiter, the *Künstlervereinigung* published *Das Neue Bild* by Otter Fischer, in which he said: 'A painting is not only expression but also representation. It does not express the soul directly but in an object. A painting without object [i.e. 'non-objective'] is senseless. ... A few colours and dabs, a few lines and blotches, are by no means art.' Even in 1920 Ozenfant and Jeanneret, although they had achieved a theoretical outlook which might well have served as a basis for Constructivist abstraction, still believed that art without semantic content, without objective representation, would lack the necessary appeal which they called 'human resonance'.

The breakthrough nevertheless came in the 1920s and non-iconic art – what Kandinsky and Malevich called 'non-objective art' – proliferated in a bewildering variety of forms.

Kandinsky

By his work and his writing Kandinsky stands out as the prophet and pioneer of Expressive Abstraction. His non-figurative painting probably dates from 1910[1] and in the same year he wrote *Über das Geistige in der Kunst*,[2] which set out the conclusions he had reached after several years' reflection about the nature of art and of non-iconic abstraction in particular. But at a time when non-figurative art in general was still a novelty provoking the keenest controversy, the distinction which is now apparent between Expressive and Geometrical

[1] A gouache, a preliminary study for *Composition VII* of 1913 is dated 1910 and is usually referred to as the 'first abstract watercolour'. But in a review of Will Grohmann's *Kandinsky. Life and Work* Kenneth Lindsay argued not entirely convincingly that this was misdated by the artist and was done in 1913. As was apparent from the large Kandinsky exhibition organized by the Haus der Kunst, Munich, in 1977, from 1910 onwards simultaneously with semantic abstraction Kandinsky was experimenting in the direction of non-iconic abstractions, some of which contained vaguely apocalyptic figurative suggestions while others derived from the brushwork and facture discernible in the backgrounds of his earlier figurative paintings. The idea of non-iconic abstraction was certainly present from about 1910 and the exact date of the earliest surviving work in this category is relatively unimportant.

[2] *Über das Geistige in der Kunst*, written 1910, was published in Munich in 1912. A Russian translation of part of it was published in Moscow in 1913. An English translation by Michael Sadlier, authorized by Kandinsky, was published in 1914, with the title *The Art of Spiritual Harmony*. A new version, authorized by the artist's widow, Mme Nina Kandinsky, was published in 1947 with the title *Concerning the Spiritual in Art*.

abstraction lay well in the future, and a good deal of what he says in this pamphlet is applicable to non-iconic art in general. Most of the ideas and motivations which have given shape and direction to later schools of Expressive Abstraction are here in embryo. But the views which he expresses on the function of non-iconic abstraction to mirror fundamental cosmic laws and reflect the structure of a super-sensuous Reality are closely parallel to ideas which were later formulated by the great masters of Constructivist abstraction such as Malevich and Mondrian. His work, too, stands midway between the two types of abstraction. While the great masterpieces of the early period display characteristics of both Expressive and Aesthetic abstraction, much of his work from the period of his later association with the Bauhaus has the character of loosely constructed Geometrical abstraction.

Wassily Kandinsky was born in Moscow in 1886. He studied jurisprudence and political science at Moscow University and he was also an accomplished amateur musician. In 1896, at the age of thirty, he abandoned a brilliant academic career and settled in Munich to become a painter. His early painting (the most interesting collection of which is to be seen at the Lenbachhaus, Munich) reveals a fascinating blend of the Jugendstil version of Art Nouveau, which at that time was in the ascendant at Munich, with traditional Russian religious art and a spice of the fantasy of Russian folk art. In his autobiographical *Rück-bliche*[3] Kandinsky shows the path by which he advanced from this early work towards abstraction. It is a personal account of the artist's own psychological history, not a theoretical defence of abstraction. But Kandinsky's experience was not unique. It is the prototype of the path which many artists have subsequently traversed, and this intimate account, in conjunction with the more theoretical *Über das Geistige in der Kunst*, offers invaluable insights for understanding what abstract painting is about, what its motivations are and what have been the ideas which, rightly or wrongly, have been chiefly associated with it. As the most important champion and forerunner of non-iconic abstraction, before the parting of the ways, Kandinsky requires to be studied in depth.

As he himself records, Kandinsky was unusually sensitive to the emotional associations of colours from very early childhood. He had

[3] *Rückbliche* was published in Berlin by Herwarth Walden in 1913. An English translation under the title *Retrospects* was published for the Guggenheim Museum's memorial exhibition in 1945.

strongly developed gifts of synaesthesia and associated particular colours with smells and with musical sounds. They had characters of their own and they remained vividly in his memory over long periods of years. Because he found it impossible to reproduce in painting the colours which moved him so profoundly he reached the conclusion, by a kind of intuitive leap rather than by logical thought, that art and nature are two separate 'worlds', with different principles and different aims. And from this he came logically to a belief in the 'autonomy' of art – the belief that a work of art stands or falls by inherent aesthetic principles, not by any resemblance to the outside world – although he did not immediately take the further step to the assumption that art need not, or should not, be representational, that it should not depict the world of things.

The following description of Moscow at the hour before sunset as he remembered it many years afterwards shows the intensity of Kandinsky's feeling for colours:

Pink, lavender, yellow, white, blue, pistachio green, flame-red houses, churches – each an independent song – the raving green grass, the deep murmuring trees, or the snow, singing with a thousand voices, or the allegretto of the bare branches, the red, stiff, silent ring of the Kremlin walls and above, towering over all like a cry of triumph, like a Hallelujah forgetful of itself, the long, white, delicately earnest line of the Uvan Veliky Bell Tower. And upon its neck, stretched high and taut in eternal longing to the heavens, the golden head of the cupola, which is the Moscow sun amid the golden and coloured stars of the other cupolas. To paint this, I thought, would be the most impossible and the greatest joy of the artist.

He goes on:

These impressions ... were a pleasure which shook me to the bottom of my soul, which raised me to ecstasy. And at the same time they were a torture because I felt that art in general and my powers in particular were far too weak in the face of nature. Many years were to pass before I came to the simple solution, through feeling and thinking, that the aims (and thus the means) of nature and art are essentially, organically, and by universal law different from each other – and equally great and equally strong. This solution, which today guides my work, which is so simple and utterly natural, does away with the unnecessary torture of the vain task that I had inwardly set myself in spite of its unattainability; it banished this torture, and as a result my joy in nature and art rose to untroubled heights.

It was through his strong feeling for the individual character of pigment colours that he came to apprehend the autonomous world of art. Of pigments he wrote:

A pressure of the fingers and jubilant, joyous, thoughtful, dreamy, self-absorbed, with deep seriousness, with bubbling roguishness, with the sigh of liberation, with the profound resonance of sorrow, with defiant power and resistance, with yielding softness and devotion, with stubborn self-control, with sensitiveness, unstableness of balance came one after another these unique beings we call colours – each alive in and for itself, independent, endowed with all necessary qualities for further independent life and ready and willing at every moment to submit to new combinations, to mix among themselves and create endless series of new worlds . . .

Thus these sensations of colour on the palette . . . became experiences of the soul.

Thus the realm of art drew farther and farther apart from the realm of nature for me, until I could thoroughly experience both as independent realms . . .

Thus did I finally enter the realm of art, which like that of nature, science, political forms, etc., is a realm unto itself, is governed by its own laws proper to it alone, and which together with the other realms ultimately forms that great realm which we can only dimly divine.

Kandinsky records two outstanding experiences which made upon him the impact of a revelation in his development from a representational idea of artistic function to his conviction of the primary importance of the expressive qualities inherent in formal properties. The first of these was caused by Monet's painting *Haystack*, which he saw in an exhibition of the Impressionists. He wrote:

Previously I had known realistic art only, in fact exclusively the Russians, having often stood for long periods before the hand of Franz Liszt in the portrait by Repin, and the like. And suddenly for the first time I saw a *painting*. That it was a haystack the catalogue informed me. I could not recognize it. The non-recognition was painful to me. I considered that the painter had no right to paint indistinctly. I dully felt that the object of the picture was missing. And I noticed with astonishment and confusion that the picture not only draws you but impresses itself indelibly on your memory and, completely unexpectedly, floats before your eyes even to the last detail. All this was unclear to me, and I could not draw the simple conclusion of this experience. But what was entirely clear to me was the unsuspected power of the palette, which had up to now been hidden from me, and which surpassed all my dreams. Painting acquired a fairy-tale power and splendour. And unconsciously the object was discredited as an indispensable element of a painting.

The other experience was occasioned by the unexpected sight of one of his own paintings in circumstances which momentarily concealed its semantic content.

I was once enchanted by an unexpected view in my studio. It was the hour of approaching dusk. I came home with my paint box after making a study, still dreaming and wrapped up in the work I had completed, when suddenly I saw an indescribably beautiful picture drenched with an inner glowing. At first I hesitated, then I rushed towards this mysterious picture, of which I saw nothing but forms and colours, and whose content was incomprehensible. Immediately I found the key to the puzzle: it was a picture I had painted, leaning against the wall, standing on its side. The next day I attempted to get the same effect by daylight. I was only half successful: even on its side I always recognized the objects, and the fine finish of dusk was missing. Now I knew for certain that the object harmed my paintings.

In Kandinsky's case these experiences were particularly vivid. But in a less dramatic form they are very familiar to twentieth-century artists who have come to the conclusion that the syntactical (compositional) and expressive aspects of a work of art are more important than its semantic content, or even that representation of things is a distracting feature which interferes with attention to the syntactical aspect and should be abolished in order to enhance the expressive qualities inherent in pictorial forms.

In the more theoretical *Über das Geistige in der Kunst* Kandinsky is eloquent for the primacy of the expressive and compositional aspects of art although he does not explicitly condemn representational art *in toto*. He distinguishes the 'inner' and the 'outer' elements of a work of art. By 'inner' he meant the affective or expressive content, describing it as an 'emotion in the soul of the artist' which evoked a 'similar emotion in the observer'. The 'pure' artist seeks to express only 'inner and essential' feelings and ignores the superficial and fortuitous. As art matures in the course of time the artist attempts to express 'more refined emotions, as yet unnamed'. The final goal is the 'substance which only art can comprise, which only art can clearly express by those means of expression that are proper to it'. It is this unique mode of expressiveness, inherent in composition, which is the common element uniting the genuine art of all ages. Progress in art consists in the enhancement of this element and its purification from distracting features. 'The process in the development in art consists of the

separation of its quintessence from the style of the time and the elements of personality.' Such art, he declared, achieves the 'eternal'.

Kandinsky similarly distinguished between the 'purely physical' and the 'spiritual' effects of colours and shapes apart from their semantic significance. The 'physical effect' comprises the direct sensory qualities and the immediate expressive characteristics of colour and shape. On colour:

> In the first place you receive *a purely physical effect*, namely the eye itself is enchanted by the beauty and other qualities of colour. You experience satisfaction and delight, like a gourmet savouring a delicacy. Or the eye is stimulated as the tongue is titillated by a spicy dish. But then it grows calm and cool, like a finger after touching ice. These are physical sensations limited in duration. They are superficial, too, leaving no lasting impression behind if the soul remains closed.

Shapes also have their expressive characteristics:

> Form alone, even though abstract and geometrical, has its internal resonance, a spiritual entity whose properties are identical with the form. A triangle ... is such an entity, with its particular spiritual perfume. In relation to other forms this perfume may be somewhat modified, but it remains in intrinsic quality the same, as the scent of the rose cannot be mistaken for that of the violet. The case is similar with a circle, a square or any conceivable geometrical figure.

The intrinsic expressive properties are called 'internal meaning' and 'inner resonance'. But it is only in combination, that is in an aesthetic composition, that they produce a 'spiritual vibration', and 'it is only as a step towards this spiritual vibration that the physical impression is of importance'.

For Kandinsky composition was the be-all and end-all of genuine art. In *Rückblicke* he said: 'The word "*composition*" moved me spiritually, and I later made it my aim in life to paint a "*composition*". This word affected me like a prayer. It filled me with awe.' In *Über das Geistige* he explains that: 'Beauty of form and colour is no sufficient aim by itself ... we have reason to hope that the hour of pure composition is not far away.' It is by composition that the artist fulfils his function – 'the purposive vibration of the human soul'. And the principle of good composition he calls 'the principle of internal necessity'. 'All means are sacred which are called for by internal

necessity. All means are sinful which are not drawn from inner necessity. That is beautiful which is produced by internal necessity, which springs from the soul.'

Kandinsky gave both a subjective and an objective significance to 'inner necessity'. It meant both that a work of art should be a genuine expression of the artist's personality, as moulded by the spirit of his age, but also that it conform to the eternal 'quintessence' of art. Subjectively he maintained that a work of art should be composed intuitively on the basis of a very full understanding of the sensory and expressive properties of its elements, not worked out by logical reason; that it should be spontaneous and not based on accepted conventions. But from the objective point of view he seems to have believed that a genuinely aesthetic composition would be in conformity with cosmic laws and that appreciation of a work of art so composed brought artist and observer into direct cognitive contact with a reality more ultimate than the world of appearances. Kandinsky was a follower of the teachings of Theosophy and what he had to say about this is far from clear. Its relevance is difficult to judge. But that he did believe that art mediates knowledge in some transcendental sense seems not to be in doubt. He said: 'The spiritual life to which art belongs, and of which it is one of the mightiest agents, is a complex but definite movement above and beyond, which can be translated into simplicity. This movement is that of cognition.'

There is an obvious affinity between this aspect of his thinking and the transcendental beliefs of the Symbolists. But whereas the latter believed that by simplifying the representations of nature an artist could reveal transcendental truth, of which nature was a 'symbol', Kandinsky thought of composition rather in terms of a harmony among the intrinsic qualities of the pictorial shapes and colours independently of any semantic reference they might have. If a painting *was* representational, then the choice of subject was also to be subordinate to his principle of 'inner necessity'. 'It is clear, therefore, that the choice of an object (i.e. one of the elements of form) must be decided by a purposive vibration in the human soul; therefore, the choice of the object also originates from the principle of internal necessity.'

For a book meditated upon and written in the midst of controversy, *Über das Geistige* adopts a surprisingly moderate tone on the question of non-iconic abstraction. Sometimes Kandinsky clearly looks forward to an expressive art devoid of semantic reference as the threshold for

the next great advance towards art's 'purification'. At other times he is hesitant. The following passages are indicative of his attitude.

A painter who finds no satisfaction in mere representation, however artistic, in his longing to express his internal life, cannot but envy the ease with which music, the least material of the arts today, achieves this end. He naturally seeks to apply the means of music to his own art. And from this results the modern desire for rhythm in painting, for mathematical, abstract construction, repeated notes of colour, setting colour in motion, and so on. ... Painting is still almost exclusively dependent on natural forms and phenomena. Its business now is to test its strength and means, as music has done for a long time, and then to use its powers in a truly painterly way, to a creative end.

The freer the abstract form, the purer and more primitive the vibration. Therefore in any composition where corporeal form seems superfluous it may be replaced by abstract or semi-abstract form.

It is because our painting is still at an elementary stage that we are so little able to be moved by wholly autonomous colour and form composition. ... When we remember, however, that spiritual experience is quickening, that positive science, the firmest basis of human thought, is tottering, that dissolution of matter is imminent, we have reason to hope that the hour of pure composition is not far away. The first stage has arrived.

Yet he can also say:

Must we then altogether abandon representation and work solely in abstraction? The problem of harmonising the appeal of the concrete and the abstract answers this question. ... To deprive oneself of this possibility of causing a vibration would be reducing one's arsenal of means of expression: anyhow, that is the case today.

From what has been said of the combination of colour and natural form, the way to a new art can be traced. Today there are two dangers. One is the completely abstract use of colour in geometrical form (danger of degenerating into purely external ornamentalism): pure patterning. The other is a more naturalistic use of colour with concrete form (danger of shallow fantasy). Thus we reach either pure abstraction (more thoroughgoing even than geometrical form) or pure naturalism. Either of these alternatives may in their turn be exaggerated.

He concludes:

I should like to remark finally that in my opinion we are fast approaching a time of reasoned and conscious composition, in which the painter will be proud to declare his work constructional – this in contrast to the claim of the

impressionists that they could explain nothing, that their art came by inspiration. We have before us an age of conscious creation, and this new spirit in painting is going hand in hand with thought towards an *epoch of great spirituality*.

Kandinsky himself, of course, followed the path of non-iconic abstraction. Although he set such store by expressive qualities, he initiated a number of formal idioms which have become part of the general vocabulary of modern abstract painting, and he achieved a precision in their use which perhaps no other abstract painter has surpassed and few have equalled. The most important of these were a new vocabulary of space and a new idiom of movement. He was helped towards his extraordinary mastery in both of these by the researches into the more recondite sensory properties of colour and shape which are described in *Über das Geistige in der Kunst* and in his later book *Punkt und Linie zu Fläche* (1928).

In the conventions of Western naturalistic art, as these were systematized at the Renaissance, the picture image is taken to represent a portion of space delimited by the horizontal plane of the earth's surface bisected at right angles by the picture plane. This section of space is articulated by linear perspective with diminution in the size of objects at a distance and the convergence of parallel lines in recession from the eye, a 'centric' vanishing point for orthogonals. This is not the only method of perspective that can be adapted to pictorial needs. Chinese painting, for example, traditionally adopts what is called 'parallel perspective' in which parallels in recession are drawn as parallels, taking for granted a 'wandering eye' and a high viewpoint. The Cubists and others modified Renaissance perspective by artificially reducing depth in the manner of relief sculpture, emphasizing the importance of the picture plane. But Kandinsky's innovations were far more drastic. With the abandonment of representation the picture space no longer represented a quarter sphere bounded by the plane of the earth's surface and the picture plane but a complete sphere unlimited in all directions, drawing the observer into the picture like an astronaut in deep space. Geometrical perspective has disappeared. Instead he organized his picture space by a very precise manipulation of the more recondite sensory properties of colours and shapes. He made use of the properties of different colours to approach or recede from the observer, to expand or contract, and so on. Making unconscious use of the Gestalt principle which confers identity even on

non-representational shapes, he was able also to articulate his space by overlapping and partially overlapping forms, sometimes transparent or semi-transparent, and by the contrast of clearly defined ('bared') and suggested ('veiled') forms which he had mentioned in *Über das Geistige*. There is nothing casual and rarely anything ambiguous in the articulation of a Kandinsky composition.

His other most important contribution was the creation of virtual movement without the depiction of moving things. From about 1920 he was able to impart movement to his canvases in a manner and to a degree which had not been realized hitherto. Sometimes the elements swirl and oscillate throughout the picture space, sometimes a few elements move against a static structural background, sometimes a portion of virtual space drifts and flows through a motionless background. By a subtle and precise contrast of intrinsic properties of his elements he could control not only direction, but almost as it were the speed of apparent movement.

In thinking of Kandinsky as the pioneer of Expressive Abstraction it is easy to exaggerate the lyrical and impulsive character of his work. Werner Haftmann, for example, has written:

Kandinsky's abstract painting meant not only a radical shift to the images that rise to the eye from the precincts of the soul and not only an artistic turn from the recognition of things to the recognition of the palette and its magical powers of communication; it meant also a complete negation of the fatal tension that had entered into the human mind when it began, for the first time since the Renaissance, to harbour doubts as to the solidity of things. Kandinsky effaced the world of things, denied the confrontation, averted his eyes. For him painting was no longer a dialogue between man and his environment; it was man's dialogue with his inner world, which could now be communicated without recourse to the configured symbols of the outside world.

Expressive Abstraction is not necessarily or always a spontaneous, improvisatory upwelling of unrehearsed forms from the unconscious levels of the mind. On the basis of a penetrating and profound study of the more recondite and expressive properties inherent in pigment colours and forms, Kandinsky laid the basis of a universal idiom for expressive pictorial construction, 'purified' from semantic reference. This contribution was even more important than his theories.

10

Expressive Abstraction and Abstract Expressionism

The basic principles of Expressive Abstraction have nowhere been clearly formulated and innovative artists in this field, pushing ahead into new realms of creativity, have neither been wholly coherent nor completely articulate about their aims and intentions. They were searching for their goal amidst a welter of conflicting ideas, rather than pursuing a goal already understood. Now, from the sharper perspectives of hindsight, it will be useful to adumbrate the main lineaments which differentiate this mode of abstraction from others.

In addition to their matter-of-fact, empirical properties of measurable shape, colour, size, weight, etc., the things around us possess what we may call a 'physiognomic personality', which is a highly complex and fluid amalgam combining associations drawn from history, function, and familiarity (an old village church has a different 'feel' from a modern bungalow) in conjunction with the expressive, emotional, and aesthetic qualities inherent in their visible forms and the 'suggested' properties such as mass, texture, rigidity, vitality, etc. In the foregoing pages we have shown how, beginning with the artistic generation immediately succeeding the Impressionists, many Aspect Realists devoted their efforts to depicting the expressive aspects of the visible world, giving prominence to these in abstraction from other aspects. Some of these artists – Gauguin and the Symbolists in particular – thought that by the manner of their abstraction they could penetrate and reveal metaphysical realities behind the appearances. The Neo-Impressionists and others were interested in systematizing the expressive aspects of visual experience in order to be able to put the construction of over-all expressive compositions on a scientific basis. The Expressionists of Germany were interested primarily in communicating pictorially their personal attitudes and their feelings of empathy or revulsion by the manner in which they depicted their subjects. Certain modern Expressionists such as Manessier, Bazaine, Singier, Tal Coat, carried the isolation of expressive elements to a point where object recognition was obscured.

But other artists, instead of isolating the expressive qualities of natural appearances and making it their aim to reproduce these in paint, concentrated attention on the pictorial elements themselves, the 'virtual' lines, shapes, colours, and planes of the picture image, and used these as building materials for the construction of expressive but completely non-iconic compositions. This change in the direction of attention is at the root of Expressive Abstraction. For the expressive

characteristics of the pictorial elements, particularly pigment colours, are not identical with those of the visible world of things and although the difference became apparent only slowly and gradually, although for a long while artists were imperfectly aware of what they were seeking and doing, it is in this that the unique distinction of Expressive Abstraction lies. Kandinsky was a pioneer in this field, and the difference between his investigations into the expressive characteristics of the pictorial elements and the attempts of Seurat to systematize the expressive features of visual appearances, is symptomatic of the new tendency. The Aspect Realists sought to isolate the expressive features of natural appearances and to give them pictorial representation. Expressive Abstraction seeks to abstract the expressive characteristics of the pictorial elements, the elements of the picture image, and to construct expressively with them. In practice the two methods often merge, but they derive from radically different principles and lead in different directions. What the Abstract Expressionists meant when they affirmed, as they so often did, that their pictures were *not* devoid of subject although they represented nothing from the external world, was, precisely, that they invited intensified attention to the qualities of the picture image (which was their 'subject') instead of presenting equivalents for visual qualities taken from the world outside the picture.

It has been characteristic of most schools of Expressive Abstraction that they have advocated impulsive and spontaneous rather than planned and prepared composition. The artists themselves, and still more the critics who took it upon themselves to interpret what the artists were doing, liked to declare that the art work was the outcome of an immediate emotion without preconceptions and that it carried within itself the impress of the artist's emotion. It was, in effect, a biographical statement, a gesture, on the part of the artist. In an article, 'The American Action Painters', written in 1952, Harold Rosenberg said: 'The painter no longer approached his easel with an image in his mind; he went up to it with material in his hand to do something to that other piece of material in front of him. The image would be the result of this encounter. . . . A painting that is an act is inseparable from the biography of the artist.' With the painter Willem de Kooning chiefly in mind, Rosenberg coined the term 'Action Painting', which became current during the 1950s as a virtual synonym of Abstract Expressionism. The implication of the term was to emphasize

the view,.which was popular at that time, that a painting should be a record of the physical process of its creation, that is of the actions of the artist while painting it, interpreted as gestures which, as gestures may do in ordinary life, expressed the emotional moods of the artist.

The French critics with their background of classicism tended to take the view that the emotions embodied in abstract painting should be organized into a unified consistency that transcends the casual conflicting turmoil of successive gratification and frustration which every artist knows. Marcel Brion believed that the initial emotion which inspires a work must be sustained throughout.

Je veux dire que l'émotion initiale, qui se situe au point de départ de la création, doit demeurer telle pendant toute l'élaboration de l'œuvre, celle-ci transformant en un langage articulé ce qui, chez certains, a seulement la forme du *cri*. C'est cette émotion initiale qui continue de gouverner l'évolution de l'œuvre d'art, sans déformation, sans atténuation, de telle sorte qu'à l'achèvement de l'œuvre, le fait plastique qu'est devenu le tableau représente encore exactement le choc émotionale du début.

The American critics on the other hand tend to emphasize the casual and occurrent character of the emotions experienced by an artist in the course of his work and the tension between conflicting moods which will survive in the finished product. Why such record of personal emotions should be of interest to anyone except the artist's intimate friends and his psychoanalyst is not discussed. It is a problem which ought to be faced but is not. But the implications are that the emotions embodied in expressive abstract art are not the emotions of ordinary life, not emotions experienced by the artist for things and events in the world within which we live, but a craftsman's feelings for the materials of his craft and a professional's moods in the manipulation of those materials. Just as the subject-matter of Abstract Expressionism is the pictorial image itself, so the emotions embodied in it are the emotions which accompany the formation of the image from the physical materials with which the artist works. So Meyer Schapiro declared in an article on 'The Younger American Painters of Today', published in the *Listener* for 26 January 1956: 'In its most radical aspect – in the works of Willem de Kooning and Jackson Pollock – the new painting appears as an art of impulse and chance. This does not mean that it is formless and unconsidered; like any art,

it aims at a coherent style. What I am describing rather are qualities which make up the expressiveness of this art; its physiognomic, so to speak. We see excited movements, scattered spots and dashes, fervent streaking, an explosive release . . .!' And in the following year he said:

> The consciousness of the personal and spontaneous in the painting and sculpture stimulates the artist to invent devices of handling, processing, surfacing, which confer to the utmost degree the aspect of the freely made. Hence the great importance of the mark, the stroke, the brush, the drip, the quality of the substance of the paint itself, and the surface of the canvas as a texture and field of operation – all signs of the artist's active presence. The work of art is an ordered world of its own kind in which we are aware, at every point, of its becoming.

Robert Goldwater too has emphasized these artists' emotional engrossment in the physical substance of their art and in the processes of its manipulation.

> Here are artists who like the materials of their art: the texture of paint and the sweep of the brush, the contrast of colour and its nuances, the plain fact of the harmonious concatenation of so much of art's underlying physical basis to be enjoyed as such. They have become fine craftsmen with all the satisfaction that a craftsman feels in the controlled manipulation of his art, and all his ability to handle his medium so that his pleasure is transmitted to the beholder.

Consistently or not, Expressive Abstraction is said to be both spontaneous and coherent, impulsive and impetuous yet controlled craftsmanship and technique. The finished work is said to embody and communicate the emotions experienced by the artist in fashioning it. These are not the emotions we experience in the predicaments of everyday life or towards the objects with which we have contact in the living environment; they are the specialized emotions which a craftsman experiences in manipulating the materials of his craft – and in this case manipulating them for no other purpose than to create an object whose only *raison d'être* is to carry these emotions. This concept of craftsmanship indulged for its own sake is a curiously involuted conception of artistic activity, a folding in of the artistic process upon itself, an esoteric exercise out of contact with the rest of life.

In fact there is much more to Expressive Abstract art than this. But it has not been fortunate in the critics who have interpreted it to the world, and these critics have not fully understood the implica-

tions of the interpretations which they have offered. It has been well said by G.H.Hamilton that

expressive abstraction appeared at the end of the War as the only viable form of creative communication in a world that had lost confidence in the ability of appearances to convey any meaningful content. Just as the realities of religious experience, had a new religious painting been urgently required, seemed no longer comprehensible in figural representations now that theological speculation had become increasingly abstract, so the realities of the artist's personal existence, no longer to be validated by reference to social or political institutions, could only be expressed by the response of form and material, in the act of creation, to the necessities of his psychic situation. That situation had already been defined by the Existentialist philosophers.

Abstract Expressionism and Tachism

Abstract Expressionism is the most generally accepted name given to the work done by the artists of the New York School, most of whom achieved stylistic maturity about 1947 and did their best work between that time and the middle fifties. There was in fact little or no stylistic uniformity among the fifteen artists who were considered to make up the School – for example, in the exhibition 'The New York School – The First Generation Painting of the 1940s and 1950s' held at the Los Angeles County Museum in 1965. Apart from the accidents of time and place it would not have occurred to historians and critics to bring together into a 'school' the monochromatic or near-monochromatic paintings of Newman, Reinhardt, and Rothko, the more impulsive, sometimes almost calligraphic, abstracts of Kline and Motherwell, the all-over drip paintings of Jackson Pollock, and the paintings done by De Kooning, Gottlieb, Guston, and Hofmann. Nor was the title appropriate, since not all the work was (non-iconic) abstract and not all was expressive. De Kooning made pretty consistent use of figure imagery, and residual figuration persisted in the work done during this period by Baziotes, Gottlieb (particularly in his *Pictographs*), Hofmann, and Gorky. The paintings of Newman, Reinhardt, and Rothko are not, typically, expressive in the sense that those of Kline, Still, and Motherwell are expressive and none of them exploit the self-revelatory brushwork which was thought to be the mark of Action Painting, the alternative name by which the work of this School was known.

At one end of the spectrum we find the kind of psychic automatism for which the term 'Action Painting' was most appropriately coined, corresponding to what in Europe is more commonly known as 'gestural painting'. During the 1940s the idea that a work of art should be treated, by both artist and viewer, as a manifestation and record of *gesture* rather than an end-product complete in itself had a fairly wide diffusion internationally. The finished work was not to be contemplated and admired out of relation to the processes of its production as we assess factory products or the products of craftsmanship. A different attitude was postulated. Greater importance was attached to the artist's performance than to the result of the performance and the result was to be apprehended not primarily as an end-product but as a record of process or performance, as the slime-track – to borrow a metaphor from Francis Bacon – is a sign of the passage of the snail. The process of which the art work was the record and sign was to be conceived on the analogy of gesture, a complex and sophisticated type of gesture which, nevertheless, like other gestures, was expressive of the mental conditions of the artist. And because the performance was impulsive and quasi-automatic rather than deliberately planned, it was thought to be expressive of feelings and moods deeper and more universal than those which come easily to the surface of consciousness. This conception of the art work as performance before end-product extended even further than expressive abstraction. It was, for example, inherent in the famous *Manifiesto Blanco* put out in 1946 by Lucio Fontano in Argentina and in his subsequent Italian Manifestoes, although his later Spazialismo was in other respects a reaction against *art informel*. But within expressive abstraction this outlook and philosophy found its finest efflorescence in some of the work of American Abstract Expressionism. Robert Motherwell looked on the picture surface as a field within which to register spontaneous but profound human reactions and impulses. The monumental calligraphic automatism of Franz Kline was paralleled elsewhere by the Italian Vedova's sense of alienation and inadequacy, the tragic protest of the Spaniard Antonio Saura and the violence of the German Sonderborg.

From the 1930s Willem de Kooning was temperamentally addicted to the equivocal, the ambiguous, and the allusive. As Dore Ashton said in *The Life and Times of the New York School* (1972): 'De Kooning's organic vision was geared from his early years to the discernment of unexpected disjunctures of form, and the constant sense of flux

beneath outward appearances.' More perhaps than any other member of the New York School, his outlook reflected the existentialist anxiety, the rejection of complacency, comfort, and conformity, which were so important to the *avant-garde* during the 1940s. The techniques which he developed reflected his outlook. He deliberately retained half-erased signs of changes of mind, *pentamenti* indicative of previous stages in the work. The female figures which entered his compositions like substantial ghosts in the late 1940s lacked subjective expression apart from a suggestion of primitive barbarism, but were in complete accord with the expressive character of the abstraction into which they fitted. While to many critics he seemed to typify most fully certain aspects of Abstract Expressionism, it is not entirely far-fetched to trace a similarity between his work at this time and the work of the COBRA group of artists, particularly perhaps Alechinsky and Karel Appel.

Both in American and in world opinion the dominating personality in Abstract Expressionism was Jackson Pollock. Virtually unknown to the general public at the time of his first one-man show at Peggy Guggenheim's 'Art of this Century' gallery in 1943, his work was acclaimed for its energy, vigour, and audacity, and was enthusiastically taken up both by colleagues and by *cognoscenti*, museum men, and critics, until in 1949 he was the subject of an article in *Life* magazine entitled 'Is Jackson Pollock the Greatest Living Painter in the United States?' He was championed by the critic Clement Greenberg as the greatest painter of his day and was hailed by many as the forerunner and protagonist of a 'new American painting culture capable of breaking the hegemony of Europe'. (He himself, incidentally, was admirably and sensibly restrained on this matter.)

I accept the fact that the important painting of the last hundred years was done in France. American painters have generally missed the point of modern painting from beginning to end. The only American painter who interests me is Ryder.... The idea of an isolated American painting, so popular during the thirties, seems absurd to me, just as the idea of creating a purely American mathematics or physics would seem absurd.... An American is an American and his painting would naturally be qualified by that fact, whether he will it or not. But the basic problems of contemporary painting are independent of any one country.

(Quoted by Maurice Tuchman in *The New York School* from an interview published in *Arts and Architecture*, February 1944.)

Pollock was influenced in the early years of the 1940s by the Surrealist doctrine of automatism. (He said: 'I am particularly impressed by their concept of the source of art being the unconscious.') He pursued this doctrine with unparalleled energy and vigour, carrying it through into the territory of technique so that it influenced not only what was done but how it was done. Instead of painting from the wrist he used gestures of the whole arm and like Alechinsky he painted with the canvas on the floor. As every student now knows, he adopted the famous 'drip' technique, pouring the paint upon unprimed canvas. Only at the last stage was the canvas trimmed to size and mounted on a stretcher. But it would be a mistake to regard his paintings as nothing more than spontaneous outpourings (although they were that) devoid of deliberate ordering and critical control. He was an admirer of Kandinsky as well as the Surrealists, and was well aware of the necessity for formal order. He spoke sarcastically of 'the kids who think it simple to splash a Pollock out'. Indeed Pollock possessed to a very unusual degree that gift for order which is essential to all expressive abstraction that aspires to the name of art. The mysterious ability to create a Gestalt which can be apprehended as a single unity of perception had become with him a second nature which guided his impulsive and spontaneous processes despite the technical difficulties with which he saddled himself. It is through this unconscious ordering that his pictures tower to greatness.

It was in virtue of this latent intellectual control that Pollock pioneered innovations which became of supreme importance to the following decades. From the point of view of principle the rejection of virtual picture space and the adoption of the 'all-over' style of composition stand out among them.

In a typical Pollock painting such as the *Mural* of 1943 at the University of Iowa, or *Mural on Indian Red Ground* of 1950, the electric, dancing, labyrinthine line encloses no figures any more than does the undirected scribbling of a child. The white and the black lines have no recession in depth and there is no distinction between figure and ground. Patches of colour may either advance or recede ambiguously. There is no organization of planes. Where figural elements are suggested by the convolutions of lines the line is not a contour suggesting modelling or the definition of planes regressing in a third dimension. As Michael Fried has shown, this two-dimensional space embodies an entirely different conception from the shallow picture-space of

Cubism with its faceted planes setting up a tension against the surface. In *American Art since 1900* Barbara Rose rightly said: 'Since Cubist space, no matter how shallow and how insistent on the integrity of the surface plane, still permits in and out fluctuations in depth, one may interpret Pollock's drip paintings as the first significant change in pictorial space since Cubism.' These paintings represent, in fact, the repudiation of virtual picture space: the space we see is identical with the real two-dimensional space occupied by the pigmented canvas. They constitute, therefore, an important step towards the abolition of the picture image and the rejection of that 'artifice' which sets up a difference between the picture image and the physical reality which is the picture. Do away with the third dimension and the image necessarily approximates much more closely to identity with the physical reality. It was in connection with the desire of later schools of painting to do away with the picture image and so weaken the artifice which stands between art work and reality that this new space of Pollock was recognized as a precursor.

Another of the most important contributions of the Abstract Expressionists was the emergence of a new concept of 'wholistic' composition opposed to the traditional idea of composition as a unified configuration constructed from intimately related parts. Instead of this the whole picture was to become a single undifferentiated image, *without* segregable parts, existing in an unbounded and unstructured picture space. The monochromatic or near-monochromatic 'imagist' works of Newman, Reinhardt, Rothko implemented this new conception of composition by making the single image identical with the whole picture, often gearing it to the rectilinear shape of the frame. In the 'over-all' style, of which Pollock was the acknowledged master, there is no single image but each area of the canvas has equal emphasis and the need to balance part against part or to orient the composition in any direction disappears. One may speculate that Pollock's habit of working with the canvas on the floor may have helped him to tackle it from all sides and so to overcome the tendency towards directionality. There is no up–down movement in the all-over composition and the swirling linear movement is not geared towards the edges but related to a centre.

This idea of all-over unstructured composition was not, of course, completely without antecedents, as C.H.Waddington among others

has noticed. In his book *Behind Appearance* (1969) he said of the late work of Monet such as his *Waterlilies* series: 'These paintings emerge as all-over modulations of the picture surface with, in the more extreme examples, no particular focus of interest and no natural edges – they might extend indefinitely in all directions. And the space they indicate is one which extends into the depth of the water, with every further foot of recession indicated because water is not so trivially transparent as air.' A similar method of composition is apparent in *parts* of many Fauvist paintings. Of Derain's *Les Barques de Collioure*, for example, Waddington wrote: 'Cover the one big boat with your hand and the rest appears almost completely abstract and non-representational, and shares with the Monet the characteristics of an all-over, edgeless distribution of interest and the implication, not of empty space containing some solid objects, but of a three-dimensional volume with every cubic inch occupied with something or other.' A two-dimensional form of all-over composition was also developed by Mark Tobey under Oriental influences to which he was subjected in the mid-1930s. His technique of 'white writing' set up on gently modulated coloured grounds a delicate tracery of intricately vibrating lines which invite meditative absorption. A very different mode of all-over composition, less improvisatory and less impulsive, was evolved in France by Roger Bissière in his 'tapestry' abstracts. Yet it was in Pollock's paintings that the all-over style culminated and it is these which gave a new impetus to further development of the style in America.

After a difficult start the prestige of Abstract Expressionism was enormous. It was aptly summed up by Maurice Tuchman when he wrote in the Foreword to his revised catalogue of the 1965 exhibition: 'Virtually every important American artist to have emerged in the last fifteen years [this was written in 1971] looks to the achievement of American abstract expressionism as a point of departure, in the same way that most European artists of the 1920s and 1930s referred in their work to the inventions of cubism.' The impact which it made on European artists was also unprecedented. The European counterparts of Abstract Expressionism, *art informel*, Tachism, and lyrical abstraction, also adopted an aggressively improvisatory approach (even if a painting was planned, it should seem to be spontaneous), repudiated formal composition and emphasized the expressive characteristics of the pictorial image. The critic Bernard Dorival compared a typical

Tachist composition to the disorderly flight of ants whose hive has been destroyed.

Pas de composition. Les formes ne convergent pas vers un centre – même désaxé – n'obéissent pas aux injunctions de lignes de force ou de rhythmes; mais, courant à travers la toile en tous sens, elles évoquent la fuite désordonnée de fourmis dont une catastrophe aurait détruit la fourmilière. La limite de la toile ne les arrête pas: fusant confusément, elles aspirent à l'outrepasser et à se prolonger, s'égarer dans l'espace. L'œuvre en dégage une apparence rapide, création d'une main qui, indépendante de toute pensée directrice, n'obéit qu'à elle-même et à la griserie de son propre geste, de l'immédiat de son propre geste.

Michel Tapié spoke even more strongly. It is necessary, he said, 'se lancer dans une œuvre sans idée de composition, sans aucune idée du tout, sans récherche d'équilibre, ni d'un certain déséquilibre bien en cours, hors des préoccupations de beauté, d'intelligence, de sentiment, de recette magique, de temps, de "problème" de couleur . . .' The most violent in their disorder were the German-born members of the École de Paris, Hans Hartung and the 'primitive' of the movement, Otto-Alfred Schultze-Battmann, known as Wols, the Swiss Gérard Schneider and the self-taught painter Georges Mathieu. Hartung's painting was described by Werner Haftmann as 'a seismographic technique, which records every tremor of the psyche'. It was 'a concrete imprint of a moment of human life. The painter's situation is made visible by his creative action.' Important contributions were also made by the Russian-born artists André Lanskoy, Nicolas de Stael, and Serge Poliakoff. The French were on the whole more restrained in construction, particularly the younger artists who worked in the style of 'lyrical abstraction' such as James Pichette, Roger-Edgard Gillet, and Jacques Doucet.

In England the most prominent artist in this field was Alan Davie, in whose decorative abstractions proliferate a wealth of weird plant-like growths, mythical and mysterious totem-like symbols, and associative forms. Less impulsive than the work of the COBRA artists, he bears much the same relation to Celtic mythology as they to Nordic folklore. Among others, both Harold and Bernard Cohen went through a Tachist phase.

I propose, however, to follow the views of Patrick Heron because, formerly practising as an art critic and reviewer, he is unusually articulate about his own work. This was hailed by the critics as Tachist

in 1956, although since that time he developed in the direction of 'wobbly' Hard Edge, a development which he explained by the fact that 'a colour is most intense when it is delimited; and the sharper the boundaries or frontiers or linear edges which delimit it are, the more intense that colour will be'. Despite some idiosyncratic views about colour and space, Heron voiced lucidly the basic concern of the Abstract Expressionists for the picture image and its relation to the physical medium. His ideas were summarized in his Power Lecture, delivered in 1973 and published in the collection *Concerning Contemporary Art* (1974), edited by Bernard Smith.

In opposition to Cubism and other forms of Perceptual Realism he maintained that 'painting is exclusively concerned with the *seen*, as distinct from the *known* ...'

This is why concepts, and also symbols, are the enemy of painting, which has as its unique domain the realm of pure visual sensation. Painting should start in that multi-coloured, and at first amorphous, texture of coloured light which is what fills your vision, from eyelid to eyelid, when you open your eyes. The finished painting should also end in pure sensation of colour – having passed into the realm of the conceptual in the process, and come out again on the other side.

His attitude to the pictorial image and its physical basis was formulated in the catalogue for an exhibition 'Space in Colour' which he organized in 1953. This is important because he here defines precisely what later movements, to be described under the heading 'Concrete art', repudiated and wished to abolish.

In painting, space and form are not actual, as they are in sculpture, but illusory. Painting, indeed, is essentially an art of illusion [which was why Charles Biederman and his followers thought that painting had had its day]. But the secret of good painting – of whatever age or school – lies in its adjustment of an inescapable dualism: on the one hand there is the illusion, indeed the *sensation*, of depth; and on the other there is the physical reality of the flat picture-surface. Good painting creates an experience which *contains* both. It creates a sensation of voluminous spatial reality which is so intimately bound up with the flatness of the design at the surface that it may be said to exist only in terms of such pictorial flatness.

As many of the Abstract Expresionists were accustomed to do, he referred to the formation of a pictorial image (which he liked to call 'space in colour'), embodied, as it were, in the physical medium, as

the 'subject' of his painting to the exclusion of semantic and expressive meaning. 'Colour', he said in 1962, 'is both the subject and the means; the form and the content; the image and the meaning, in my painting today.'

It has already been remarked that interpreters of *art informel* by-pass the question why, if this painting is *merely* 'psychic improvisation' repudiating both representation and composition, it should be expected to hold any interest for people other than the artist's inti-mates. Heron is one of the few writers who has attempted to suggest a more solid function for this apparently introverted and esoteric art which cuts itself off from the world of things and finds its only subject-matter in its own technical processes. He refers to the fact that once they have become familiar great styles in art influence and change our way of seeing the world.

Painting alters the look of the world for us.... People always think that the natural world looks literally *like* the paintings of whatever school was dominant forty years before: for years after the death of Monet educated people uncons-ciously projected a patchwork of torn and liquid blobs – the brush-touches of Monet – into the faces, tea cups, walls or trees around them, unconsciously *equating* the ragged paint-textures of Impressionism with reality. What is true is that all great movements in painting produce a pattern of abstraction (and all art is abstract, don't forget) – a pattern which we then read back into natural appearances. After Cézanne, the roundest apple flaked visibly before our eyes into rigid facets; after Picasso, the softest breast divided itself diagonally along a rigid line; after Mondrian, the cityscape fell into a grid as we looked out of the window.

He sums up:

Painting's role in civilisation is that of man's laboratory for the disinterested exploration of visual appearances as such, an exploration carried out uninhi-bited by any practical demands whatsoever. The painter is and always has been in search of one thing only: and that is, a new abstract configuration, a new but purely formal significance, a new pattern emerging out of the very mechanics of physical vision itself, a new shape in the organisation of colour.

It is true that new modes of semantic abstraction, new styles of representation in art, influence and change our ways of seeing the world around us. This is one of the important debts men owe to great innovatory artists of the past. It is by no means obvious that a new style in non-iconic abstraction, unconnected with the representation

of natural appearances, would similarly affect our way of seeing the world. Mondrian certainly influenced current fashions in the production of some man-made objects such as book jackets and advertisement layouts. He did not change our way of seeing a landscape or a city street as the Impressionists and Constable certainly did. There is no evidence that Abstract Expressionism has changed our way of seeing the world or is likely to do so. Indeed this may have been one of the motives which, after Abstract Expressionism, encouraged on the one hand a revival of naturalism and on the other hand the repudiation of pictorial illusion and the picture image in conjunction with attempts to integrate abstract art objects into the real world in which we live.

11

Constructivism

'Constructivism' was taken as the title of two movements which came to fruition in the 1920s although their basic ideas and aims were opposed. Soviet Russian Constructivism came into being as the formalization of views advocated by the Productivist group of artists, led by Tatlin, which had been maturing since 1917 and were subsequently adoped as the official policy of the State. In his pamphlet *Konstructivism* (1922), which Stephen Bann later described as 'the first attempt to present constructivism as a novel and coherent artistic ideology', the typographer Alexei Gan said that Constructivism 'arose in 1920 amid the "mass action" Leftist painters and ideologists'. The origin of the title can be traced to a manifesto issued in 1920 over the signatures of Alexei Rodchenko and his wife, Varvara Stepanova, with the title 'Programme of the Productivist Group' and intended as a riposte to the Realist Manifesto of Gabo and Pevsner, which had been put out earlier in the same year. The Productivists' manifesto opened with the statement: 'The task of the Constructivist group is the communist expression of materialistic constructive work.' In the Realist Manifesto Gabo had used 'construction' and 'the constructive idea' as key terms for the expression of his ideas, although then and later he avoided 'Constructivist' and 'Constructivism'. The adoption of his own term as the title of the rival group was one way of marking their opposition. The other movement which named itself Constructivism had ramifications in most countries of Europe and is usually referred to as 'European', or latterly 'International', Constructivism to distinguish it from the Russian movement.

It was the central tenet of the Soviet Constructivists that all artistic activity must be diverted into architecture and town planning, industrial designing of factory-produced goods, and the indoctrination of the masses by means of theatre, cinema, graphic art, photography, posters, and propaganda literature. It condemned traditional, non-utilitarian art as 'speculative' activity and repudiated the work of Malevich, Tatlin, Rodchenko, and others done before 1920. The 1920 manifesto contained the statement: 'The group stands for ruthless war against art in general' and among its 'Slogans of the Constructivists' were: 'Down with art' and 'Art is a lie'. No significant school of European Constructivists accepted the condemnation of non-utilitarian art or showed much interest in the applied arts, while the early abstract work of the Russian artists, particularly Suprematism, has by general consent been brought under the umbrella of Constructivism in

European usage. Only El Lissitzky was able to accommodate himself to both Russian and European Constructivism and he did so by abandoning the central tenet of Soviet Constructivism in articles written for European consumption. An editorial which he wrote for the first number (1922) of a trilingual magazine *Vesch/Gegenstand/Objet*, which he founded in Berlin together with the writer Ilya Ehrenburg, contains the statement:

We have called our review *Objet* because for us art means the creation of new 'objects.' That explains the attraction that realism, weightiness, volume, and the earth itself hold for us. But no one should imagine in consequence that by objects we mean expressly functional objects. Obviously we consider that functional objects turned out in factories – aeroplanes and motor cars – are also the product of genuine art. Yet we have no wish to confine artistic creation to these functional objects.

In his Trowbridge Lecture at Yale University in 1948 Naum Gabo summarized his difference from Soviet Constructivism in words which would be acceptable to most European Constructivists.

The word Constructivism has been appropriated by one group of constructive artists in the 1920s who demanded that art should liquidate itself. They denied any value to easel painting, to sculpture, in fine to any work of art in which the artist's purpose was to convey ideas or emotions for their own sake. They demanded from the artist, and particularly from those who were commonly called constructivists, that they should use their talents for construction of material values, namely in building useful objects, houses, chairs, tables, stoves, etc., being materialist in their philosophy and Marxist in their politics. They could not see in a work of art anything else but a pleasurable occupation cherished in a decadent capitalist society and totally useless, even harmful in the new society of communism. My friends and myself were strongly opposed to that peculiar trend of thought. I did not and do not share the opinion that art is just another game or another pleasure to the artist's heart. I believe that art has a specific function to perform in the mental and social structure of human life. I believe that art is the most immediate and effective means of communication between the members of human society. I believe art has a supreme vitality equal only to the supremacy of life itself and that it, therefore, reigns over all man's creations.

We shall henceforth be concerned with Constructivism in the broader sense of the International movement.

Although many of the ideas go back not very explicitly to 1918 when the Dutch periodical *De Stijl* was founded by Theo van Doesburg

as the organ of Neo-Plasticism, European Constructivism came into being with a minority statement made by van Doesburg, Lissitzky, and Hans Richter at a Congress of International Progressive Artists held at Düsseldorf in 1922. They spoke under the pretentious title International Faction of Constructivists, and claimed that artistic principles should be given priority over organizational expediencies in defining on an international basis what a progressive artist is. The kernel of their declaration was contained in the third item: 'We define the progressive artist as one who fights and rejects the tyranny of the subjective in art, as one whose work is not based on lyrical arbitrariness, as one who accepts the new principles of artistic creation – the systematisation of the means of expression to produce results that are universally comprehensible.' In the following year Richter founded the periodical *G* (standing for *Gestaltung*, Formation) in Berlin with the intention that it should be 'the organ of the constructivists in Europe'. Van Doesburg contributed an article 'Elemental Formation' to the first number, expanding the idea of the systematization of the means of expression. He contrasted the old 'capricious practice' of *composition* 'dependent on personal taste, discretion or intuitive assessment of the elements of the work of art' with the new idea of *construction*, which demands 'conscious control of the elemental means of expression'. 'What we demand in art is EXPLICITNESS, and this demand can never be fulfilled if artists make use of individualized means. Explicitness can result only from discipline of means, and this discipline leads to the generalisation of means. . . . Creative consistency forces him (the contemporary artist) into a revision of his means, into a systematic making of rules, that is to conscious control of his elemental means of expression.'

Constructivist ideas were introduced into the teaching of the Bauhaus by Moholy-Nagy after he succeeded Johannes Itten there in 1923, and the Bauhaus published a collection of Mondrian's essays from *De Stijl* in 1925 and a German translation of Malevich's *The Non-Objective World* in 1927. The Suprematism of Malevich and the Neo-Plasticism of Mondrian were the two most important individual movements which were considered to fall within the ambit of pre-War Constructivism.

The French made comparatively little contribution to the development of Constructivism. But Paris offered a welcome shelter in the late 1920s and early 1930s for expatriate Constructivist artists and in

1930 the association *Cercle et Carré* was formed in Paris with its own periodical under the editorship of the young Belgian Neo-Plasticist artist Michel Seuphor. This was followed in 1932 by *Abstraction-Création – Art Non-Figuratif*. The organization of these associations was not exclusive or programmatic and they brought together a very large number of artists working in a very wide range of different styles. They therefore did little to render the concept of Constructivism more specific, although some interesting discussions of Constructivist principles are to be found in the publications.

In 1930 van Doesburg, who had been opposed to the formation of *Cercle et Carré*, published a brief rival manifesto of his own. Although it was put forward with the title *Art Concret*, it might serve as a summary of the central tenets of Constructivism at that time. The six brief items of the declaration (signed also by Carlsund, Hélion, Tutundjian, and Wantz) were as follows:

1. Art is universal.
2. The work of art must be entirely conceived and formed by the mind before its execution. It must receive nothing from nature's given forms, or from sensuality or sentimentality.
 We wish to exclude lyricism, dramaticism, symbolism, etc.
3. The picture must be entirely constructed from purely plastic elements, that is planes and colours. A pictorial element has no other meaning than 'itself' and thus the picture has no other meaning than 'itself.'
4. The construction of the picture, as well as its elements, must be simple and visually controllable.
5. Technique must be mechanical, that is exact, anti-impressionistic.
6. Effort for absolute clarity.

An editorial by Michel Seuphor published in the first issue of *Cercle et Carré*, in 1930, while emphasizing yet again the subordination of impulsive composition to cool, planned construction, introduced a further idea which had been prominent in the minds of Malevich, Mondrian, and other leaders of geometrical abstraction. It was the idea that Constructivist art is in harmony with and provides insight into the ultimate nature of reality, not indeed by reproducing external appearances but by identity of *structure*. The idea was taken up by Charles Biederman, the theorist of post-War Constructivism, and seemed so important to him that eventually, in 1952, he rejected Con-

structivism for a new doctrine which he named Structurism. Seuphor
wrote:

We are a part of nature, but we are also the summit of nature, the ultimate
consequence of its evolution up to this point, and we sum it up in its entirety
within ourselves. Man can therefore do no other than rely on nature, and the
prerequisite of his vital equilibrium is that there should always be constant
harmony between them ...

Our greatness? It does not consist in gesticulating at the stars or in being
close to the gods. It lies in the simple desire to have clear knowledge, in the
ability to make exact measurements of things, to compare them methodically,
and to draw from them general conclusions that the mind has the faculty of
retaining in the form of abstractions so that it may reproduce them at will
and make good use of them in every circumstance. Our greatness: our aware-
ness of the exact work of our hands. And this awareness holds within it the
secret of our constant growth, our becoming. It enables us to intensify within
ourselves the instinctive, the intuitive, the emotive and the pathetic and to
subordinate these precious gifts of being to the trained mind, canalising them
into a superior order, into a constructive, supernatural conception of life....
The immutable self (the human truth) is the substructure of our lives and
the direct reflection of the universal truth, which is the substructure of nature.

Structure, which is the 'first condition of every work' is dependent
on our wishes.

To construct is to evaluate relationships, to calculate equivalences, to coordi-
nate positive forces with neutralising realities ... to organise all the data in
such a way that unity, perfect stability is obtained.... Every work worthy of
man must be verifiable, that is to say it must carry within it its own clearly
analyzable evidence. Henceforth a so-called work of art that displays only the
more or less complex annotation of free sensibility or emotion (something that
is particularly open to criticism and hard to regulate) will be regarded as form-
ing part of sexuality or of an infantile-pathological domain that it would be
easy to set limits to.... Well-governed sensibility, when it assumes an active
part in us, becomes a form of right thinking or 'pure reason,' or again, if you
wish, of our moral equilibrium. By uniting it in the work with its structural
principle we achieve what I shall call here an *architecture*. And there we have
laid our finger on the entire role of the artist. To establish upon the basis of
a severe structure, simple and unadorned in all its parts, and according to a
principle of close unity with this undisguised structure, an architecture that,
by the technical and physical methods peculiar to the age, expresses in a clear
language the immanent and immutable truth and reflects in its particular
organisation the magnificent order of the universe.

In the late 1930s a number of Constructivist artists moved to England and settled in London. They included Gabo, Pevsner, Moholy-Nagy, Gropius, and Mondrian. In London they were in touch with Ben Nicholson, Barbara Hepworth, Henry Moore, and the critic Herbert Read. With the outbreak of war, however, they moved on to the United States and there was no indigenous Constructivist movement in Britain until the 1950s. But in 1937 Gabo collaborated with Ben Nicholson and the young architect J.L.Martin to edit a collective volume *Circle*, called an 'International Survey of Constructive Art'. Mondrian's contribution 'Plastic Art and Pure Plastic Art' remains the most important source for the theoretical basis of Neo-Plasticism. Gabo's editorial, 'The Constructive Idea in Art', extends the concept of Constructivism even more widely than had been done hitherto. He wrote:

The Constructive idea is not a programmatic one. It is not a technical scheme for an artistic manner, nor a rebellious demonstration of an artistic sect; it is a general concept of the world, or better, a spiritual state of a generation, an ideology caused by life, bound up with it and directed to influence its course. It is not concerned with only one discipline in Art (painting, sculpture or architecture) it does not even remain solely in the sphere of Art. This idea can be discerned in all domains of the new culture now in construction. This idea has not come with finished and dry formulas, it does not establish immutable laws or schemes, it grows organically along with the growth of our century. It is as young as our century and as old as the human desire to create.

More specifically, he wrote in the same article:

It [the Constructive idea] has revealed an universal law that the elements of a visual art such as lines, colours, shapes, possess their own forces of expression independent of any association with the external aspects of the world; that their life and their action are selfconditioned psychological phenomena rooted in human nature; that those elements are not chosen by convention for any utilitarian or other reason as words and figures are, that they are not merely abstract signs, but they are immediately and organically bound up with human emotions. The revelation of this fundamental law has opened up a vast new field in art giving the possibility of expression to those human impulses and emotions which have been neglected. Heretofore these elements have been abused by being used to express all sorts of associative images which might have been expressed otherwise, for instance in literature and poetry.

This is clear enough formulation of the principles of non-iconic abstraction. But curiously enough it does not differentiate Geometri-

cal Abstraction or Constructivism from Expressive Abstraction. Indeed it reads in isolation more like a formulation of the idea of Expressive Abstraction and there is in fact nothing in it which might not have been written by Kandinsky. Even by the end of the 1930s the basic principles of Constructivism were often not clearly understood by its protagonists.

Summary of Constructivist Principles

(1) Constructivism is non-iconic. Representation is excluded both from the constituent parts and from the work as a whole. A Constructivist work conveys no information about the appearance of anything in the world other than the work itself.

Highly charged language is frequently used in laying down this principle. Constructivist art is said to be 'pure', and the discarding of representation is described as 'freedom' or 'emancipation'. Adequate reasons to justify this are not forthcoming. While the preference for non-iconic abstraction is abundantly clear, it is not self-explanatory any more than are contrary affirmations such as Ozenfant's statement that a non-iconic art would be 'devoid of all sufficient human resonance'. These are very fundamental affirmations of taste and conviction on both sides, but they are not arguments.

(2) Constructivism is opposed to the kind of expressiveness which is exploited by Expressive Abstraction. It does not exploit the expressive qualities of the materials from which a work is made, but seeks to reduce to a minimum the expressive characteristics of the visual elements of the picture image. Expressiveness is eliminated so far as possible from shapes, colours, texture, and facture. In general geometrical or near-geometrical shapes are preferred, many Constructivists restrict themselves to a few unmodulated primary colours and there is a tendency to prefer smooth, machine-like, impersonal finish. This dislike for expressive appeal in the parts of a composition may partly account for the preference which many Constructivists had for highly simplified geometrical elements – the square in the case of Malevich, orthogonals in the case of Mondrian – although the exclusion of expressiveness does not necessarily require this.

Despite this, Constructivists have not regarded their works as being devoid of emotional appeal. But the emotion derives from the

structure or organization, not from the sensory properties of the parts or the materials, and not from the expressive qualities of the colours or contained forms. It is said to be of the kind which Ozenfant called 'excitement of an intellectual order'.

It is very generally claimed that the typical Constructivist work is 'universal', by which is meant that the proper response is experienced equally by all human beings, or by all human beings at an appropriate level of development, and that it is uniform in contrast with sensuous and 'sentimental' emotions, which vary from man to man.

(3) Constructivist composition must not be impulsive and improvisatory like that encouraged by Expressive Abstraction, but must be planned and deliberate and must follow objective structural principles which can be intellectually apprehended and controlled. To mark this difference the word 'construction' was preferred to 'composition'. This principle was inherent in van Doesburg's aspiration for systematization of what he called 'the elementary means of expression' even before Constructivism was formally inaugurated, and the principle was never abandoned.

This principle also was linked with the belief that Constructivist art should be 'universal' in a sense that is opposed to subjective feeling or mood. 'Pure plastics', said Mondrian, 'in its essential expression is unconditioned by subjective feeling and conception.'

(4) A premium was put upon the qualities of explicitness, precision, clarity, lack or ambiguity or vagueness, comprehensibility, and simplicity. In these respects Constructivism had something in common with the aesthetic preferences of Purism. Yet there was little or nothing in the theory or the explanations which could justify these preferences, particularly the leaning towards simplicity, or the very marked preference for rectilinear rather than curvilinear elements. (Ben Nicholson was one of the few artists who used both the rectangle and the circle as equally valid structural elements.) Visually complex structures may be no less capable of mathematical formulation, no less apprehensible intellectually, than simple ones. Mathematically and intellectually the rectilinear shapes have no advantage over circular and curvilinear forms. That these aesthetic preferences were not in fact very closely tied up with the intellectual pretensions seems indicated also by the fact that there were few serious attempts in Constructivist circles to pursue investigations into the old principles of

the Golden Mean and the root rectangles (i.e. rectangles which are linearly incommensurable but whose sides are commensurable in the square). Yet these principles, even as applied rather rudimentarily by the ancient Greeks and their modern followers such as the Nabis and the Section d'Or group, lead to constructions of greater elegance *intellectually* than what was done by most of the Constructivists.

(5) It was a commonly held belief among Constructivists that their works revealed by their structure the reality behind the appearance of things – or at any rate that they were in harmony with that reality – although they carefully did not reproduce the appearances. By this it was *not* meant that the works reproduced the visible structure of things without reproducing any other aspect of their appearance, i.e. Constructivism was not another form as Aspect Realism. Nor was it meant that the works revealed the structure of the world in the sort of way that a diagram might reveal the economic structure of society or the hidden structure of the earth's crust. For diagrams are conventional signs and communicate nothing at all unless the conventions are explained in words or unless an element of stylized representation is introduced. The belief of the Constructivists was intended in a more abstruse sense, as is shown by the fact that they thought their constructions also revealed the structure of 'universal' human mentality. But how metaphysical reality, or an invisible structure of reality, can be inherent in something which is after all another visible object, was left unexplained.

(6) Finally, perhaps as a distant inheritance from Russian Constructivism, some Constructivist artists believed that in conjunction with a refurbished ideal of architecture Constructivist art would take the initiative in creating an environment appropriate to the new society and the new type of man expected to emerge in the post-War era. In the last issue of *Abstraction-Création*, published in 1936, Jean Gorin wrote:

The aim pursued by the new Constructive plastic art is not an individualistic one. It is not an ivory-tower art, as people might be tempted to suppose at first glance. On the contrary, the bases of this new plastic art are deeply rooted in the new age through which we are living, as age of great economic and social upheaval, of the reign of science, collectivism, and universalism ... Purely constructive plastic art is fundamentally architectural; it is the higher function of all genuine architecture. In and through architecture it attains its

fullest expression, forming a unity with her. Thus an environment is created that is adapted to the development of collective life and favourable to the fullest flowering of the man of modern times.

Mondrian had a similar vision and these ideas were revived by a small association of artists connected with the periodical *Art d'Aujourd'hui*, who formed the Groupe Espace in 1949. They included Jean Gorin, Nicolas Schöffer, and Edgard Pillet.

Before the distinction between Concrete Art and Constructivism was at all clearly understood, Max Bill gave a definition of Concrete Art which fits pretty closely most of these characteristics of Constructivism. He claimed that it was non-iconic, not abstracted from natural appearances, that it eliminated subjective individuality so as to satisfy the universal human spirit and that it achieved this by following 'innate' and objective principles of composition.

The term 'concrete art' refers to those works that have developed through their own innate means and laws, in other words that bear no relationship to external phenomena and are not the result of any kind of 'abstraction.' Concrete art is autonomous. It has an independent existence. It sets out to be the expression of the human spirit and is designed to satisfy the human spirit. It must be clear, unambiguous and aim at perfection. Concrete art finds expression in various ways. One of them is mathematical and constructive art. Basically concrete art is real and yet spiritual. It strives towards universal unity, yet is unique. The individualistic element is pushed aside for the benefit of the individual.

Suprematism

In a Manifesto published by Malevich in the catalogue of the 10th State Exhibition 'Non-Objective Creation and Suprematism' held in Moscow in 1919 Malevich declared: 'Suprematism arose in Moscow in 1913.' For five months in 1913 Malevich was working on stage designs for Kruchenikh's Futurist opera *Victory over the Sun*, for which Matiushin wrote the music. Critics have usually followed Camilla Gray in supposing that Malevich was referring to preliminary drawings made for these stage sets, fifteen of which are now in the Leningrad Theatrical Museum. But the first Suprematist paintings were exhibited at the Petrograd exhibition 'o,10. The Last Futurist Exhibition' in the winter of 1915/16. (The title of the exhibition, also written 'Zero-Ten', symbolized the end of Futurism and the birth of the new

world of Suprematism.) In the intervening years Malevich was also doing works which he described as 'transrational (*zaum*) realism' to distinguish them from his earlier Cubist-Realist works. These were in the manner of Synthetic Cubism, combining unrelated objects with no common significance apart from their formal structure and shape.[1]

The earliest Suprematist paintings seem to have consisted of elementary geometrical figures – a square, a cross, a circle – done in black on a white ground. They were followed by more complex and dynamic compositions, using also the elongated rectangle and introducing a few primary colours. After 1916 the colour tones began to be more subtly graded and the dynamic relations more intricate, while shadowy, half invisible geometrical shapes loomed in the background. The trend culminated in his famous 'White on White' pictures which were exhibited in 1919, each consisting of a single white square with outlines barely visible against the white background. In 1919 Malevich said 'the plane, forming a square, was the source of Suprematism, new realism of colour, as non-objective creation'.

Throughout the whole history of art there has been no such radical breach with all that had gone before as the revolution in ideas brought about by Suprematism, and it is astounding that this revolution should have matured in the short space of two years within the life-span of one man. It involved an entirely new conception of the nature of art, conflicting head-on with the age-long idea of art as the 'mirror of nature'. As the semantic, representational function was discarded, the art work became 'non-objective' in Kandinsky's terms, an independent artefact wholly divorced from extra-pictorial reality. Nor were the pictorial elements of a Suprematist work abstracted from natural appearances. As Malevich said, they are created by the artist 'out of nothing'; he 'gives them life and the right to individual existence'. The work as a whole was to be an autonomous construction demanding recognition for what it was in itself, not for what it might 'tell' about anything apart from itself. Suprematism was not a form of Aspect Realism, not Perceptual Realism, but a repudiation of all that Realism – and Cubism – had hitherto stood for. So 'realism' acquired a new meaning in the vocabulary of the Suprematists. An art work was 'realistic' by being itself, a real thing, without pretensions to be or to represent or to copy anything other than itself; not because

[1] The best discussion is by A.B.Nakov in *Malevich Ecrits* (Paris, 1975), and in the catalogue to the Tate Gallery exhibition, *Kasimir Malevich*, in 1976.

of veridical representation or authentic semantic information. It was real because it was an artefact without artifice or illusion.

For Malevich went further than the 'non-objectivity' of Kandinsky, further than the repudiation of semantic function. Suprematism demanded the repudiation of all illusion, the annihilation of 'virtual' or three-dimensional picture space. The geometrical elements of a Suprematist picture have no volume, create no planes receding into depth. The space of Malevich was as flat and as entirely two-dimensional as the 'new' two-dimensional space of Jackson Pollock which was hailed as revolutionary a generation later. Colour, he declared, must become 'pure sensation'. He meant flat, unmodulated colour, coinciding with the geometrical form, banishing from Suprematism all colour composition in which each area of colour is influenced through simultaneous contrast by every other area, and all combine into a harmonious whole. Instead colour was seen as defining area and belonging to the pictorial element as when we say a piece of textile material, a saucepan or a door, is red or green or black. In these respects Suprematism spelled as complete a rejection of artifice and illusion as did the 'Hanging Constructions' of Rodchenko and the 'Corner Reliefs' of Tatlin. Something of the significance of this was understood by Russian theoreticians at the time. Thus Suprematism was spoken of as a 'victory over the three-dimensionality of cubic or conic volumes' and Matiushin wrote that 'the day is not far distant when the spectre of three-dimensional space will be vanquished'. As Malevich himself obscurely recognized, this campaign against artistic illusion meant the death of art as it had hitherto been understood, and set the stage for the approximation of fine art to industrial design which was the hall-mark of later Soviet Constructivism, although Malevich himself opposed social utility as a function of fine art.

Whereas for Mondrian, Van Doesburg, and to a varying extent for European Constructivists in general, geometrical abstraction favoured static and well-balanced compositions, many of the Suprematist works of Malevich emphasized dynamic quality. In many of them he used elongated rectangles with the effect of lines, the elements seem to be in free flight and the planes acquire a rotative or centrifugal movement deriving perhaps from Futurism and carrying distant affinities with Rayonism. The movement of the pictorial elements was not related to the format of a frame. A dynamic quality also characterized some

of the Suprematist works of Rosanova, Puni, and Popova. This dynamic quality of suggested movement, without the creation of a three-dimensional picture space in which the movement takes place, makes a noteworthy contrast with the static and contemplative character of Neo-Plasticism. Furthermore, when Malevich used simple geometrical elements without dynamic effect he made no attempt to do away with their expressive character, for the square itself has a distinct expressive 'personality', as it were. This too was in direct contrast with Mondrian's insistence on excluding all contained elements with expressive character of their own and throwing the whole burden of composition on a system of relations among non-expressive orthogonals.

Although in a practical way Malevich understood clearly enough what he was doing and what he was trying to do, his philosophy was more meagre than that of either Kandinsky or Mondrian. To the question of why, his answers were unclear. Yet his ideas are interesting both because he was the first artist deliberately to found a school of geometrical abstraction and because his influence on various trends of European Constructivism persisted through up to the Minimalists of the 1960s. The fullest statement of his ideas is contained in two essays which, translated into German, were published as a Bauhaus booklet in 1927 under the title *Die gegenstandslose Welt*. An English translation from the German was published in Chicago in 1959. There is no fully reasoned formulation of principles in *Die gegendstandslose Welt*, but a few dominant ideas give a certain coherence to the opinions he propounds. By 'non-objective', a term which he borrowed from Kandinsky, Malevich meant non-representational or non-iconic abstraction, a world of art devoid of forms which image or suggest the appearances of the natural world. To this extent the philosophy of his essay, obscure as it is, reflects the spirit of what Kandinsky later formulated when he wrote in 1938: 'This art creates alongside the real world a new world which has nothing to do *externally* with reality. It is subordinate *internally* to cosmic laws.' Negatively Malevich asserts that 'pure' art must not be utilitarian in the service of society and must neither represent nor idealize the things of the natural world. The former of these conditions was a repudiation of Russian Constructivism and its reduction of fine art to industrial design. The latter is more germane to our present theme. Malevich is definite not only that art *need* not, but that it *must* not, carry semantic information about the visible world, and he gives as his reason that representation

'obscures the true nature and function' of art. 'Suprematism', he says, 'is the rediscovery of pure art which in the course of time had become obscured by the accumulation of "things".'

On the positive side he alleges that the true function of art is the expression of feeling. 'Under Suprematism I understand the supremacy of pure feeling in creative art.' By 'pure feeling' he did not mean the emotions and affective associations which attach to people and things, ideas and events, in ordinary life. These emotions, he thought, merely stifle and distract from 'pure feeling'. But what he understood by it is unclear. Sometimes he speaks of 'feeling' in a sense for which we should nowadays rather speak of immediate sensation. Sometimes what he meant seems to have been closer to what Clive Bell and others called 'pure aesthetic emotion', that is affective response to the formal qualities of a composition which carries no representational or associative connotations. But Malevich also believed that this emotion, so aroused, is cosmic in character and brings one into contact with a realm of absolute and unchanging values. The appeal to 'pure' or cosmic feeling is indicative of a kind of mysticism not uncommon among abstract artists of a geometrical persuasion who are less concerned with the embodiment of personal emotions than with a putatively universal feeling and the achievement of a mystical sense of cosmic harmony. In point of fact what they have in mind could possibly be explained without appeal to mysticism by the heightening and expansion of the perceptive faculty exercised upon an aesthetic construct which, although it may be composed of intellectually simple elements, exists for perception as a single complex configuration or Gestalt. For a particular sort of emotional concomitant belongs to such intensification of perceptual alertness.

What is strangely lacking is any clear explanation why, having repudiated representation and semantic information, Malevich opted for the very simplest geometrical shapes – or indeed why geometrical abstraction rather than the expressive abstractions which were beginning to emerge in the Blaue Reiter school or the colour abstractions of the Orphists. He says indeed: 'The square=feeling; the white field=the void beyond feeling', and: 'The square changes and creates new forms, the elements of which can be classified in one way or another depending upon the feeling which gives rise to them.' But this is rationalization not explanation. Malevich voices no theory and no explanation of his restriction in Suprematism to the simple geo-

metrical shapes and to shapes deriving from them. The following quotations are typical of what he has to say about non-representation and feeling:

To the Suprematist the visual phenomena of the objective world are, in themselves, meaningless; the significant thing is feeling, as such, quite apart from the environment in which it is called forth.... Hence, to the Suprematist, the appropriate means of representation is always the one which gives fullest possible expression to feeling as such and which ignores the familiar appearance of objects. Objectivity, in itself, is meaningless to him; the concepts of the conscious mind are worthless. Feeling is the determining factor ... and thus art arrives at non-objective representation – Suprematism.

Suprematism did not bring into being a new world of feeling but rather, an altogether new and direct form of representation of the world of feeling.

And so there the new non-objective art stands – the expression of pure feeling, seeking no practical values, no ideas, no 'promised land.'

The Suprematists have deliberately given up objective representation of their surroundings in order to reach the summit of the true 'unmasked' art and from this vantage point to view life through the prism of pure artistic feeling.

Thus do we have, again and again, the opportunity of convincing ourselves that the guidance of our conscious minds – 'creation' with a purpose – always calls into being relative values (which is to say, valueless 'values') and that nothing but the expression of pure feeling of the subconscious or superconscious (nothing, that is, other than artistic creation) can give tangible form to absolute values.

Neo-Plasticism

Piet Mondrian was the principal figure in the Dutch movement Neo-Plasticism. Together with van Doesburg he founded the periodical *De Stijl* in 1917 and in 1920 he published the essay *Le Néo-Plasticisme*. His views are most concisely formulated in an essay 'Plastic Art and Pure Plastic Art' contributed to the Constructivist journal *Circle* in 1937, although his writing is difficult to interpret because of his habit of qualifying any major statement by the assertion of its opposite. But certain key ideas can be extracted.

Mondrian explicitly distinguishes two tendencies in art. One, which he calls objective, he describes as the 'direct creation of universal beauty', and the other, the subjective tendency, is the 'aesthetic expression of oneself'. Though he sometimes says that both elements

are necessary and that art demands a harmonization of the two tendencies, his more characteristic view seems to be that the history of art shows an evolution directed towards the intensification of the objective element and its purification from subjective expression. Thus he says: 'the evolution of the plastic arts shows that the dualism which has manifested itself in art is only relative and temporal' and the opposition of the two trends 'is actually an unreal one'.

He then claims that universal beauty does not arise from the particular character of the form, but from the dynamic rhythm of its inherent relations, or – in a composition – from 'the mutual relations of forms'. This provides him with a principle – lacking in the exposition of Malevich – for preferring non-figurative to figurative art, and ultimately Geometrical Abstraction which 'uses simple and neutral forms or, ultimately, the free line and the pure colour'. For very simple geometrical forms are the most free from subjective associations and emotion. On these lines he seeks to justify his own system of vertical and horizontal lines or bands and primary colours, for these are the most 'neutral' of all and throw the emphasis most completely on the relations among these elements.

As in the case of Malevich, however, it is patent that these arguments were in the nature of self-justification and that Mondrian was moved chiefly by a personal inclination for the clarity and precision of simple geometrical forms and a repugnance for the emotional and expressive kind of abstraction practised by Kandinsky. This is apparent in such sentences as the following: 'Through the clarity and simplicity of neutral forms non-figurative art has made the rectangular relation more and more determinate until finally it has established it through free lines which intersect and appear to form rectangles.'

Since any image, however geometrical it may be, even though it be a square or a circle, has *some* expressive character, a personality, as it were, of its own, Mondrian wished to construct compositions which consisted solely of systems of relations and were entirely free from such contained forms. Hence his restriction to orthogonals which repeated the rectilinear format of the picture without introducing interior contrasts or self-sufficient contained images. In this he differed from Ben Nicholson, who exploited simple rectilinear and circular images, and differed still more from Arp, whose simple, contained forms had distinct 'personality', sufficient expressive character indeed to warrant his having been exhibited among the Surrealists.

It is curious that although Arp's forms were *contained*, making no pretension to mirror the format of the canvas, it was Arp rather than Mondrian who was accepted as a precursor by those among the Minimalists who most pressingly advocated a mode of 'wholistic' composition in which the single image becomes the whole art work and also reflects or repeats the format of the canvas. In fact, however, the method of such artists as Frank Stella, in whose work a system of relations is set up based upon the format of the canvas, has distinct affinities with the principles by which Mondrian was guided. Van Doesburg's theoretical modification of Neo-Plasticism, which he named Elementarism, admitted diagonals and lines at an angle to the vertical, thereby breaching the strict isomorphism between image and format which was regarded as so important by the abstract painters of the 1960s that they introduced the shaped canvas in order to maintain isomorphism when they admitted the diagonal in the image.

Mondrian also arrogated a 'cosmic' character for this Geometrical Abstraction, claiming that it revealed the 'essence' of things. The evolution from the individual towards the universal and from the subjective towards the objective is 'towards the essence of things and of ourselves'. Art shows that there are 'constant truths' and 'fixed laws' concerning forms and their relations in composition: these may be regarded as subsidiary to the 'fundamental law of equivalence which creates dynamic equilibrium and *reveals the true content of reality*'. The laws which are 'more or less hidden' behind the superficial aspects of nature but revealed in geometrical abstract art are 'the great hidden laws of nature which art establishes in its own fashions'. Surrealism 'cannot touch true reality' because it remains in the realm of dreams, which are only a rearrangement of the events of life. But 'one can express our very essence through neutral constructive elements; that is to say, we can express the essence of art'.

Many of Mondrian's ideas, particularly his exaltation of the orthogonal and the primary colours, were based on those of the Dutch mathematician and Neo-Platonic philosopher Dr. Schoenmaekers, who published *Het nieuwe Wereldbeeld* (*The New Image of the World*) in 1915 and *Beeldende Wiskunde* (*Plastic Mathematics*) in 1916. But Mondrian clothed speculations with concrete reality and in addition had a certain visionary gift of his own which enabled him to look ahead to a time when the distinctions between paintings, sculpture and architecture would have disappeared and the art of Geometrical

Abstraction itself would invade and permeate the whole environment, being no longer distinct from it. He concluded his essay as follows:

It would be illogical to suppose that non-figurative art will remain stationary, for this art contains *a culture* of the use of new plastic means and their determinate relations.... This consequence brings us, in a future perhaps remote, towards *the end of art as a thing separated from our surrounding environment, which is the actual plastic reality.* But this end is at the same time a new beginning. Art will not only continue but will realise itself more and more. By the unification of architecture, sculpture and painting a new plastic reality will be created. Painting and sculpture will not manifest themselves as separate objects, nor as a 'mural art' which destroys architecture itself, nor as 'applied' art, but *being purely constructive* will aid the creation of an atmosphere not merely utilitarian or rational but also pure and complete in its beauty.

Originator and staunchest and most rigorous advocate of Neo-Plasticism as he was, Mondrian had a wider vision which coincided in its most important aspects with the basic outlook of Constructivism. It is therefore unnecessary in the present context to deal with the vicissitudes of Neo-Plasticism at greater length.

Post-War Constructivism

For a decade after the end of the War expressive abstract painting held the centre of the stage with a gamut of diverse manifestations. In sculpture radical innovation came later. During the first decade the great masters of expressive figural sculpture from the inter-war years were raised to new prominence. There were Alberto Giacometti and Germaine Richier. In Italy Marino Marini, Emilio Greco, Giacomo Manzù, and Andrea Cascella, though the last worked on the borders of Constructivism. In England Barbara Hepworth had cultivated a style of polished yet expressive abstraction. Moore was followed by a number of talented younger men working in an expressive manner – Kenneth Armitage, Bernard Meadows, Reg Butler, Lynn Chadwick, Ralph Brown. In the U.S.A. a number of sculptors such as Reuben Nakian, Ibram Lassaw, Herbert Ferber, and Theodore Roszack were the counterpart in their field of the Abstract Expressionists in painting. There followed a new sculptural use of assemblage led by Louise Nevelson, and there followed, too, the so-called 'junk' artists – Mark di Suvero, John Chamberlain, Richard Stankiewicz, and, in France, César Baldaccini – who, in a manner analogous to the

arte povera of Alberto Burri and Antonio Tápies, exploited for artistic purposes the expressive associations which attach to the detritus and rubbish of a technological society, welding together scrap steel, broken parts of wrecked machines, refuse from demolished buildings, and so on.

Meanwhile experiments were made with a new type of 'spatial' sculpture which had its antecedents partly in the work of the Constructivists Gabo, Pevsner, and Moholy-Nagy, partly in the pierced and holed sculpture of Moore and Hepworth. But the new sculpture was not content that space should penetrate the bulk of a work, being as it were absorbed and incorporated into its substance. Rather, by the use of transparent materials and by wires on thin metallic strips to define the form, space was converted into the major sculptural material, moulded and transformed.

Despite all this, however, it was not until the 1960s that sculpture came into its own as the primary artistic idiom and the medium most clearly adapted to the sensibility of the time. As it rose to prominence the very concept of sculpture changed. A new purpose and a new sensibility had taken hold upon artist and public alike. Even in superficial appearance the sculpture of the 1960s was so novel that a connoisseur from the 1930s might well have been in two minds whether to regard it as sculpture at all. The traditional processes of carving in wood or stone and modelling for casting in bronze, techniques by which the sculptor could leave the impress of his craftsmanship integrally engraved upon his work, were forsaken in favour of the more impersonal industrial techniques of welding steel and aluminium or, later, for the still more anonymous man-made materials such as perspex, vinyl, plexiglas, and so on. The leaders of the new sculpture were David Smith in America and Anthony Caro in England. They were succeeded in America by the school of Primary Structures or Minimal Art, and in England by a group of talented artists, several of them former pupils of Anthony Caro, who were brought to public attention by 'The New Generation' exhibition at the Whitechapel Gallery in 1965.

The roots of the new sculpture drew sustenance from Geometrical Abstraction and many of its attitudes were shared with the Constructivists. But in other respects its concepts were so novel that it belongs rather to the category of art which will be described subsequently under the heading of 'Concrete Art'.

A new impetus and a new direction were given to Constructivism in the post-War years by the publication in 1948 of Charles Biederman's *Art as the Evolution of Visual Knowledge*, followed in 1951 by *Letters on the New Art*, and in 1952 by *The New Cézanne*. These works were in line with the new trends and supplied what seemed to be a sound theoretical basis for the half-realized aims and inarticulate gropings which vitalize every new movement of aesthetics. The influence of Biederman's ideas was not only felt in America but stimulated a new Constructivist movement in England led by Kenneth Martin and Anthony Hill. His ideas were further disseminated through the magazine *Structure* founded in 1958 by the Dutch artist Joost Baljeu with the object of formulating a centralized aesthetics of Constructivism. Their greatest strength, however, lay in the fact that they seemed to express what many artists were already themselves feeling.

Biederman maintained that from the earliest times the making of art had been dominated by two conflicting impulses. One, the mimetic impulse, had led artists into a continual search for fresh techniques of representation which would enable them to make ever more exact reproductions of natural appearances. The other, the impulse to exercise man's innate inventive or creative powers, was manifested in the attempt to display the typical or generic and to represent an ideal instead of 'literally' recording the 'uniquely particular or individual characteristics of the objective world'. Throughout history, he said, the creative urge had been stifled or restricted by the mimetic function imposed upon art. Recently, however, since the invention of the camera, a few men had begun to understand that the job of recording natural appearances can now be done more efficiently by mechanical means and that artists must put it on one side and devote themselves wholly to 'invention'.

However, the 5th century Greeks, and the artists of the Renaissance, and all those who afterwards sought the 'ideal,' were thwarted in their effort to release the Inventive potential in man because they sought their objective by remaking nature's own forms, just as the majority are still doing in our own times. This not only confined and restricted the Inventive activity of the artist to the limiting forms of nature-art, but also set him in direct competition with nature, *on its own grounds* so to speak. This was a competition in which the cards were stacked against man! Today the impediment to this objective to create, to invent, has been removed by the Constructionist decision; man no longer needs to copy or manipulate the art of nature. When artists of the 20th century finally

realised that a mechanical recording instrument had been invented that was incomparably superior to the old primitive recording tools, it became possible for the advanced artists to leave the recording task to the Camera artists entirely and to concentrate on the Inventive factor which had previously been frustrated by the Mimetic task demanded of art.

From this he drew his justification for non-representational art as a 'must', holding that 'today there are very decided reasons why we should not make illusions if our objective is to produce invented forms'. But the argument went further. For him 'illusion' was not merely the representation of natural appearances but consisted basically in the creation of a three-dimensional image by the use of two-dimensional means. Therefore he thought that the avoidance of illusion involved doing away also with the picture image, with virtual three-dimensional picture space, whether the image was representational of the world of appearances or not. But the picture image in virtual picture space is inherent to the very nature of painting whether figurative or non-iconic and therefore, he held, painting as an art-form is obsolete and must be replaced by the three-dimensional construction. It was here that his influence was most directly felt, in the new 'construction' which was neither painting nor sculpture but avoided the 'illusory' third dimension, blurring the old distinction between the two. Thus Anthony Hill could write in *Structure*: 'Due to Charles Biederman these problems have been taken up by artists who accept the construction as the successor to the old domain of painting and sculpture.'

Biederman had yet another, more metaphysical argument why modern artists should abandon traditional painting in favour of three-dimensional construction. The artist, he claimed, even though his work is non-representational, does not cut himself off entirely from nature. He no longer reproduces the external appearances of the natural world but he does try to reproduce, or to work in harmony with, the *structure* of nature. Precisely what this assertion means is no more easy to understand than the similar statements of Kandinsky, Malevich, and Mondrian. But Biederman drew from it more drastic conclusions than they. He argued that since the natural world exists in three-dimensional space, art can only achieve structural harmony with nature if the art object is itself really three-dimensional instead of creating an image which is virtually but not actually in three dimensions.

Although Biederman's advocacy of an advanced form of Constructivism met ready acceptance, the arguments he adduced were not sound. In the first place, and perhaps most seriously, his jump from the position that since the invention of the camera representational art is no longer necessary to the position that representation is aesthetically restrictive and an impediment to creativity does not hold water. If something is no longer necessary, it does not follow that it is inevitably a hindrance or an encumbrance. It may still be a useful implement. And indeed it could just as cogently be argued, and has been argued, that the factor of representation ensures an artist additional possibilities of formal enrichment and complexity which are denied to him without it. Visually, the fact that a line or a patch of colour represents something endows it with a different emphasis and prominence, an insistence which it would not otherwise have in the formal relations of a picture and this psychological factor enriches the artist's means of organizing his composition, gives him an additional parameter and his picture a new dimension.

Nor is it clear that representation runs counter to creativity. The world of natural appearance does not exist in a state of neutral objectivity independently of being perceived, there to be reproduced accurately or inaccurately whether by man or by a camera. An appearance is always an appearance *to* somebody and how a thing appears to me or to you depends on our respective habits of perception, our inherited or cultivated ways of seeing the world. Whether we want to or not, we are of necessity bound to depict an *aspect* of nature if we depict at all, nature as it appears to us. And it might as plausibly be argued that it is depicting this or that aspect of nature that gives scope for the creative faculty. It is, indeed, precisely for this, for seeing and enabling others to see novel aspects of the perceptible world, that the great creative artists have been praised and admired. Although the belief that representation sullies the 'purity' of creative art has had a long history among non-iconic artists of this century, both Expressive and Constructivist, many of the most creative of artists, including Picasso and Matisse, have thought that pictorial art always reflects nature, if not directly at least in a less obvious way.

Furthermore even if we decide to eschew representation of appearances and accept a non-iconic art, it does not necessarily follow either that it must be Constructivist rather than Expressive, or that the picture image must be abolished. A construction built up in real three-

dimensional space is not necessarily more 'creative' than a picture with its own virtual space in which non-iconic forms move in mutual tension and balance. And the tension that is set up between the virtual picture image and the actual pigmented canvas has itself an aesthetic value. Patrick Heron agreed with Biederman that the illusion of three-dimension space is integral to painting as an art. While Biederman drew the conclusion that painting is therefore obsolete, Heron, speaking for hardedge Tachism, maintained that one must exploit to the full the possibilities of non-iconic 'colour-space'.

All this is not to imply that Biederman was *wrong* except if his arguments were held to constitute a valid objection to other styles than the advanced Constructivism which he advocated. He did provide a *rationale* for Constructivist art and even to some extent for the still more far-out modes of Concrete art still to be discussed. But the impact made by his books depended on the fact that they coincided with a widespread movement among an active body of artists in this direction.

Largely under the influence of Biederman and his American followers a new Constructivist movement grew up in England during the 1950s. Its leaders were Kenneth and Mary Martin, Anthony Hill, Victor Pasmore, and Adrian Heath. In 1951 Kenneth Martin published a *Broadsheet No.1* in conjuction with an exhibition at the A.I.A. Gallery, putting forward the ideas of the group, which were in fact little different from the ideas of the older Constructivists. After making the point that 'what is generally termed "abstract" ' – by which he meant non-iconic, Geometrical Abstraction – 'is not to be confused with abstraction from nature', he went on:

Just as an idea can be given a form so can form be given a meaning. By taking the severest form and developing it according to a strict rule, the painter can fill it with significance within the limitations imposed. Such limitations of form have been constantly used in poetry and music. The square, the circle, the triangle, etc., are primary elements in the vocabulary of form, not ends in themselves. In a rigorous form of art which uses as figures such formal elements, a complete pictorial expression can be achieved....

Proportion and analogy are at the base of such a pictorial architecture. The painting grows according to these laws and these have their counterpart in the laws of nature. Not painting which imitates the illusory and transient aspects of nature, but which copies nature in the laws of its activities.

Through such an analogy with nature and through its aspirations towards music, abstract painting fulfils a spiritual necessity. The painter creates towards a spiritual harmony using the most fundamental means ...

This was an interesting rediscovery of the basic ideas of pre-war International Constructivism. There was as yet little or no advance towards the new ideas of Concrete art or the exaggerated ideals of simplicity which characterized American Primary Structures. A concise statement of his conception of the Constructivist method as he understood it was contained in an article he wrote on 'The Development of the Mobile' in 1955.

In all these instances I have attempted to achieve a form from the simplest basic principles. I believe that this is fundamental to the constructivist idea. The work is the product of the simplest actions. It is not a reduction to a simple form of the complex scene before us, it is the building by simple events of an expressive whole. Our tools are like the notes of a piano. We can start with a simple sequence, we can order it according to one or two simple rules, the result could be like a fugue.

The preoccupation with simplicity which was common to most Constructivists from Malevich and Mondrian onwards is apparent here also, although the logical connection is not apparent. In Martin an artificial simplicity of means contrasts with the complexity of the result. A few simple basic forms are made by simple mathematical or logical but arbitrary rules to generate highly complex structures, kinetic or static. The simplicity of the structural principles is not, however, apparent in the result. The demand for a simple structural principle, which is not discernible by an observer who contemplates the finished work, remains arbitrary, illogical, and inexplicable.

12

The New Sensibility of the 1960s

In the 1960s there emerged a new conception of art drastically opposed to Expressive Abstraction, subjective emotionalism and rhetoric in all their forms. Although not entirely unheralded, it appeared with seemingly unprecedented abruptness and swept the field with the ruthlessness of a revolution so that critics spoke of a new sensibility and a new aesthetic. It was manifested in Pop art, in what has been called the New Humanism, and in the Minimal art of Primary Structures. We shall be concerned here with certain aspects of the new abstraction, specifically with what may be broadly described as the repudiation of artifice.

Though antecedents and anticipations of Post-Painterly Abstraction, Hard Edge painting, Minimal art, and the rest have been found in pre-war Geometrical Abstraction and Constructivism, and even in tendencies inherent in the work of some artists of the New York School, Barnett Newman in particular, the outlook of the younger artists was different, their interests and values clashed with traditional artistic values. The artists themselves were careful to differentiate their own work from apparent similarities in their predecessors. For example Frank Stella admitted in an interview with Bruce Glaser published in *Art News* (1966) that members of the Groupe de Recherche d'Art Visuel 'actually painted all the patterns before I did – all the basic designs that are in my painting ...' But, he went on, 'it still doesn't have anything to do with my painting. I find all that European geometric painting – sort of post-Max Bill school – a kind of curiosity – very dreary.' Asked why he wanted to avoid symmetry and compositional effects, Donald Judd replied: 'Well, those effects tend to carry with them all the structures, values, feelings of the whole European tradition. It suits me fine if that's all down the drain.... Vasarely's composition has the effect of order and quality that traditional European painting had, which I find pretty objectionable ...'

In place of the autobiographical, self-revelatory 'psychic improvisation' of Action Painting and *art informel* the aesthetic of the 1960s substituted an art of bland impersonality and disengagement, an art of anonymity, where the artist stood aloof from his work, refusing commitment and presenting it as an object among other made objects, more like a factory product than a personal document. A decade earlier William Baziotes said of his pictures: 'They are my mirror. They tell me what I am like at the moment.' Such language would be impossible

for the younger artists. Their interests were imperturbably fixed upon the work as an object with its own ideas and problems. Following Wittgenstein, recent philosophers have begun to discuss fine art as a 'form of life', something made by human beings for human beings within a socially accepted tradition of meaning, a mode of communication on a spiritual level. It is this which explains the difference between the excellence of an object of art and a thing of natural beauty or a factory product. The new art discounts this difference, eliminating the distinction between art object and objects in general. It makes little or no attempt to seduce or charm an audience. It is a deadpan art of the literal and matter-of-fact. The art object may be banal, obvious, boring – this is not regarded as a demerit. It's merit is that it is what it is seen to be, that and nothing else. As Stella said,

I always get into arguments with people who want to retain the old values in painting, the humanistic values that they always find on the canvas. If you pin them down, they always end up asserting that there is something there besides the paint on the canvas. My painting is based on the fact that only what can be seen *is* there. It really is an object. Any painting is an object and anyone who gets involved enough in this finally has to face up to the objectness of whatever it is that he's doing. He is making a thing. All that should be taken for granted. If painting were lean enough, accurate enough, or right enough, you would just be able to look at it. All I want anyone to get out of my paintings, and all I ever get out of them, is the fact that you can see the whole idea without any confusion.... What you see is what you see.

The new art of the 1960s was intellectual rather than sensuous in its impact, conceptual rather than perceptual. It not only went along with Constructivism in banishing the expressive aspects of the world but rejected too the perceptual richness and excitement which the Constructivists sought from the unification of a complex structure into a single perceptual Gestalt. It was an art of reduction, an art of deliberate impoverishment but without the romantic titillation that the Italian *arte povera* drew from its paradoxical use of the refuse and outworn materials of urban civilization.

If all this sounds negative, it was positively and deliberately so. From the point of view of this study, however, there were two very positive lines of advance which must be noticed in some, not all, of Minimal art and the new sculpture. One is the interest to encourage an intensification of perception (as, for example, induced colours at

the edges where two colour areas meet) not for their own sake as was done by Op art but for precise artistic purposes. The other tendency is a very general attempt, not to bridge, but to deny the gap between art and life, between the simplified art object and its environment. This was to be achieved not as in the past by thinking of the art object as a decoration to embellish architecture or natural surroundings but by making it an integral part of its surroundings. In the most recent sculpture the sculptured work becomes an object without privileged status in an environment of things.

Colour Field Painting

The large fields of saturated colour painted by Newman, Still, and Rothko in the late 1940s, the all-black canvases exhibited by Ad Reinhardt and the all-white panels of Robert Rauschenberg in the 1950s, initiated the trend towards Colour Field painting which had been practised by Yves Klein in a different context of ideas and which was still being elaborated in the 1970s by such artists as Francis Hoyland in England. The principle of such painting was quite contrary to the *White on White* of Malevich and the *Black on Black* of Rodchenko earlier in the century, for form was eliminated in order to give sole prominence to colour. The often very large size of these canvases ensured that they occupied the whole field of vision when a spectator stood at ordinary gallery distance from them and thus encouraged the spectator to immerse himself wholly in the sensation of colour perception. Discrimination being reduced to a minimum, perception (which in essence is discrimination) was carried in the direction of pure sensation. The tendency culminated in the more subtly modulated colour expanses of Jules Olitski, where the random modulations over the whole area forbid perceptual discrimination and create the impression of a colour haze existing entirely free of support. Colour is abstracted from form and is presented as a perceptual object in itself, not as a feature ancillary to the recognition of things and the discrimination of materials as we use it in practical life and not as an aid to the discrimination of shapes as it was made to function in Geometrical Abstraction. Enormous technical ingenuity was spent in order to produce a result free of any impression of artifice.

The most important reaction from the emotive use of colour practised by the school of Action Painting in America and favoured also

by Tachism and lyrical abstraction in France was the technique of staining unprimed canvas taken over by Morris Louis and Kenneth Noland from Helen Frankenthaler in the late 1950s. Influenced by the lyrical possibilities of the method in the work of Helen Frankenthaler, Morris Louis developed most consistently its artistic values in opposition to the 'painterly' techniques of the expressive brush-stroke as exploited by the Action painters such as Pollock and de Kooning, while Noland took it in a more structural direction leading on to the Hard Edge school that was to follow. These three painters took the first decisive step towards depersonalizing the expressive facture of Action painting and gestural painting, working to exclude the disturbing presence of the artist as it had radiated overwhelmingly from the manipulation of the artistic materials and pointing towards the cool objectivity which was the prevailing feature in the new aesthetic of the 1960s. In the work of Louis especially, colour was treated as an external phenomenon rather than an expressive vehicle of subjective emotion and colour became a perceptual object divorced equally from drawing and expression. The stained canvas was itself the perceptual object, no longer the bearer of an image other than itself whether representational or non-iconic. The paintings are divorced both from pictorial artifice and from subjective expressive appeal.

Of this tendency Robert Morris has said: 'Colour as it has been established in painting, notably by Olitski and Louis, is a quality not at all bound to stable forms. Michael Fried has pointed out that one of their major efforts has been, in fact, to free colour of drawn shape. They have done this either by enervating drawing (Louis) or eliminating it totally (recent Olitski), thereby establishing an autonomy for colour that was only indicated by Pollock.' He goes on to say that the 'essentially optical, immaterial, non-containable, non-tactile nature of colour' is incompatible with the physical nature of sculpture. The analogies of the new sculpture point in the direction of Hard Edge painting and they are of necessity only partial. The Colour Field trend led on towards the dematerialization of the art object with the effect of isolating the colour experience as a shimmering perceptual apparition unanchored in any physical reality. Stages in this progression were the vibrant colour flecks on a saturated ground and the delicately modulated colour discs of Robert Irwin, both in the later 1960s.

The large monochromatic canvases of Colour Field painting, which usurp the whole visual field but provide inadequate articulation of

form to sustain perceptual discrimination, encourage a state which has been called 'pure sensation'. In a spectator who persists in fixing attention upon them they may induce a state which has been likened to Oriental contemplation, which also results from fastening mental attention on an object inadequately articulated to sustain it.

Hard Edge Painting

The term 'Hard Edge' was coined by the critic Jules Langsner in America as an alternative to the older Geometrical Abstraction. It was taken up by Lawrence Alloway, who defined its application as follows in the catalogue of his exhibition 'Systemic Painting' at the Solomon R.Guggenheim Museum in 1966: 'The purpose of the term, as I used it in 1959–60, was to refer to the new development that combined economy of form and neatness of surface with fullness of colour, without continually raising memories of earlier geometric art. It was a way of stressing the wholistic properties of both the big asymmetrical shapes of Smith and Kelly and the symmetrical layouts of Liberman and Martin.' 'Hard Edge' became popular to describe the school of painting initiated by Ellsworth Kelly and Jack Youngerman, both of whom had known European Constructivism, Al Held, Leon Polk Smith, Charles Hinman, Raymond Parker and others. They took over from pre-war Constructivism the immaculate surface and impersonal machine-like facture – which they enhanced by the use of commercial and metallic paints – large areas of flat, uninflected colour, sharp boundaries, clarity of definition, and precision of forms. But they went further than this. Charles Biederman had maintained that since the 'illusionism' of the picture image is integral to the very idea of painting, painting as an art form is obsolete and must be supplanted by the three-dimensional construction. Patrick Heron, accepting that the illusionism of the image is inevitable in painting, wished to develop a new kind of image through the medium of a kind of space generated by colour itself.

These Hard-edge painters wanted to abolish, or at any rate to suppress, the image from painting – not, of course, merely the iconic or representational image, but that which differentiates a painting from coloured objects of perception in general. While they were not always fully or explicitly aware of this, this was the end to which their innovations tended. One of the more interesting devices they developed was

the use of forms, geometrical or not, which were incomplete Gestalten so that they seemed to lead out of the canvas and were inevitably completed by the spectator's eye outside the area of the picture. The psychological effect is to diminish the separation of the picture from its environment and to cause it to merge, as it were, into the surrounding space. The very large size of these paintings, or many of them, also had the effect that they seemed as it were to envelop the spectator, in much the same way that the recent sculpture often envelops, instead of standing posed before him as something to be inspected. The completed forms, part only of which were actually present on the canvas, would therefore carry not only outside the picture but outside and beyond the spectator's immediate field of vision. In addition to these fairly general characteristics other optical effects were cultivated in the field of colour perception, such as the juxtaposition and contrasts of close-value colours, or of hues at unusual and nearly identical levels of saturation and intensity, or the use of after-images and induced colours to contradict the sharp divisions defining the forms. Although not as extreme as the optical tricks exploited by Op art, all these devices had the effect of making the picture an objective phenomenon playing upon the senses rather than a mirror leading the eyes into an image world.

The transformation of the art work was carried yet a stage further by Jasper Johns in his Flag paintings. Johns did not paint a picture of a flag, an image, but a replica of a flag. This was possible because a flag simply *is* a specific pattern, that is its nature and its whole being, and by painting that pattern to occupy his complete canvas Johns was *making* a flag not – or not merely – making a picture of a flag. Yet Johns was a superb craftsman in the manipulation of paint and from a technical, artistic point of view what he made had the quality of a fine painting. The work was ambiguous: technically it was a painting; it was actually a flag; yet functionally it was intended to operate as a picture, not as a flag to be waved. Other objects whose nature is pattern, and which therefore invite such ambiguity, are the Targets also used by Johns and the Traffic Signs exploited by Winfred Gaul. But Gaul's motives and philosophy were very different from those of Johns, and it is illuminating to note the difference. Johns chose flags and targets because of their very banality. As Edward Lucie-Smith has written: 'The point about these images is largely their lack of point – the spectator looks for a specific meaning, the artist is largely

preoccupied with creating a surface. . . . Like Kenneth Noland, he is interested in pictorial inertia, for example. One of the reasons for choosing banal patterns is that they no longer generate any energy. He is also interested in the idea of the painting as an object rather than as a representation.'

Winfred Gaul, however, spoke of his work as follows:

In 1961 I began to turn my attention to a specific phenomenon of mobile society: traffic signs and signals. Traffic signs are contemporary and completely powerful, they are the real icons of the streets; more than that, they are subversive, subliminal, tabu-pictures, visible forms of an invisible norm. As art has primarily to do with this norm, even if it attacks or exposes it, traffic signs and signals seem to me to be especially suitable for an art which is concerned with communication. Whereas pop art and 'happenings' are happy only to imitate reality, to mirror real situations and thus to expose their commercialisation. I penetrate the waste landscapes of the barren cities. My 'signals' are the hieroglyphs of a new urban art. They usurp the banality of the jargon of their originals to form a new language of a new, cool and unexploited beauty. Their aesthetic is a new dimension, of harsh colours and gigantic shapes, an art whose place is amongst the skyscrapers and industrial buildings, on the intersections of motorways, flooded by traffic. Simultaneously inviting and forbidding, these huge signals stand in the landscape, at night illuminated by lamps, not painting, not sculpture, not a machine, without use, without a function – artificial objects, art objects.

We may deplore the rhetoric and bombast, suspect the idea and dislike the achievement. But the idea and the intention are clear and they are at the opposite pole from those of Johns and the Minimal art which followed.

Frank Stella took the Flag paintings of Jasper Johns as the point of departure for his *Coney Island* and *Grape Island* of 1958. In both these paintings the horizontal bands echo the stripes of the flag and emphasize the flatness of the picture. But whereas in Johns the flag motif is coextensive with the picture – where the flag ends the picture ends – Stella's horizontals have no logical or psychological ending but run indefinitely beyond the perimeter of the picture. The motif is not closed but is open in all directions like a diaper pattern, and this is a feature of most of his paintings in the early 1960s, even the shaped canvases such as *Gezira* (1960), *Ophir* (1960–1), *Ouray* (1960–1), *Ifafa* II (1964). On the other hand he does not, like many of the Hard Edge painters, use forms which because they are incomplete Gestalten *demand* to be completed outside the area of the picture. The pictures

are enormous and the visual complexity is reduced to a minimum: the simple pattern ends unemphatically where the picture happens to end. It is a quality which cannot be experienced from a small reproduction in a catalogue or a book.

The flatness and the suppression of the image are reinforced by the nature of the patterns, which echo the horizontal, vertical, or diagonal axes of the picture, thus tying together the motif and the conformation of the picture as a physical object. Other artists have used the device of making the motif echo the contours of the physical canvas, but few so consistently or effectively as Stella. The effect is heightened by his use of notched and shaped canvases, where the shaping of the contour is dictated by the demand of a simple pattern. It is an effect which he managed to maintain even in pictures where he combined disparate geometrical shapes such as *Conway 1* (1966) and *Moulton-boro III* (1966). And something of the same effect is achieved, though necessarily rather more complex, in pictures such as *Flin Flon III* (1969) and *Khurasan Gate Variation 1* in which he uses circles and arcs in a rectilinear format.

Besides the flatness, the suppression of the image and the identification of the picture with the patterned physical object, Stella was at one with the prevailing ideas of the 1960s in his insistence upon the 'non-relational' character of his patterns. His motifs were not constructed from related parts in the traditional manner of composition. They were, for example, a complete refutation of Mondrian's conception that composition consists in the establishment of a complex set of relations among geometrically simple elements. In Stella's pictures there are, ideally, no elements to be related. Even the figure–ground relation is eliminated or in some cases transformed and concealed by a kind of conjuring trick. He carried yet further into the geometrical sphere the 'all-over' system initiated by Jackson Pollock and exploited by Cy Twombly and Jack Tworkov. After 1959 there are no centres of interest in his pictures to be balanced or symmetrically related: interest is evenly distributed over the whole, though nowhere invited.

It is because in this sense he is endeavouring to create Primary Structures – objects which are not composed or constructed by relating isolatable parts into a system – that Stella is classified with the Minimalists.

Primary Structures

Like so many of the labels which have enjoyed a vogue in the literature of twentieth-century art, 'Minimal art' has ballooned to such an extent that its original meaning has become blurred and its usefulness diminished. Introduced by Richard Wollheim in an article contributed to *Arts Magazine* for January 1965, it carried from the first two shades of meaning related conceptually but pointing to two very different kinds of art. On the one hand the term refers to works which display a less-than-usual degree of internal differentiation and therefore (though this does not necessarily follow) a 'minimal' amount of 'artwork' on the part of the artist. The ancestors of this kind of Minimal art were Suprematist works by Malevich and his followers, monochrome canvases by Yves Klein, and monochrome or near-monochrome works by so-called Abstract Expressionists such as Barnett Newman, Clyfford Still, and Ad Reinhardt. Though their aesthetic outlook is different, many artists of this school have affinities with prewar Constructivism. The other type of Minimal art consists of art works whose internal differentiation may in some cases be 'very considerable', but which comes 'not from the artist but from a non-artistic source, like nature or the factory'. The type includes works by Claes Oldenburg, Roy Lichtenstein, Andy Warhol, Richard Hamilton. Among their ancestors were the 'ready mades' of Marcel Duchamp and in some cases they have carried to extremes the use or incorporation of real materials and real objects in art works which was anticipated by the Synthetic Cubists and by Kurt Schwitters. It is with the former school of Minimal art that we are primarily concerned here, and in particular with its doctrine of Primary Structures.

The term 'Primary Structures' was used of a kind of sculpture based on highly simplified geometrical forms which was foreshadowed by the late works of David Smith and blossomed in the years immediately following his early death in 1965. Its chief exponents were Tony Smith, Carl Andre, Donald Judd, Dan Flavin, Robert Morris, Ronald Bladen, Walter De Maria. The style obtained public recognition at an exhibition entitled 'Primary Structures' arranged by Kynaston McShine at the Jewish Museum, New York, in 1966, but it was recognized that some artists had been doing this sort of work since about 1961. The term has been quite loosely applied and it has been extended to painting and to Serial or Systemic art based on the repetition of

a simple modular form. If a central core of meaning can be found, it is that of a work of art which, contrary to Mondrian's idea, is not constructed as a unitary system of interrelated elementary parts, but is itself a single elementary, immediately apprehensible, visual whole, which cannot be visually analysed into a plurality of contained parts. The word used is 'wholistic'. The formal motif and the work are identical and inseparable. The monochromatic works of Barnett Newman and his *Stations of the Cross* are sometimes referred to as the prototypes of this. Lawrence Alloway said of them: 'Newman asserted the wholistic character of painting with a rigour previously unknown; his paintings could not be seen or analyzed in terms of small parts. There are no subdivisions or placement problems; the total field is the unit of meaning.' It was this idea which motivated the defence of 'non-relational' art by Stella and Judd and their rejection of traditional composition and construction. Judd said:

when you start relating parts, in the first place you're assuming you have a vague whole – the rectangle of the canvas – and definite parts, which is all screwed up, because you should have a definite *whole* and maybe no parts or very few. The parts are always more important than the whole ... the whole's it. The big problem is to maintain the sense of the whole thing ... You see, the big problem is that anything that is not absolutely plain begins to have parts in some way. The thing is to be able to work and do different things and yet not break up the wholeness that a piece has.

Commenting on Mondrian's statement about relations, Robert Morris in his article is *Artforum* 'Notes on Sculpture' (1966) put the matter more precisely and more fully in a statement which might well be regarded as a definitive formulation of the principle of Primary Structures:

A single, pure sensation cannot be transmissible precisely because one perceives simultaneously more than one property as parts in any given situation: if color, then also dimension; if flatness, then texture, etc. However, certain forms do exist that, if they do not negate the numerous relative sensations of color to texture, scale to mass, etc., do not present clearly separated parts for these kinds of relations to be established in terms of shapes. Such are the simpler forms that create strong gestalt sensations. Their parts are bound together in such a way that they offer maximum resistance to perceptual separation. In terms of solids, or forms applicable to sculpture, these gestalt are the simpler polyhedrons. It is necessary to consider for a moment the nature of three-dimensional gestalts as they occur in the apprehension of the

various types of polyhedrons. In the simpler regular polyhedrons, such as cubes and pyramids, one need not move around the object for the sense of the whole, the gestalt, to occur. One sees and immediately 'believes' that the pattern within one's mind corresponds to the essential fact of the object. Belief in this sense is both a kind of faith in spatial extension and a visualisation of that extension. In other words, it is those aspects of apprehension that are not coexistent with the visual field but rather the result of the experience of the visual field. The more specific nature of this belief and how it is formed involve perceptual theories of 'constancy of shape,' 'tendencies toward simplicity,' kinesthetic clues, memory traces, and physiological factors regarding the nature of binocular parallax vision and the structure of the retina and the brain. Neither the theories nor the experiences of gestalt effects relating to three-dimensional bodies are as simple and clear as for two dimensions. But experience of solids establishes the fact that, as in flat forms, some configurations are dominated by wholeness, others tend to separate into parts. This becomes clear if the other types of polyhedrons are considered. In the complex regular type there is a weakening of visualisation as the number of sides increases. A sixty-four-sided figure is difficult to visualise yet because of its regularity one senses the whole, even if seen from a single viewpoint. Simple irregular polyhedrons, such as beams, inclined planes, truncated pyramids, are relatively more easy to visualise and sense as wholes. The fact that some are less familiar than the regular geometric forms does not affect the formation of a gestalt. Rather, the irregularity becomes a particularising quality. Complex irregular polyhedrons (for example, crystal formations) if they are complex and irregular enough can frustrate visualisation almost completely, in which case it is difficult to maintain one is experiencing a gestalt. Complex irregular polyhedrons allow for divisibility of parts insofar as they create weak gestalts. They would seem to return to one of the conditions of works that, in Mondrian's terms, transmit relations easily in that their parts separate. Complex regular polyhedrons are more ambiguous in this respect. The simpler regular and irregular ones maintain the maximum resistance to being confronted as objects with separate parts. They seem to fail to present lines of fracture by which they could divide for easy part-to-part relationships to be established. I term these simple regular and irregular polyhedrons 'unitary' forms. Sculpture involving unitary forms, being bound together as it is with a kind of energy provided by the gestalt, often elicits the complaint among critics that such works are beyond analysis.

This formulation is important because it brings to the surface a misapprehension whose tendency has been to exaggerate the difference between the art of the 1960s and traditional art in a way which twentieth-century innovators in France and Britain have fortunately

escaped. It is a misapprehension about the nature of Gestalt perception, or the perception of an artistic configuration. A Gestalt is a presentation which is directly apprehended perceptually as a single unity, not intellectually put together from separate parts. But it is not necessarily or usually without parts. It may be directly perceived as a unity of parts. Draw six dots in the form of a triangle. This presentation is directly perceived as a triangle, but as a triangle of dots. We are aware of a plurality (six) of dots as we are aware of the triangle. (The triangle exists to perception only as a presentation of all the dots: it is an 'emergent' perception. Not one, two, or three of the dots constitute a perceptual triangle. Take even one dot away and you see an open arrow-head, not a triangle. Intellectually, the six dots could be related in a variety of other ways.) This is a very elementary example of a Gestalt with parts. Perceptual Gestalten may be complete or open, simple or complex, unequivocal or ambiguous.

Traditional composition, if successful, involves the creation of a very complex Gestalt which is apprehensible as a single perceptual unity, a unity of contained parts related by rhythms, balance, symmetries, etc. at various levels of containment, but none the less ultimately a perceptual unity of Gestalt. The contained parts are not simply related intellectually but are apprehended in perception as a Gestalt. Though far more complex, it is the same principle as the triangle of six dots. Awareness of a composition-Gestalt is not (not usually) 'immediate' as our apprehension of a simple polyhedron is immediate, but is the result of a process – perhaps a long and laborious process – of familiarization. The apprehension of fine pictorial compositions makes demands on the observer; the preparatory familiarization may be strenuous, depending on the past experience and visual habits of each observer. But the demands are justified and the efforts repaid because of the enrichment and expansion of the perceptual act accruing. A masterpiece of art, even though it may be *intellectually* simple, is the most subtly complex Gestalt which the world has to offer to perception. It extends and enlarges the perceptual faculty beyond all else. There may be other values too: it may represent a landscape, indicate character, may be symbolic, may be expressive, etc. But unless it has the formal property of being a perceptual Gestalt, it is not successful as art.

Apprehension of a compositional work of art is direct but is not immediate, for it is the outcome of a process of familiarization. (The

apprehension of music also is not immediate, but for different reasons. We perceive a melody as a Gestalt: that is what it means to perceive a *melody* and not just a succession of unrelated notes. And we apprehend a musical composition as a Gestalt, a unity though more complex. But the apprehension is not immediate since time is involved in the perception. It is, however, direct in the same way that apprehension of visual Gestalt is direct: it is not intellectually constructed from discrete relations.) Apprehension of a simple polyhedron is both direct and immediate. It is immediate because it falls *within* existing perceptual habits and the experience does not in any way expand or enlarge perception. We can visualize a simple polyhedron. But in the ordinary sense of the word we can 'visualize' any Gestalt which we have apprehended in perception, though powers of visualization vary from person to person. One of the boons accruing from successful exposure to works of art is an extension of one's visualizing powers.

When internal differentiation is reduced as is done in Minimal art and when very simple forms are presented, forms which can be apprehended immediately without effort – 'visualized' in Morris's language – there is a likelihood that they will be boring to the spectator and to the artist. They will be boring because they fall within the boundaries of existing perceptual powers, demand no concentration of effort, and therefore do nothing to expand or enrich perception. This fact has been frequently noted and controverted. In his history *American Art in the 20th Century* Professor Sam Hunter calls the chapter in which he discusses this kind of art 'The Aesthetics of Boredom'. Lawrence Alloway has said:

When we view art as an object we view it in opposition to the process of signification. Meaning follows from the presence of the work of art, not from its capacity to signify absent events or values (a landscape, the Passion, or whatever). This does not mean we are faced with an art of nothingness or boredom as has been said with boring frequency. On the contrary, it suggests that the experience of meaning has to be sought in other ways.

When internal relations within the art work are expunged as in the 'primary forms' of Morris or when they are reduced to the mere juxtaposition of modular forms as in serial art, in order to rescue interest from being swamped by perceptual boredom there supervenes a reflex concern for establishing relations between the art work and its environment and between the art work and the spectator. Morris himself

has said that whereas in earlier art 'what is to be had from the work is located strictly within' it (he is speaking here, of course, of the *formal* properties), 'the better new work takes relationships out of the work and makes them a function of space, light and the viewer's field of vision. The object is but one of the terms in the newer aesthetic.' In accordance with this trend much attention has been given to 'space modifying' and 'space distorting' work, sculpture is often constructed deliberately to fit a specific environment, and a new interest has been taken in 'scale'. Ronald Bladen's *The X* is an enormous cross 22 ft. 8 in. high reaching out from the floor to the walls and roof and dwarfing the hall where it was constructed. The young British sculptor David Hall made a sculpture which he called *Nine*, consisting of metal plates hovering at different angles a few inches above the floor of the gallery. Of this Edward Lucie-Smith has said: 'The shapes suggest perspectives that conflict with the true perspectives of the room. The whole work acts as a mechanism for bending and distorting space. One notices, not the piece itself, but its alteration of the area it occupies.' In Britain the sculpture of Anthony Caro, most of it, and the younger group of sculptors which includes Phillip King, Tim Scott, William Tucker, Isaac Witkin, is not set upon pedestals to confront the spectator like an actor mouthing on the stage, but stands on the ground, where it creates its own space and an environment into which the spectator is invited to enter as a participant. Richard Smith habitually made his works specifically for each exhibition, adapting them to the space in which they were to be exhibited.

13

Concrete Art and the Repudiation of Artifice

When we look at a picture under favourable conditions we do not see – or do not only see – an area of framed canvas smeared with vari-coloured pigments. We do indeed see this. But what we primarily see and what occupies the forefront of attention is an organized system of coloured shapes which is called the 'picture image'. To a greater or less degree perception of the pigmented canvas is recessive or, as is sometimes said, the canvas becomes 'transparent' in the way that words become 'transparent' when attention is concentrated on their meaning. But not wholly transparent. As when we read poetry we notice the sensuous quality of the language, the rhythm of the words, so in looking at pictures we retain some awareness of their physical characteristics, the sensuous qualities of the paint, the expressive manner in which it has been set on the canvas, or perhaps the very impersonal and deliberately unexpressive nature of the facture.

This dual way of seeing is the natural way of looking at pictures; indeed it is what is meant by seeing an artefact *as a picture*. It is the *raison d'être* of pictures: they are made – or until recently they always were made – in order to be seen in this way. When we see a picture in this way we are not *merely* seeing it as one physical object among others in a room, so many centimetres long and so many high, needing so much space when crated for transport, and so on. We are *also* seeing a 'picture image' which has its own independent and incommensurable spatial co-ordinates and which we are aware of as in some sense 'resident in' the physical artefact before us. Different painters and different schools of painting have attached different degrees of importance to maintaining a tension between our awareness of the picture image and our awareness of the physical painting. In Renaissance times emphasis was placed on the image, both as representing something and as manifesting its own attributes of harmonious colour and design. But at least there was residual awareness that one was confronted with a physical artefact in which the 'image' was anchored. When this is lost we get *trompe l'œil*, which is a kind of visual conjuring trick tending to delude the observer into believing that he is *not* looking at a picture. In twentieth-century painting, as has been said, there was a strong tendency to 'bring back to visibility the picture surface', heightening the tension between seeing the picture image and seeing the picture as a physical object. The newest trend, which will now be our concern, is to suppress or eliminate the picture image and to place the emphasis on seeing the picture as a physical artefact. If this

tendency is carried to the extreme and the image is completely done away with, we are no longer seeing the artefact as a *picture* in any traditional sense of the word – although it may still be a work of art.

As a material artefact the picture exists in the common space in which we live and move. But the picture image creates a space of its own called 'virtual' space, which is incommensurable with the space in which our bodies move and the space of the room in which the picture hangs. Although the material canvas which 'carries' the picture image is two-dimensional, the image is always and inevitably three-dimensional. (This is what painters mean when they say, as they often do, that the image breaks or destroys the unity of the picture surface. Even a single black mark on a white ground creates a 'hole'.) And the image may have other qualities, too, which are incompatible with those of the material pigmented surface. It may have the transparency of glass, the lustre of velvet, the metallic sheen of copper, the glow of fire, the luminosity of the sky, the smooth texture of peach blossom, and so on. Nor need the image be representational. If it is not, it may still have qualities of saturation, brightness, ambiguity, rhythm, tension, and many others which are not present in the material artefact and are practically impossible to obtain except in a picture image. It is such recondite qualities that have been exploited in particular by many of the modern schools such as Op art, Hard Edge painting, etc.

Philosophically the picture image has a curious mode of existence. It is not an illusion, as some recent artists and critics have liked to assert. For illusion involves an element of deception. But we know what a picture image is and when we are looking at a picture we are not deceived. We know that we are looking at a picture image and have no inclination to believe that it is part of the real-world environment, that the virtual space in which the picture image exists, or its other virtual properties, are part of the real world. When such a mistake occurs, as it may in *trompe l'œil*, the mistake arises from the fact that we are imperfectly aware of what we are seeing as a picture image. It is not a mistake that is typical of normal picture viewing. Yet in normal picture viewing the image and its properties are as real for perception as any other percept, as real as the physical artefact which we also see. There is no doubt that we are seeing it and that it is as we see it, having the properties which we see in it. Part of the delight in looking at pictures is just this, that visually the perceptual experience is completely real but we know at the same time it is a reality

that cannot be accommodated into the reality of the external world and that the incipient tactile, kinetic, gustatory, olfactory, or other sensations that are sometimes evoked, live in imagination only, could not exist except in association with the visual image. Since, too, the space occupied by the picture image may be incomparably more vast than the actual physical size of the picture to which our eyes must accommodate themselves, the interactions of colours and shapes, the rhythms of similarity and contrast set up in the picture image, are intensified to a far, far greater extent than is ever possible in ordinary seeing.

Pictures are representational or non-representational, and both in various degrees. They are called representational when the picture image reminds us of things (in the sense of representing them) we are familiar with in the real world, or alternatively, if the picture belongs to the world of fantasy, when it images things which for the time being we accept as inhabiting a real world or a fantasy world which, as in a fairy story, we for the time being welcome as real. When a picture is non-iconic the question of real or fantasy does not arise for we accept that the image conveys no information about anything other than itself. The avoidance of representation, which lies at the heart of the trend towards abstraction which we have so far been discussing, is not the same thing as the repression of the image, the newest trend though not without its foreshadowings and anticipations. A picture image may be representational or abstract, and an abstract picture still presents a picture image not identical with the physical artefact. If when you look at a picture by Jackson Pollock or Roger Bissière or Antonio Suarez you have not seen the picture image, you have not seen the picture. The abolition of the image is an entirely different matter from the abolition of representation.

In a rather different way sculptures also create an image which is not identical with the physical artefact of stone or wood or metal. A piece of sculpture is a voluminous physical object which like any other physical object occupies its own space in a gallery or on the façade of a building or in the open air. But it also has internal scale and creates its private space which cannot be measured up against the actual space which it physically occupies. A small sculpture may be monumental in scale and a large one may be mean and constricted in its forms. A piece of sculpture suggests internal structure, energy, movement, tension, planes running through and behind the visible surface: all

these, with harmony, balance and rhythm of forms, are properties of the image. The physical materials of polished or rough stone, cast bronze or carved wood do not remain unchanged in the image, though their sensuous qualities contribute to it. There are qualities of rhythm and counterpoint pervading the image which disappear when you look at the work piecemeal as a bit of shaped wood or stone. All these qualities are directly perceived, not imagined; they are part of the phenomenology of sculptural perception, and awareness of them is integral to seeing sculpture as sculpture. This is one of the reasons why a stuffed animal is not sculpture, why a wax model, however lifelike, or a life-cast of a handsome woman or an athletically proportioned man, will be banal and lifeless if looked at as we look at sculpture. This too explains why an abstract composition which is exciting and stimulating as a three-dimensional image emergent from a pigmented canvas or a flat collage may be vapid and dull if reproduced in actual low relief. It is a matter which Biederman and his followers failed to understand. When in the name of the new Constructivism they outlawed the picture image and put in its place the three-dimensional construction in actual materials they did not take into account that the construct also brings into being its image. The abolition of the image, which is what now concerns us, carries this trend of artistic asceticism a long step further. It is in effect a repudiation of *artifice* as such.

In what follows I propose to discuss a propensity which has shown itself, with increasing assertiveness and impetuosity as the century advanced, in attempts to eliminate the picture image and virtual picture space along with all 'artificial' qualities that are attached to them so that the physical materials from which a work of art is made shall retain just those visual properties they elsewhere have, those and no others, and shall be seen starkly for what they are. This is quite a different thing from a preference for non-iconic instead of representational imagery and is a far more radical step than the abolition of representation. It is not a mode of abstraction but rather a revulsion from *artifice*, and it involves an assumption that a work of art should be an artefact put into the world on a par with any other artefact, should be seen as such, that and no more. When a work of art is thought of in this way there is no more point in talking about abstraction or the lack of it than there would be in the case of a bridge or a motor-car or a piece of domestic architecture. Although this ten-

dency has been manifested chiefly in the context of Geometrical Abstraction, as when post-war Constructivists have sought to do away with the sort of picture images that Mondrian and other earlier Constructivists admitted, it may also be manifested in figurative work. The existential sculptural tableaux of George Segal use both fragments of real things – doors, windows, furniture – and plaster casts taken from the life with no attempt to hide their trite and banal quality. Real objects are used in 'situations', assemblages, collages, etc. instead of the picture image. Perhaps the most significant feature in recent art has been the drastic and often doctrinaire jettisoning of these forms of artifice, especially the picture image, which until the present century, and by most artists most of the time until about 1960, have been assumed to belong essentially to the very nature and concept of painting and sculpture.

Although its particular manifestations have been noticed often enough by the critics and those who take it upon themselves to interpret what is happening in the arts, the tendency itself has not hitherto been segregated or named. I propose to adopt the term 'Concrete' for the kind of art envisaged by those who are under the sway of these ideas.

The word 'concrete' has paraded with many different shades of meaning in the literature of the arts since the middle of the nineteenth century. In his Realist Manifesto of 1861 Gustav Courbet, as was seen, understood by 'concrete' art a representational art which carries a veridical image of 'real and existing things' in contrast to the religious and historical art of the Academies and to imaginative art in general. Thus the meaning he attached to the word was almost exactly the opposite of what it later came to mean when it carried the implication either that the image was non-representational or that there was no image at all. The latter meaning arose in protest against the language of the critics and reviewers who during the 1920s and 1930s often used the word 'abstract' in a pejorative sense without distinguishing between semantic and non-iconic abstraction. Using 'concrete' as the antonym of 'abstract', van Doesburg then claimed that Constructivist art, and specifically Neo-Plasticism, was not abstract in the sense of semantic abstraction but was constructed from fully concrete elements: a line and a square, he declared, are as concrete as anything there is. We have earlier noticed the anomaly of calling non-iconic art abstract. Nevertheless the usage continued, as is evidenced by the

formation of the Abstraction-Création group in 1931 and the fashion which continues until now of calling all non-representational art 'abstract'. Kandinsky spoke of a 'concrete' art of expressive abstraction. But in general the word 'concrete' has been restricted to Geometrical Abstraction or Constructivism.

'Concrete' was first used as a technical term to refer to a certain category of twentieth-century art when van Doesburg adopted it as the title of his Manifesto of 1930, and this laid down principles indistinguishable from those of Constructivism. The term – *Konkrete Kunst* – was taken up by Max Bill in Switzerland and was introduced by him to Brasil and Argentine. From there it came back and in 1948 the Movimento per l'arte concreta (MAC) was formed in Italy under the auspices of Atanasio Soldati, Bruno Munari, and the critic Gillo Dorfles. Max Bill gave to the term *Konkrete Kunst* a particular slant in the direction of art which was generated from mathematical formulae or from mathematically defined systems of proportion. But the exhibitions which he organized under this title comprised much more than this and were in fact identical with what was meant by Constructivist art. Max Bill's own definition for 'concrete art' was, as we have seen, a definition of Constructivism. And the first important exhibition of non-iconic abstract art after the war, staged at the Galerie René Drouin, Paris, with the collaboration of Mme van Doesburg, was entitled *Art Concret*, although it included works by such diverse artists as the Delaunays, Mondrian, Kandinsky, Magnelli, Herbin, Taeuber-Arp, and Pevsner.

It is clear, therefore, that at this time, in the decade following the end of the war, the term 'concrete' had not yet acquired a distinctive connotation differentiating it from Constructivism. The tendency we are tracing had not yet become fully conscious or sharply defined in men's minds. Yet its active presence is amply evidenced by the language that was used: the slogan 'real materials, real space' was much on men's lips in connection with newly emerging styles of art production. Now, since the new art has grown to maturity in the 1960's, there is every need to find a term by which to distinguish from the older forms of Geometrical Abstraction this newer art which eschews the picture image and virtual space and presents the work of art as an artefact on a par with other artefacts. The choice of 'concrete' has every justification. It has followed the emergence of the ideas which dominate the kinds of art we shall now describe.

I want now to mention the more notable anticipations of this trend which came to maturity in the 1960s.

(1) I have already alluded to a concern which gained strength among many artists after *alla prima* painting came into vogue to bring the pigmented surface of the canvas back to life and visibility as a material substance in its own right, so that looking at the picture we should not only see the picture image as if through a clear glass window but should also be aware of the painted canvas as an artefact. In line with this tendency the practice of artificially reducing the depth of the picture space was systematically adopted by several groups of artists, including the Cubists, during the early decades of the century and 'preserving the picture plane' became something of a fetish. In addition to this, once the picture surface was brought more prominently to attention it became possible to exploit the expressive character of its texture in order to reinforce the expressive character of the image or of the objects represented by the image. Van Gogh is, of course, the outstanding example of this kind of exploitation. The aim of these innovations was rather to set up a tension between the physical art work seen as a material artefact and the picture image than to abolish either one or the other, but a certain doctrinaire emphasis upon the importance of the physical art work lends them relevance. First the art work must be seen as a material artefact before it can be seen as only that.

(2) From about 1912 the Synthetic Cubists began to experiment with actual low reliefs instead of painting virtual space and began to use real materials – oilcloth, wallpaper, newspaper, etc. – in their collages. Neither these reliefs nor the polychrome constructions of Laurens went very far towards the abolition of the picture image and the collages sought to create deliberate ambiguity within a narrow, box-like picture space. The real materials incorporated into the picture were made to be seen in a twofold aspect, both as the real materials they were and at the same time appearing as something else in the 'illusory' picture image. Yet highly sophisticated as these experiments were, the innovations of Synthetic Cubism represent the first emergence of a type of art object on the border between painting and sculpture and the first undisguised use of real materials in the art object.

(3) The most interesting anticipation came from Russia. After visiting Picasso in 1913 Tatlin began to make constructions incorporating real

things and existing in real space without virtual picture space. They were to be seen for just what they were, just as any other artefact constructed and hung in a corner. The same thing applied to Rodchenko's 'Hanging Reliefs' made about 1920. The materials simulate nothing but themselves and no virtual image is created. These are true anticipations of the post-war constructions which inaugurated a new art-form between painting and sculpture. But this anticipation was prevented from developing further by the obsession of the Russian Constructivists with the idea that art must be socially useful. In his Manifesto *The World Ahead of Us*, dated 31 December 1920, Tatlin restricted artistic activity to the making of models for functional engineering projects. 'In this way', he said, 'an opportunity emerges of uniting purely artistic form with utilitarian intentions.' He cited as an example his own model of a *Monument to the Third International*.

The new constructions of the post-war years had the sort of visual reality which belongs to engineering models but with the proviso that utilitarian function was not envisaged.

(4) The special branch of Geometrical Abstraction commonly known as Op art also falls beneath the umbrella of Concrete art. At first sight this may seem a strange classification since Op art relies specifically on the exploitation of optical illusions and ambiguities for calculated effects. It makes systematic use of such illusions as the moire effect; distortion of regular geometrical shapes against a background with strong directional cues; transformations in a periodic pattern effected by varying the size, shape, or placement of basic geometrical units; manipulations of planned variations in a regular pattern to cause the surface to warp, swell, advance, or recede; induced after-images which cause ambiguities; and many more. In a fairly straightforward manner Josef Albers in his *Interiors* of the 1940s and his *Structural Constellations* of the 1950s and 1960s explored what he called the 'discrepancy between physical fact and psychic effect'. The sort of ambiguity often courted by Victor Vasarely, Bridget Riley, and François Morellet arises when two incompatible 'psychic effects' are produced by the same geometrical construction.

But these optical illusions and ambiguities are not specifically *artistic* effects. They do not belong to a picture image that is created, for none is created. They fall within the ambit of illusions and ambi-

guities which occur in ordinary, everyday perception though they are deliberate exaggerations and enhancements of marginal instances of these. They derive from the sort of phenomena studied in psychological laboratories engaged in the investigation of perceptual laws and they are paralleled by the textbook and laboratory figures which are the ordinary weaponry of psychologists. The work of artists such as those in the *Groupe de Recherche d'Art Visuel* has no doubt added to and refined the result of purely psychological research into this very specialized field of perception. Whether or not the results lend themselves to aesthetic purposes depends on the talents and aims of each artist. As Concrete art in general has embraced as one of its aims the intention to narrow the gap between art and life until the distinction is lost, so Op art reduced the gap between art and the ordinary practice of the research laboratories.

By the use of planned ambiguity to induce a calculated and uncomfortable sensation of instability in the spectator Op art may create an illusion of movement. The term *cinétisme* was applied to this kind of painting by Vasarely, one of its originators, and critics have thereafter classified it as a form of kinetic art. It lies in fact midway between the kind of art which tries to create *virtual* movement but ends up with internal dynamism and the modern kinetic art which utilizes actual moving parts.

Kinetic Art

From about the middle of the nineteenth century the word 'kinetics' entered the vocabulary of science as the name of the branch of dynamics which investigates the relations between the movements of bodies and the forces acting upon them in contrast to statics, which is concerned with bodies in equilibrium. In 1891 the word acquired a new application when as a result of researches by Eadweard Muybridge it became possible to take a rapid succession of photographs of a continuous process or movement and a machine was invented, called the kinetoscope, for projecting photographs on to a screen so as to create an illusion of movement on the principle of the magic lantern or the later cinematograph projector. 'Kinetic' was first used in connection with the arts by Gabo in his Realist Manifesto, but 'dynamic' continued to be the term in most general use for the impression of 'virtual' movement in painting and sculpture as well as for

the impression of internal tension or stress among the planes and masses of an art work. It was not until the 1950s that the phrase 'kinetic art' became established as a recognized addition to critical classification.

Since then the term has been extended to cover a pretty wide spectrum of styles and techniques. In a collection of papers from the magazine *Leonardo* published in 1974 under the title *Kinetic Art: Theory and Practice*, the editor, Frank J. Malina, defined the scope of kinetic art as follows:

Kinetic art includes visual artifacts of three-dimensional or constructional type with mechanical motion of solid bodies, such as animated clockwork systems (which can be found on clock-towers in many cities of Europe) and Calder mobiles driven by air currents. The second major domain of kinetic art comprises the use of cinema equipment to create pictures of changing composition and colour projected on to a framed area (the screen). . . . Finally, there is a whole range of the less familiar kinetic 'painting' systems, utilising a translucent screen.

These constructions are as a regular thing non-representational, fully three-dimensional and make no use of a picture image or of virtual space. They must therefore be classed as a mode of Concrete art.

Among the objects ordinarily classified as kinetic art are two categories which involve virtual movement. Into one category fall objects which are so constructed that their appearance changes drastically and perhaps unexpectedly as the spectator changes his position in relation to them. The first to use this device was El Lissitzky in the wall of the 'Abstract Gallery' which he designed at Hanover in 1928. Since the mid-century the method of creating apparent movement in the art object by taking advantage of the observer's movements has been explored particularly by the Venezuelan Jésus Raphaël Soto and by the Israeli artist Yaacov Agam. Agam adopted the name 'kinetic' to describe his work about 1952. The other category comprises works which create apparent movement by the serial lighting of parts of the work on the analogy of those neon advertisements which light up the letters of a legend or the parts of a design in a serial order so that the lights appear to move. Of constructs which involve actual movement the simplest type is the unpowered mobile such as was inaugurated by Alexander Calder in the early 1930s (though Rod-

chenko's Hanging Constructions of 1920 might be put into this class with the proviso that movement was not their primary intent). The principle of the unpowered mobile is a built-in tendency to casual movement dependent on the structure – for example, a plaque or ball suspended on a thin, wire-like rod. By the 1960s such objects had become so popular that outside the realm of art they were being sold in novelty shops as gadgets for interior decoration. Three-dimensional constructions with mechanically moving parts as a feature of major importance constitute the bulk of what is usually meant by kinetic art. By the end of the 1960s the variety of objects being produced and the diversity of materials and techniques were so great that classification is almost impossible. Kinetic sculpture was being combined with auditory and light effects, computers were being pressed into service and the *Leonardo* anthology even had articles on the application of polarized light and on the production of illusions by 'Photic-stimulation of Alpha Brain Waves with Flashing Lights'. Almost every possible type of motive power was being exploited – the muscular exertion of the spectator, clockwork, springs, water-power, motors, electricity, magnetism, and so on. In some cases the movement was so slow as to be scarcely discernible and in other cases it might be too fast for the eye to follow. Sometimes movement was regular, sometimes purely haphazard and sometimes a fortituitous factor was built into a systematic movement process.

The production of art objects incorporating real movement instead of simulated motion did not make headway until after the Second World War and the anticipations were remarkably few if we exclude the many automata, animated pictures, mechanical toys, etc. which were produced for other than aesthetic reasons, such as the androids of Jacques de Vaucanson and the Jacquet-Droz family in the early eighteenth century and the mechanical musical boxes that are still being made. We exclude also theatrical devices, puppets and manikins which have interested artists both past and present. Despite their emphasis upon dynamic movement the Futurists made few if any experiments with actual movement except in the cinema. In their manifesto of 1915 'Futurist Reconstruction of the Universe' Balla and Depero spoke of reconstructions 'which rotate, decompose, transform, appear and disappear'. But they did not carry out these suggestions except for movable figures for their 'mechanical theatre'. Archipenko's *Medrano I* and *Medrano II* and the 'detachable' sculptures of Laurens,

all made about 1914, had movable parts but did not demonstrate actual movement. It was not until 1922 that Archipenko invented the Archipentura, an electrically driven machine for creating moving pictures on the magic lantern principle. Perhaps the earliest work to incorporate real movement was Duchamp's *33 West 67th Street*, a bicycle wheel mounted on a stool; but this, significantly, was one of his 'ready mades' designed to illustrate the principle of anti-art. In the early 1920s experiments were made with the use of movement to create an illusion of *volume*. These included the *Rotorreliefs* and *Rotative Demi-Spheres* of Duchamp, which, when made to revolve, created the illusion of rising and falling spirals, Delaunay's revolving colour discs and Gabo's *Kinetic Construction No.1*, a thin strip of steel which when caused to vibrate produced the appearance of volume as it was forced out of the vertical. Gabo also produced a drawing for a kinetic construction involving real movement in 1922 and a design for a fountain to be moved by water-power in 1929. In 1920 Tatlin designed a revolving movement for his *Monument to the Third International*, but this was not realized and was perhaps incapable of realization. Moholy-Nagy's *Lichtrequisit* of the 1920s was an elaborate electrical device using movement primarily for the production of light effects.

In the early 1930s Alexander Calder began to make his unpowered Mobiles, which with the hanging constructions of Tatlin and Rodchenko are the first real forerunners of kinetic art. From 1933 the Italian artist Bruno Munari was working on mobiles which he called *macchini inutili* (useless machines) and he issued a manifesto of 'machine art' in 1938. In the 1940s he constructed a number of kinetic objects, such as *L'ora X* in which hands were driven by clockwork round a timeless clock face. But experiment with movement for movement's sake as an aesthetic and expressive element did not seriously begin until after the mid-century. About 1959, after prolonged experiment with his *plans mobiles* (mobile planes) and *multiplans*, the French artist Pol Bury began to make more complicated three-dimensional structures in which movement was designed to serve expressive purposes. In the 1950s also the Swiss Jean Tinguely made reliefs composed of layers of movable rods and during the 1960s more complicated kinetic constructs, some of which were intended to be ironic satires on the machine. The Greek sculptor Takis made mobiles which he called *Signals* during the 1950s and from 1959 experimented with magnetic force in kinetic objects. The New Zealander Len Lye, a

pioneer in cinematograph animation, afterwards made 'animated steel' sculptures intended to display fundamental patterns of movement, combining movement often with noise and light effects.

These are but a few of the very many artists who have taken up the new art-form. The rapid growth of interest in it is attested by the many exhibitions devoted to kinetic art both in Europe and in America, by the increasing number of exponents and by the overwhelming variety of different forms and techniques. Almost every modern scientific technique has been pressed into service. But in the 1970s kinetic art is still in an experimental stage and no clear aesthetic has emerged. The veteran French aesthetician Étienne Souriau, in his *Les Catégories esthétiques* of 1956, distinguished a class of 'agogic' aesthetic categories concerned with tempo and differentiated two types of response: responses characterized by appeasement and calm on the one hand and on the other hand those involving excitement and incitation. From a survey of the work being done one might add to this the contrasting responses of hypnotic acceptance of a regularly repeated stimulus on the one hand (this type of response was exploited by François Morellet and several members of the Groupe de Recherche d'Art Visuel and the Nouvelle Tendance) and on the other hand surprise and shock in face of the unexpected. Movement itself has expressive or physiognomic qualities. It can be graceful, smooth, clumsy, jerky, repetitive, monotonous, rhythmical, sporadic, and so on. Or it can be dignified, capricious, solemn, proud, gay, lively, or languid. Pol Bury has been interested to explore and embody the expressive qualities of movement itself, though for understandable reasons most of these qualities are such that the language contains no words to name them. But a few kinetic artists have followed this lead. Attention to the expressive aspects of movement itself in isolation from the moving thing is in its infancy. For by far the greater part of kinetic art is closer to Constructivism than to Expressive Abstraction. Of course it is not abstraction at all but belongs to the new category of Concrete art.

Concrete to Conceptual Art

From small, almost casual anticipations in the second and third decades of the century the repudiation of *semblance* in all its forms became in the 1960s, as we have seen, a major principle. Its most

important manifestations were, perhaps, the incorporation of real movement instead of virtual movement or internal dynamism and the rejection of the three-dimensional picture image in favour of the construction in actual three dimensions. Both these manifestations involved the emergence of what were to all intents and purposes new art-forms: kinetic art and the 'construct' midway between traditional painting and traditional sculpture. But the tendency itself has been far more pervasive than this. It dominated the new sculpture which succeeded David Smith in America and Anthony Caro in England. And it extended even to the new representational art. We have mentioned the *Flags* of Jasper Johns, which were ambiguously situated between real flags and representations of flags. The same principle controls the art of Roy Lichtenstein and other Pop artists. Lichtenstein's representations are not representations of people and things but representations of the representations in popular comics, posters, etc. His subject-matter is twentieth-century kitsch in all its vulgarity and banality. Hence his art *is* kitsch, vulgar, and banal. But it is deliberately and knowingly so; and it is executed with a superb technique and often with a concealed excellence of composition which removes it entirely from the realm of kitsch.

We have also seen how in Minimal art this tendency coalesced with a revived and far more radical passion for simplicity, which not only demanded non-expressive simplicity in the elements but eschewed composition and relations, creating simplistic, immediately apprehensible works of expressive overtones.

Both these tendencies, the rejection of semblance – what we have called 'artifice' – and the exaggerated simplicity, represent what critics have called a new sensibility. They were not supported by any convincing argument but were insisted upon as a new orthodoxy by a younger generation of artists such as Sol LeWitt, Robert Morris, and Don Judd. They were the symptoms and the orthodoxies of the aesthetic outlook which dominated an important area of artistic production in the 1960s.

The term 'Conceptual Art' was first coined in connection with the Primary Structures of Robert Morris, but came to be applied internationally to a still newer and more radical artistic mode in which a documentary record or a set of instructions takes the place of the traditional physical or quasi-physical art object. Instead of a work of art being presented for perception, communications media – texts, photo-

graphs, maps, diagrams, sound cassettes, video, etc. – are used to refer the spectator to happenings, events, or situations removed in time and place from what is presented in the gallery as a means of reference. A 'Note on Conceptual Art' contained in the Tate Gallery *Biennial Report* for 1972–4 described this new type of art as a logical continuation of two further important trends, the tendency to direct the attention of the spectator increasingly upon the process by which an art work comes into being, that is the *idea* of the work, and the tendency to demand an ever-increasing measure of spectator involvement not only in the form of appreciation but by actual participation in the process of production. With regard to the latter, however, it seems to be at least as true that many practitioners of what is loosely called Conceptual Art have preferred to tread esoteric paths even to the verge of solipsism. As Professor Sam Hunter said in *American Art in the Twentieth Century*: 'The self-referential quality of the Conceptualists' propositions belongs less to the genre of audience-participation games than to a kind of nonmaterialized, visionary sculpture, which very often includes the performer's own body and physical actions. The Conceptualist is too intent on redefining his own reality in relation to art and language to consider directly involving spectators in the creation of his piece.'

The tendency to direct attention towards the idea rather than the finished product as an object of perception became the standard of a new orthodoxy towards the end of the 1960s. In his Introduction to the catalogue for an exhibition 'Art as Thought Process' which he organized for the Arts Council of Great Britain in 1974, Michael Compton wrote: 'Many artists in the last ten or twelve years have sought to direct attention more to the process by which the art is made (that is to the *work* which the artist does) than to the finished object.' He also said that such works 'invite the viewer to follow the thought process of the artist as it can be discerned in his work and, by means of his consciousness of this very thought process and of his own attempts to deal mentally with what he discerns, to come to a new awareness'. The familiar art object as a material or perceptible thing functioning for the expansion and exercise of perceptual awareness for its own sake has given place to a new conception of an art object whose primary purpose is to serve as a medium for the communication of an idea or a thought process. In Conceptual Art proper the 'dematerialization' of the art object has been taken to the point where the

traditional art object has been dispensed with and we are presented with a record or communication which in itself claims to have no interest for perception or expression. Abstraction has been carried to the last limit and to the point where the art work as a perceptible object has disappeared.

There remain two serious difficulties, which, although not necessarily fundamental to the new 'art of the idea', were still proving intractable by the middle 1970s. First, it was claimed that such works were 'self-evident', that the 'idea' was unambiguously patent in the work. This, of course, is a logical requirement because in so far as the function of the work is to communicate an idea rather than to function as an object of perception, any ambiguity or lack of clarity is a defect. But in the new type of Concrete art practised by such artists as Kenneth Martin, Keith Milow, Mark Lancaster, this is not the case. Quite complex drawings or structures are generated by simple mathematical formulas or arbitrary rules set up by the artist. But the formulas and rules are not patent in the art work. No layman, and perhaps no expert mathematician, could apprehend from looking at the works of these artists, usually uninteresting perceptually, what are the formulas or rules from which they are generated. When random elements and the operation of chance are incorporated, it is logically as well as practically impossible to derive the 'idea' from visual inspection. Since the works are not intended to be perceptually stimulating, and since they do not efficiently communicate their 'idea', we are brought to an impasse. All that is left us is an element of surprise or amusement that so simple an idea (combined perhaps with chance features) can generate a visual structure so apparently complex though, we are told, logically simple.

The second difficulty lies in the fact that the 'ideas' of Conceptual art – like the ideas of Primary Structures – are, typically, made not only simple but deliberately trivial, banal, and uninteresting. Most Conceptual artists deliberately make their productions uninteresting or trivial from a *visual* point of view in order to deflect attention from the perceptible object to the 'idea'. This is logical. And the notion that aesthetic qualities may attach to conceptual constructs is not new. Aesthetic delight in the elegance or economy or consistency of mathematical theorems or scientific and philosophical theories has long been recognized. Beauty prizes are even awarded in chess tournaments. But artists have not usually been noted for profundity or skill, beauty or

elegance, in the conceptual field; and in any case Conceptual artists and their exponents among the critics often make a point of the deliberate banality of the 'idea'. For example, Joseph Kosuth's *One and Three Chairs* (Museum of Modern Art, New York, 1965) combines a real chair, a photograph of a chair and a dictionary definition of 'chair'. The work certainly makes no attempt to be a visually interesting or moving composition in the traditional sense. Yet the idea which it presents – real, tangible chair; photograph; definition of concept – is trivial. Sol LeWitt caused a metal cube to be fabricated and buried it in the ground in Holland. The photographs of the event are not, and were not intended to be, fine examples of photographic art. The 'idea' was blatantly and deliberately banal. The exhibition 'Art as Thought Process' included a printed questionnaire in which the first question read: 'Suppose this question. Is this piece of paper an art work?' The last two items of Section B ran as follows:

5. Nondeductive rules in detecting art are not so much designed to single out regularities which are intrinsic features of the universe, as they are designed to systematize the choice of regularities of which predictive extensions are made in making nondeductive inferences.

6. Questioning 5 above, if there are nondeductive rules which the concept of art is founded upon, what kind of features do they have? Do they locate a regularity in the facts given in a certain situation?

As a visual object this sheet of paper had no more claim to be regarded as a work of art than any other printed sheet. Judged by standards which prevail among philosophers and art theorists, it was incompetent, obscure, and trivial. Yet for it to be included in the exhibition somebody must have decided that the right answer to the first question was an affirmative one.

The deliberate triviality of object and idea does not mean necessarily that Conceptual art may not signify the beginning of a new phase in the age-long metamorphoses of art-forms emerging from the coincidence of the tendency to abstract from visual interest and the tendency to abandon artifice for simplicity or banality. But it raises the question of the importance which can or should be attributed to the communication of banal 'ideas' from one man to another and the nature of the satisfaction derived from such communication by the artist or his public. The intuition of artists has often been in advance of the world's understanding. And what this indicates is that by the mid-1970s the

rationale of this new art form had not been understood either by the critics who purported to explain it or by the museum curators who were responsible for selecting what examples merited exhibition and purchase.

14

Epilogue

When a work of art is *representational* it carries visual information about things in the world outside itself, their colours, shape, structure, etc. This, precisely, is what it means to call a work representational. Traditionally it has been taken for granted that the major function of all pictorial art is to convey such information about the world as it is or as it has been imagined ideally to be. And it has often been tacitly assumed – though not, perhaps, generally by artists themselves – that the accuracy and completeness of the information conveyed, the exactness of correspondence between representation and object represented, is a criterion of the excellence of representational art so that an artist who succeeds in fooling those who see his work into believing that it is not a representation but the actuality of what it represents is deserving of the highest praise in his craft. Hence such remarks as that of Plato, who said in the *Laws* that you cannot judge the success of a work of representation unless you are independently familiar with the thing it represents. And hence the many apocryphal stories in the literature of the arts such as the one about the master who tried to brush away the fly painted by a prodigy pupil on his canvas.

Borrowing the language of Information Theory, we have called this kind of information *semantic information*, and when the amount or scope of such information is deliberately reduced we have spoken of *semantic abstraction*.

In the first part of the book we have shown that it has been a major distinguishing feature of the aesthetic outlook implicit to the development of twentieth-century art to ascribe diminishing importance to the communication of semantic information, until at the limit it may be abandoned altogether. Information about the visible world may be curtailed for a variety of different reasons. In particular, information about some aspects of the world may be played down in order to bring into greater prominence other aspects, in which the artist was more keenly interested. This we have called *Aspect Realism*. And as the interests of artists have changed with regard to the aspects of things they wished to depict, so there have arisen different kinds of Aspect Realism, from Impressionism to Cubism, each characterized by its own mode of abstraction.

Among the forms which Aspect Realism may take is that which sets the emphasis upon the *expressive* qualities of things, their affective, emotional and aesthetic properties, tending to subordinate scientific-

ally objective depiction to a manner of representation which gives prominence to these properties. This is often linked on the one hand with powerful feelings of empathy on the part of the artist, amounting at times almost to emotional identification with the thing he depicts, and on the other hand with a strong interest in the expressive qualities of the art work itself. We saw both these things to the fore in the early writings of Matisse. When the process of subordination is carried to the limit where subject recognition lapses, there may still survive in the expressive characteristics of the art work itself suggestions of the expressive features of the segment of external reality from which the abstraction originated. This may be seen in the work of some painters of the Tachist school, such as Manessier, Singier, Jean Le Moal, Pierre Tal Coat. We have distinguished this kind of Expressionism, whether it is fully abstract or still representational as with Soutine, for example, from the form of Expressionism, practised largely in Germany, which lies outside the confines of Aspect Realism and exploits both abstraction and distortion in order to communicate the artist's personal feelings towards the world he depicts.

Like all other visible and tangible things, works of art also impart information about their own sensory properties and structure. This we have called *syntactical information*, again following the language of Information Theory. While in the past relatively little overt concern was manifested for syntactical information, the aesthetics of twentieth-century art has been marked by increasing emphasis upon it corresponding to the fading of interest in semantic information for its own sake. A work of pictorial art came no longer to be regarded primarily as a representation, a mirror – clear or distorted – through which one sees a segment of the world depicted, but as an artefact made expressly to be seen in its own right for what it in itself is. In twentieth-century art it was no longer the aim to make the medium totally 'transparent' but techniques were devised for making us more fully aware of the medium, for rendering it 'opaque'. People spoke of 'bringing the eye back to the picture plane', and there arose a cult of dislike for all that was wrongly called 'illusion'.

When semantic information is reduced to a point beyond which it is not possible to recognize a subject of the work attention is necessarily focused solely upon syntactical information, that is upon the sensory and expressive qualities of the artistic medium and its structuring, although even so the medium may still retain expressive properties

reminiscent of expressive properties seen by the artist in some segment of external reality which, as it were, served as his starting-point for the conception of his work. There is, however, another kind of abstraction differing radically in principle from semantic abstraction. This occurs when a work is brought into being not by a curtailment of semantic information but entirely apart from semantic reference, being an artefact composed as an independent structure from parts which are themselves devoid of semantic import and emotionally neutral. We have distinguished this sort of abstraction by the name *non-iconic abstraction*. A typical formulation of the principles by which it is governed was found in the writings of Kandinsky.

As there are two classes of abstraction, semantic and non-iconic, so there are two classes of non-iconic abstraction, which became clearly differentiated about the mid-century. One class has put the main emphasis on expressive information, exploiting the expressive properties of the artistic medium and sometimes purporting to repudiate formal and structural properties. The main manifestations of this kind of abstraction have been *art informel*, Tachism, Abstract Expressionism, and certain kinds of abstract Surrealism. The other kind of non-iconic abstraction by and large rejects expressiveness in the whole or in the parts, placing the major emphasis on structural properties of the whole, and seeks to compose an art work from elements devoid of expressive personality which it unites into a complexly structured whole whose *raison d'être* is to activate expanded and enlarged perception. The main manifestations of this kind of abstraction have been Suprematism, Neo-Plasticism, and Constructivism. We found a typical formulation of the principles by which it is governed in the writings of Mondrian and Charles Biederman.

It has commonly been claimed that the former type of non-iconic abstraction directly reveals the psychological states of the artist, being as it were a kind of pictorial autobiography, while the latter kind furnishes non-intellectual insight into the metaphysical structure of the universe. We have treated both these claims with some reserve.

Works of art constitute a special class of artefacts distinguished from other artefacts by the possession of 'virtual' properties. This is a somewhat complicated notion. Virtual properties are properties which are directly apprehensible to the senses although they are not scientifically verifiable and we do not in fact believe that they are 'real' in the same sense that things in the world around us are real. Yet they are not

subjective or imaginary but are objectively present in the works of art we see. When we look at a piece of flat pigmented canvas representing a forest scene we actually see a forest receding in three-dimensional space but we do not in fact believe we could walk in this forest. Depth is a 'virtual' property of three-dimensional picture space which differs from the actual two-dimensional space occupied by the canvas. There are also virtual properties of shape, size, colour, structure, etc. and in the hands of a fine artist works of art may possess virtual properties of all these kinds which are not possessed by the segments of the world which they represent and some which could not belong to the natural world. It is by their possession of virtual qualities that works of art are distinguished from non-artistic pictorial representations. Virtual properties are not restricted to representational art, however, but belong also to non-representational abstract works. These are not seen exactly as we look at useful artefacts. They too create a virtual picture space of their own, which may have recession into depth, interacting colours, structural rhythm, apparent size, etc., and it is often by means of these virtual properties that their impact is made. Although historically virtual properties of art works may have arisen mainly as an adjunct to representation, the movement towards abstraction has often enhanced rather than diminished their importance in creating the artistic effect.

Besides the trend towards abstraction we have been concerned with another pervasive characteristic of twentieth-century art, which we have called the 'repudiation of artifice'. Put briefly, this may be described as a somewhat doctrinaire desire to abolish virtual properties, often under the mistaken belief that they are a form of 'illusion'. Sometimes this repudiation has been confused with the rejection of semantic information, although it is in fact distinct from it. Indeed, in so far as abstract work relies on the exploitation of virtual properties the move to abolish these properties is in conflict with the movement towards abstraction. It represents a desire to do away with all distinctions between works of art and other classes of artefacts with the single exception that works of art serve no useful purpose other than to attract perceptual interest. Their sole *raison d'être* is to be looked at. But, it is insisted, they must be looked at exactly as any other artefact is looked at and this stipulation must govern the way in which they are made. They must be seen as the real materials from which they are made, not as suggesting other materials; they must be seen

as occupying the space they do occupy, as having the shapes they do have; their colours must be seen as the colours they are; and so on. There must be no creation of artificial properties belonging to an 'unreal' picture space and three-dimensional constructions must similarly eschew 'unreal' qualities of energy, vitality, etc. which were valued in traditional sculpture.

Perhaps the earliest manifestation of this tendency may be seen in the constructions of Tatlin and Rodchenko, which substituted an actual third dimension for its pictorial representation and by their emphasis on real materials paved the way for the subordination of autonomous art to industrial design. The post-war vogue for constructions which exist midway between painting and sculpture was a manifestation of the same principle, which found theoretical expression in Biederman's rejection of traditional painting on the ground that painting necessarily creates an 'illusory' third dimension. Another important expression of the same tendency is traced in concrete art as developed in Switzerland by the followers of Max Bill and by exponents of post-war Constructivism such as Kenneth Martin and Anthony Hill. The whole development of kinetic art, from its tentative beginnings in the 1920s to its vastly accelerated progress around the mid-century, belongs to the same category. Impatient with the age-old problem of finding ways to suggest movement in a static medium, or regarding this as the creation of an 'illusion' little short of trickery, kinetic art substitutes actual movement in a medium made to move. We saw a similar principle at work in the new colour painting initiated by Morris Louis, whose aim it was to confront the viewer with real colour in place of 'virtual' colour. And much Minimal art too combined the dogmatic repudiation of virtual properties with an equally ascetic addiction to simplicity involving a dislike for ambiguity and structural complexity. While these are some of the main manifestations of the tendency with which we have been concerned, it too, like abstraction, has been very pervasive throughout the characteristic expressions of twentieth-century art.

The repudiation of artifice is sometimes justified as a necessary condition for bringing art into closer contact with the life of the people, an attempt to 'close the gap between art and life'. This justification may rest on a misunderstanding. Certainly the rejection of virtual properties means the repudiation of all traditional and much of twentieth-century art, for virtual properties are essential to the very

concept of art as that has evolved up to the present time. Whether the idea of artefacts differing from all other artefacts *only* by their non-usefulness will prove a viable substitute for the historical conception of art, remains still to be seen. Certainly art as it has evolved possesses staying power to survive.

INDEX

1. Constantin Brancusi *Maiastra* (1911)
Height 35⅝ ins; Tate Gallery, London

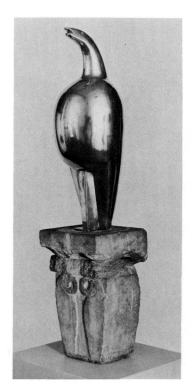

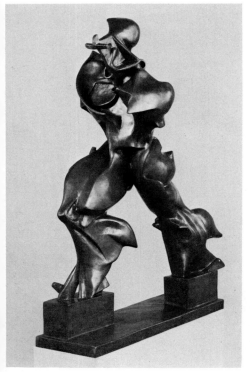

2. Umberto Boccioni *Unique Forms
of Continuity in Space* (1913)
Height 46¼ ins; Tate Gallery,
London

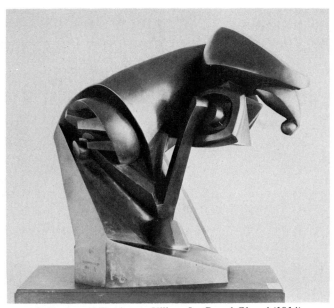

3. Raymond Duchamp-Villon *Le Grand Cheval* (1914)
Height 39⅜ ins
Collection, Walker Art Center, Minneapolis
Gift of the T. B. Walker Foundation

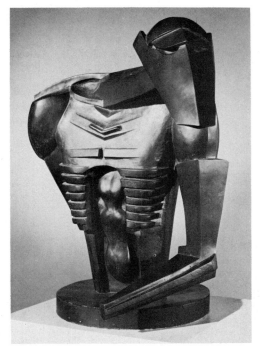

4. Jacob Epstein *Torso from The Rock Drill* (1913–14)
Height 27¾ ins; Tate Gallery, London

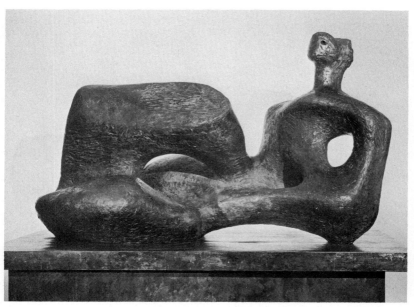

5. Henry Moore *Reclining Figure* (1957–58)
Height 54 ins; Tate Gallery, London

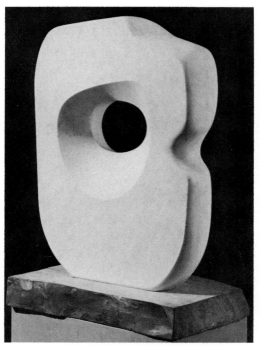

6. Barbara Hepworth *Pierced Form* (1963–64)
Height 49¾ ins; Tate Gallery, London

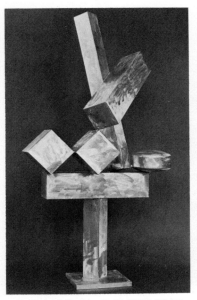

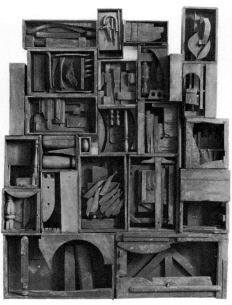

7. David Smith *Cubi XIX* (1964)
Height 113 ins; Tate Gallery, London

8. Louise Nevelson *Black Wall* (1959)
Height 112 ins; Tate Gallery, London

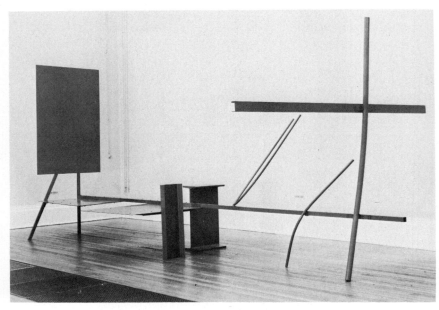

9. Anthony Caro *Early One Morning* (1962)
Height 114 ins; Tate Gallery, London

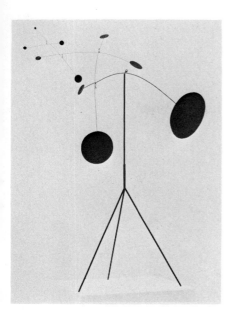

10. Alexander Calder *Black Mobile* (*c.* 1948)
Height 36½ ins; Solomon R. Guggenheim
Foundation, New York

11. (below) Robert Morris *Untitled* (1965–71)
Height 36 ins; Tate Gallery, London

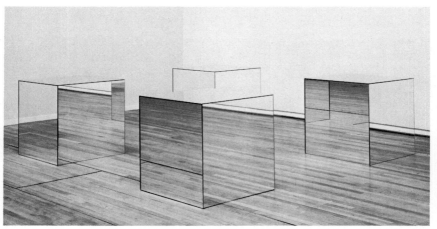

12. Donald Judd *Untitled* (1972)
Height 14⅝ ins; Tate Gallery, London

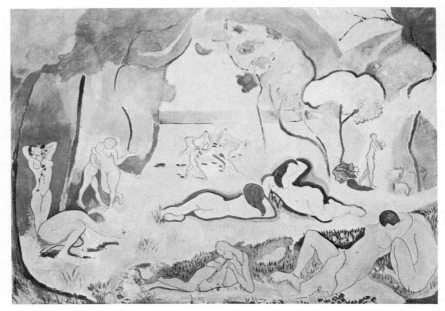

13. Henri Matisse *Bonheur de Vivre* (1905–06) Photograph Copyright 1979 by the Barnes Foundation, Pennsylvania © by S.P.A.D.E.M., Paris, 1978

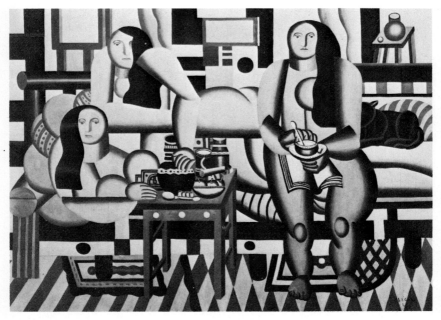

14. Fernand Léger *Le Grand Déjeuner* (1921) Collection, The Museum of Modern Art, New York
Mrs. Simon Guggenheim Fund © by S.P.A.D.E.M., Paris, 1978

15. Wassily Kandinsky *Cossack* (1910)
Tate Gallery, London © by A.D.A.G.P., Paris, 1978

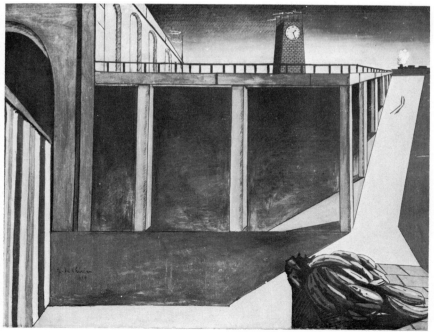

16. Giorgio de Chirico *Gare Montparnasse* (1914) Collection, The Museum of Modern
Art, New York
Fractional Gift of James Thrall Soby © by S.P.A.D.E.M., Paris, 1978

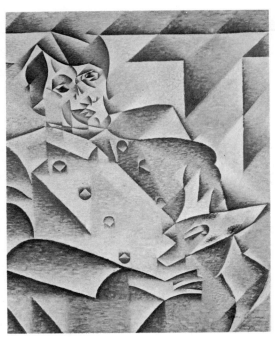

17. Juan Gris *Portrait of Picasso* (1912)
Courtesy of The Art Institute of Chicago

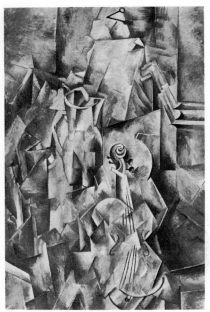

18. Georges Braque *Violon et Cruche*
(1910)
Kunstmuseum, Basle
© by A.D.A.G.P., Paris, 1978

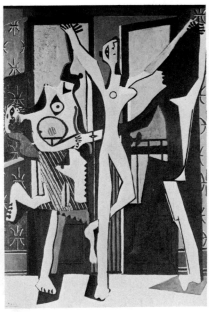

19. Pablo Picasso *The Three Dancers*
(1925)
Courtesy of The Art Institute of
Chicago
© by S.P.A.D.E.M., Paris, 1978

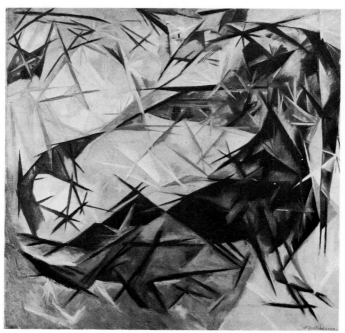

20. Natalia Goncharova *Cats* (1911–12)
Solomon R. Guggenheim Foundation, New York
© by A.D.A.G.P., Paris, 1978

21. Mikhail Larionov *Glasses* (1911)
Solomon R. Guggenheim Foundation, New York
© by A.D.A.G.P., Paris, 1978

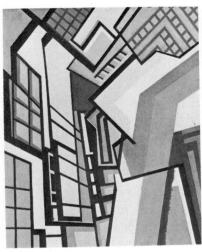

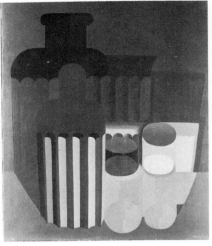

22. Wyndham Lewis *Workshop* (1915)
Tate Gallery, London

23. Amédée Ozenfant *Glasses and Bottles*
(1922–26)
Tate Gallery, London
© by S.P.A.D.E.M., Paris, 1978

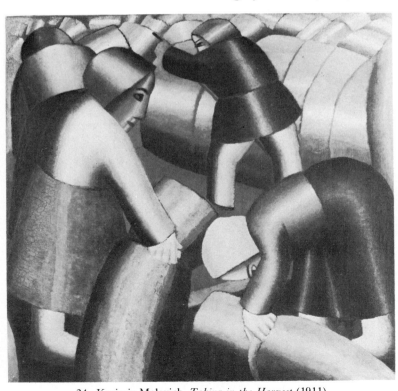

24. Kasimir Malevich *Taking in the Harvest* (1911)
Stedelijk Museum, Amsterdam

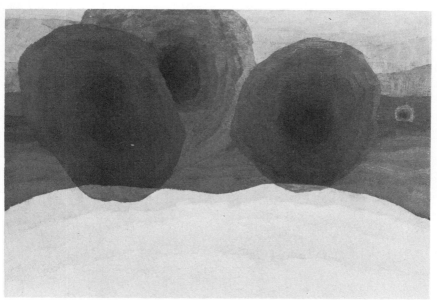

25. Arthur Dove *Fog Horns* (1929)
Colorado Springs Fine Arts Center, Colorado

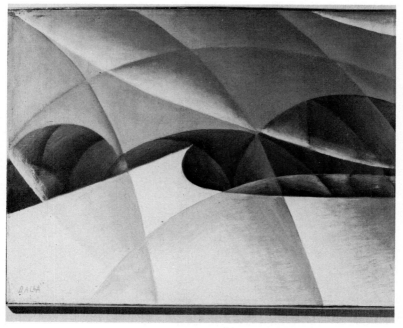

26. Giacomo Balla *Velocità astratta* (1913)
Tate Gallery, London

27. Umberto Boccioni *Stati
d'animo: Quelli che restano* (1911)
Civica Galleria D' Arte
Moderna, Milan

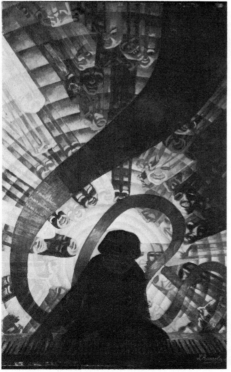

28. Luigi Russolo *La
Musica* (1911–12)
Tate Gallery, London
Collection, Mr. and Mrs. Eric
Estorick

29. Hans Hartung *T 1963–R 6*
Tate Gallery, London
© by A.D.A.G.P., Paris, 1978

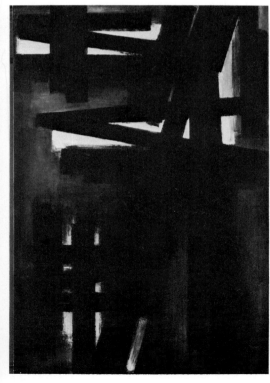

30. Pierre Soulages *23 May 1953*
Tate Gallery, London
© by A.D.A.G.P., Paris, 1978

31. Franz Kline *Chief* (1950)
Collection, The Museum of
Modern Art, New York
Gift of Mr. and Mrs. David M.
Solinger

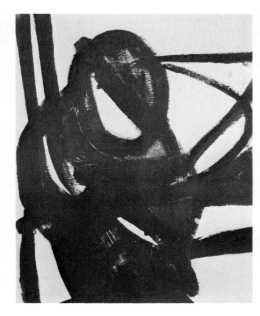

32. Willem de Kooning *Woman 1*
(1950–52)
Collection, The Museum
of Modern Art, New York

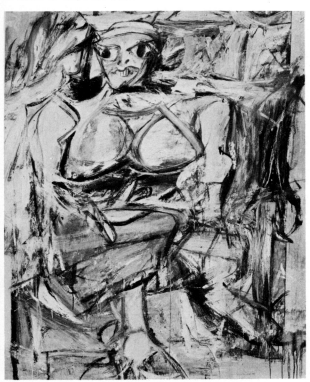

33. Charles Biederman
Structuralist Relief (1954–65)
Tate Gallery, London

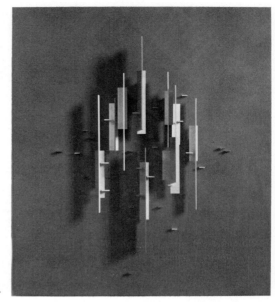

34. Jasper Johns *Target
With Four Faces* (1955)
Collection, The Museum of
Modern Art, New York
Gift of Mr. and Mrs. Robert C.
Scull

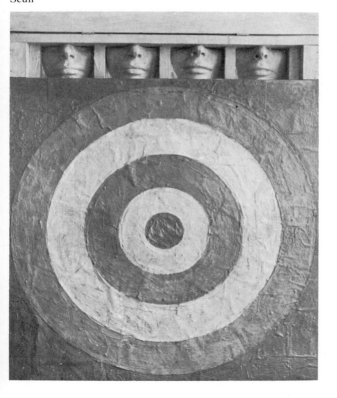

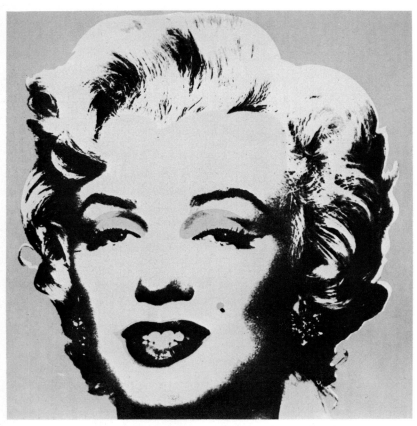

35. Andy Warhol *Marilyn* (1967) Tate Gallery, London